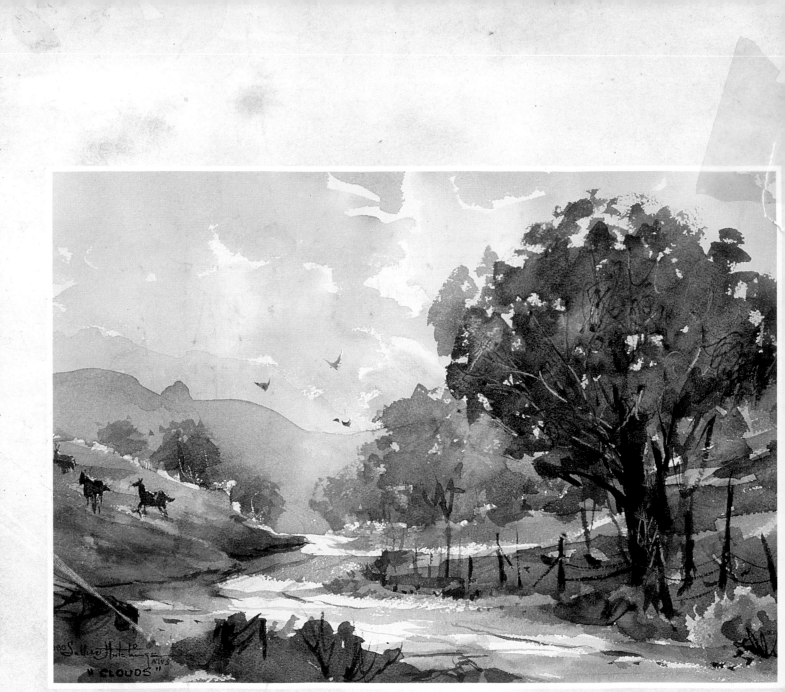

Clouds by LaVere Hutchings

THE ENCYCLOPEDIA OF

WATERCOLOUR LANDSCAPE

TECHNIQUES

HAZEL SOAN

SEARCH PRESS

A QUARTO BOOK

Published in paperback 2002 by
Search Press Ltd
Wellwood
North Farm Road
Tunbridge Wells
Kent TN2 3DR

ISBN 0 85532 999 8

This book was designed and produced by

Quarto Publishing plc
The Old Brewery
6, Blundell Street
London N7 9BH

Senior editor Kate Kirby
Editor Hazel Harrison
Art editors Liz Brown, Antonio Toma
Designer Julie Francis
Picture researcher Jo Carlill
Photographers Paul Forrester, Colin Bowling
Picture Manager Giulia Hetherington
Editorial editor Mark Dartford
Art director Moira Clinch

Typeset by Central Southern Typesetters, Eastbourne
Manufactured in Singapore by Bright Arts (Singapore) Pte Ltd
Printed in China by Leefung-Asco Printers Ltd, China

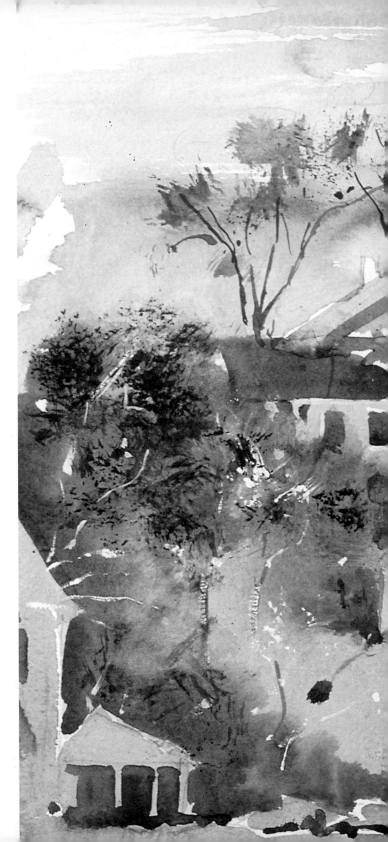

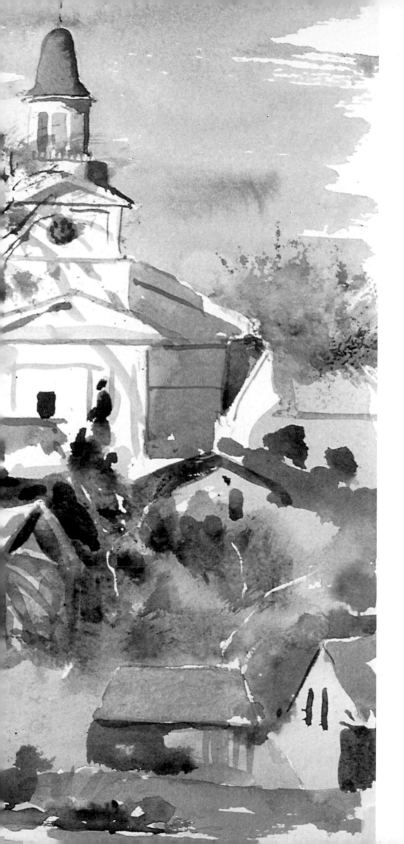

Contents

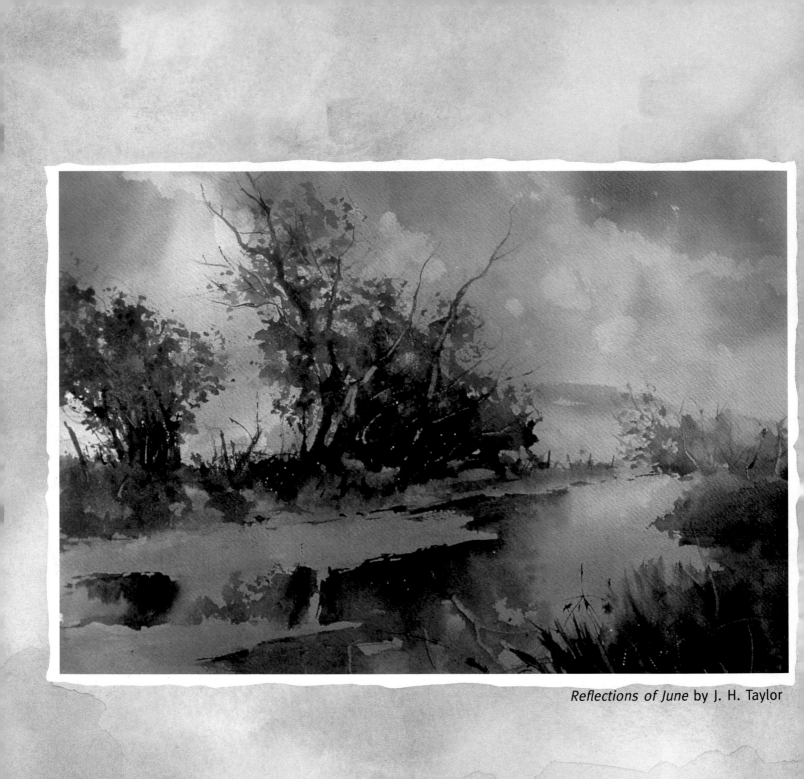

Reflections of June by J. H. Taylor

Foreword

Once you have tasted the pleasure of painting in watercolour you will become addicted. Everything about the medium is aesthetically satisfying: the rich variety of mouthwatering colours; the sensuous sable brushes; the soft white textured papers; even the paint curling from the tip of the brush in the crystal clear rinsing water.

The special radiance of watercolour comes from the light being reflected back from the white paper through the transparent layers of colour. In watercolour the quick sketch often buzzes with more life than the laboured painting because this quality has been lost under layers of overworked washes. The pigments are so lovely in themselves, the less you try to force them into some prearranged idea the fresher and more vital your paintings will be. Resist the temptation to fiddle with your watercolour while the wash is drying. The effect is to create overworked areas of colour and tired paintings. Freshness and vitality are the appeal and attraction of watercolour both for the painter and the viewer.

Of course you must be in control, but remember the old adage "less is more" and you will be well on your way.

The "happy accidents" that characterize watercolour are not always easy to encourage, or control, but will occur more readily if you allow your watercolour a measure of freedom.

Don't make too many rules for yourself. Buy a decent sable brush and allow your washes to dry without interference; these are rules enough!

Some people will tell you watercolour is a difficult medium because you cannot correct your mistakes. In fact once the paint is dry you can actually lift off colour, touch in colour, scrub out colour and add new media such as gouache or acrylic, pastel or crayon to restore a disaster area.

Above all enjoy yourself. After years of painting in watercolour I am still overtaken by the sheer beauty of colours dried on the palette or laid at random on the test paper, marvelling at the attractive patterns they make and the unexplored colour combinations I missed.

It is the love of watercolour and joy in the pleasure of painting that will ultimately determine the success of your painting.

Hazel Soan

Tools and Materials

Watercolour artists travel light. Whether indoors or out, the basic equipment is neither cumbersome nor heavy.

The most important piece of equipment is your brush; with an inferior one you will struggle to make watercolours that satisfy. Good brushes are expensive, but it is better to buy one good size 7 sable with which you can paint both broad washes and fine lines than to buy a whole range of cheaper synthetic brushes of differing sizes. A sable brush will enable you to "feel" the beauty of watercolour even as you mix it in the palette, and will enable you to make the brushstrokes characteristic of the medium.

Water Water is the next most important piece of "equipment" (and the heaviest). If you want your watercolours to be vibrant and clear you must keep changing your water.

Jars for water
Use one large jar for rinsing brushes, and have two small water jars for diluting colours.

Brushes
From left: The large mop is for dampening paper, laying large wet washes and lifting colour. A flat brush comes in many widths. Buy as large a round sable brush as you can afford and try to supplement that with a smaller one as well. Small oxhair brushes will not give you a good brushstroke but are useful for laying masking fluid.

Tissues
Anything that mops up water will do. Tissues and rags are used not only to wipe your brushes and absorb extra water, but also to lift colour from the paper.

Tube paints
For more and stronger colour it is easier to use watercolour paint from tubes. Small tubes will last a long time as long as the lids are kept tightly closed, and paint left on the palette is always reusable in the same way as pans.

Pencils
Sketch out compositions with
a graphite or soft lead pencil.

Erasers
Have a clean eraser or putty
rubber handy for removing
unwanted pencil lines or dried
masking fluid.

Pans
For working outdoors
especially pans provide quickly
accessible colour. Some
colours yield up their pigment
with ease while others need to
be coaxed.

Palettes
Paintboxes come with folding
palettes, but you may need to
supplement these if you work
large or with lots of paint.
China palettes are far more
satisfying to use than plastic
ones and are easier to clean.
Neither are expensive.

Watercolour sketch pads
These come in a variety of sizes and with different
weights of paper. The heavier the paper (140lb as
opposed to 90lb) the less the paper will cockle. If you
work wet use sheets of 300lb watercolour paper
unless you are prepared to stretch the paper
before use.

Additional Materials

To enable you to practise the techniques explored in this book you will require some additional materials, none of which are expensive.

Several of the items shown on these pages are worthwhile additions to your basic watercolour kit and have a variety of uses. Few watercolourists are without small sponges, for example. These are ideal for lifting out colour for cloud effects and so on; they are an alternative to brushes as a way of laying washes, and if an area of a painting has gone wrong, you can wash it down with a sponge and repaint. A hairdryer is indispensable for cutting down drying time when working indoors.

Manmade sponge
A manmade sponge is useful for damping paper or for large washes.

Natural sponges
The pleasant irregular texture of a natural sponge makes it ideal for applying paint to paper and for washing colour out.

Masking fluid
This is a water resistant latex fluid used for masking out areas of a painting from a wash. It is sold in bottles from art shops, and is made in white and yellow.

Candles
White household candles are ideal for wax resist methods. Wax crayons can also be used.

Toothbrush
Any old toothbrush with an even head will do for spattering paint.

Salt crystals
These are used for a special texturing technique. They are scattered into wet paint. Choose large crystals of sea salt and crush them to a finer size.

WINSOR & NEWTON
AQUARELLE
Fluide
artistique de
masquage
AQUARELL
Maskierpflüssig
flüssig
Fluido para enmascarar pintura
WATER COLOUR
Art Masking
Fluid
75 ml ℮ 2.5 US fl.oz.

White paint
The opacity of white gouache or white watercolour enables the artist to make colours opaque and to restore lost highlights.

Stucco
Ceramic stucco is a textured gel. Mix it with paint to give the watercolour real body. The paint keeps its translucency but sets as actual texture on the paper.

Hairdryer
To speed up the process of drying watercolour keep a hairdryer handy in your work area. Be careful not to blow colour across the paper, unless of course that is your intention.

Blades
Sharp scalpel blades are needed for scratching out and sgraffito. Also, of course, for sharpening pencils.

Brown gummed tape
You will need to stretch lightweight paper if you are working wet. Use brown tape to hold down the paper on the drawing board.

Ink and dip pen
Ink can be applied to a painting with a dip pen or a brush. It must be waterproof if you don't want it to run or smudge once dry.

Working Methods

Watercolour is a medium you can use anywhere. It is relatively clean, easily portable, and the materials need little space or organization.

If you are working sketchbook-size a small pan paintbox with a finger ring can be balanced in the hand that holds the sketchbook, a small pot of water balanced on the palette of the paintbox and your brush held at the ready in the other hand. You can paint standing up, at the bus stop, in the airport lounge – anywhere. If you are working at home or in the studio make sure you are looking down on the paper you are painting on as much as possible rather than viewing at an angle. Distortion in a painting is often caused by the angle you are painting at. If you work very dry you could stand the paper on an easel, but usually watercolourists work quite wet so you will need to tilt your drawing board as much as possible, without soliciting runs, or sit on a high seat, or even stand over your work. At frequent intervals step back from your work to view it from a distance. There is nothing more soul-destroying than finding that the painting you thought looked great close up really does not work at a distance. If you find it hard to "see" your own work look at it in reverse in a mirror.

Working outside When working outside you will find a small fold-up seat is handy so that you can perch anywhere to make your painting. As well as your watercolour pad, take a small sketchbook for colour notes and quick reference sketches. Carry a plentiful supply of water. If you are not comfortable working on your lap invest in a lightweight easel.

Kitchen towel on surface to soak up spills and to blot excess water from brushes. If you use white kitchen towel you can also test your colours on it.

Paper is tilted towards the artist to give straight-on view.

The advantage of using a heavy 300lb paper is that it has no need to be stretched.

Make sure your light source is coming from in front or above or from the side opposite to your brush, otherwise you will work in your own shadow.

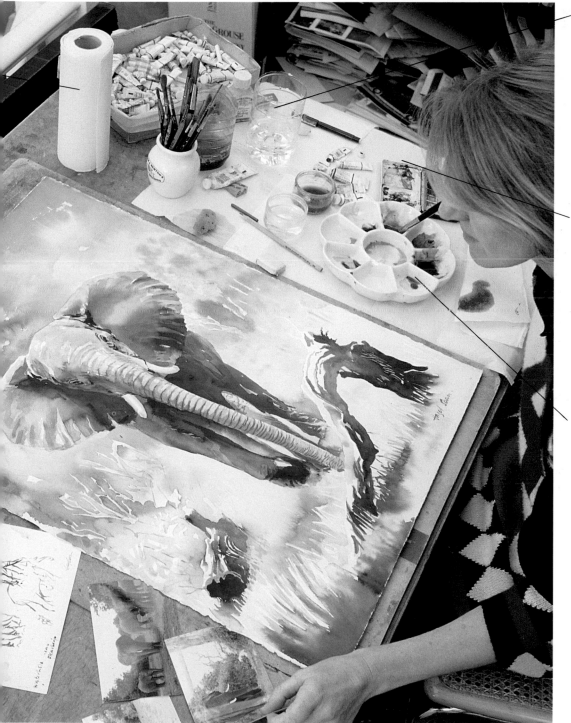

Four water pots: two for diluting colours (frequently changed), one slop jar for muddied water, one reservoir of clean water water. (This saves repeated trips to the sink).

You can use a mixture of pans and tubes. Often it is a good idea to buy tubes of colour you use often and rely on pans for intense colours you use sparingly.

Plenty of mixing palettes so you can keep reservoirs of clean colour.

Never leave brushes head down in water jars. The hairs will bend and splay, and may be impossible to straighten.

Stretching paper

Thin papers will need to be stretched to avoid cockling when wet paint is applied. The ideal method is to dampen the paper and then stick it down firmly onto the drawing board with brown sticky tape around the edges. As it dries the paper shrinks evenly because it is held in place by the gummed paper. Check that no edges lift while drying, or cockling will still occur. You then work on the paper while it is attached to the board, only cutting it free when you have finished.

A quick but not always reliable method is to tape your dry paper down in the same way with either gummed paper or masking tape. As long as you do not get water close to the edges or running under the tape this method can be a great time saver. You must again check that the tape is firmly stuck down all round while you are painting.

Planning compositions

Composition is the single most important aspect of painting. It can make or break your picture, so it is worth spending time getting it right. If you are out in the landscape a small cut-out rectangle the shape of your paper will help you recreate the landscape on the paper. Mark loosely the half and quarter marks on the side of the viewfinder to help you decide where various elements of the composition will be placed on the page.

Failing a viewfinder, make a rectangle out of the thumbs and forefingers of both hands and look through that.

Use your thumb, pencil or the end of the paintbrush held at the end of an outstretched arm to determine relative scale and size between objects in the landscape.

Using photographs

Using photographs as source material is a useful way of recording shapes and compositions from the landscape. However, if you rely on photographs as the source of your paintings as a beginner, you will not learn to translate three dimensions into two, the essence of painting, nor will you experience the visual reduction in scale that necessarily takes place when you make paintings in the real world.

It is vital that you sit in front of the subject and select the elements of the painting yourself. If you do not have time for a full-blown painting make a coloured sketch.

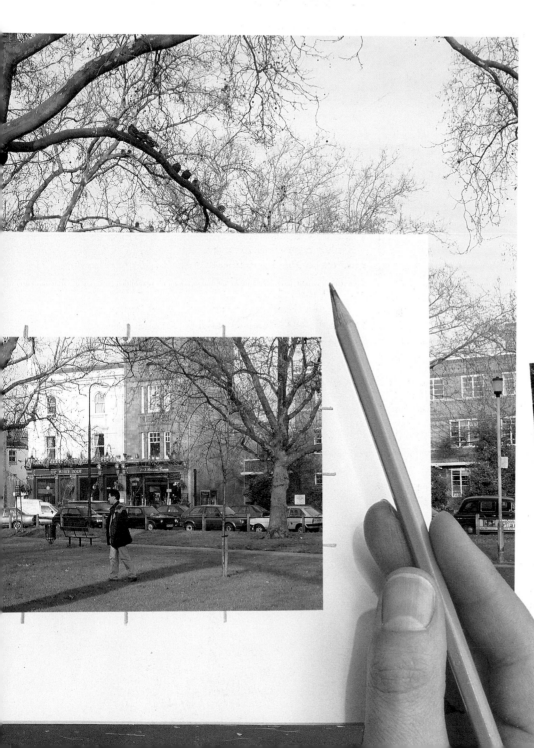

Colours

There is a vast range of colours available to the watercolour artist, but you don't need to invest in all or even half of them to make a start.

Many of the colours produced by paint manufacturers go by exotic names the beginner may never have heard of, and which seem to have no relationship with the colours you see around you. But once you have begun to paint, and practised colour mixing, you will begin to think in terms of paint colours, describing something to yourself as yellow ochre rather than browny/yellowy/gold, or as alizarin crimson rather than dark pinky red.

As colours are mixed and diluted you will discover something else, which is that some colours are less transparent than others. Alizarin crimson, for example, is transparent, while cadmium red is semi-opaque. Yellow ochre and raw sienna are similar in colour, but the latter is transparent and the former considerably less so.

Begin by choosing a basic range of about 14 colours, and get to know them well; you will find you acquire favourites. You may want to add further colours later, but still try to limit the number you use in any one painting.

Earth colours

For entirely naturalistic landscapes you might try a limited palette of the earth colours. By selecting a few colours you will more easily maintain a harmony of colour throughout the painting.

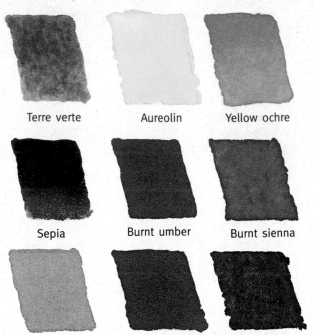

Terre verte Aureolin Yellow ochre

Sepia Burnt umber Burnt sienna

Raw sienna Indian red Indigo

Beginner's palette

Here is recommended a basic beginner's palette of 14 colours. Alternatives are given in some cases, either because two colours are similar enough to do the same job, or because individual manufacturers' pigments differ.

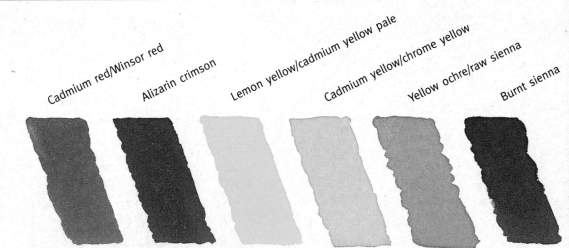

Cadmium red/Winsor red Alizarin crimson Lemon yellow/cadmium yellow pale Cadmium yellow/chrome yellow Yellow ochre/raw sienna Burnt sienna

Limited palettes

It is possible to paint with just one colour diluted to many tones, and the use of two colours – sometimes mixed, sometimes glazed over each other and sometimes used alone – presents possibilities for exciting effects. Experiment with ultramarine blue and burnt sienna for example.

With any combination of the three primary colours – red, blue and yellow – you can, of course, make a myriad of colour combinations. This uses only three colours – alizarin crimson, yellow ochre and ultramarine blue.

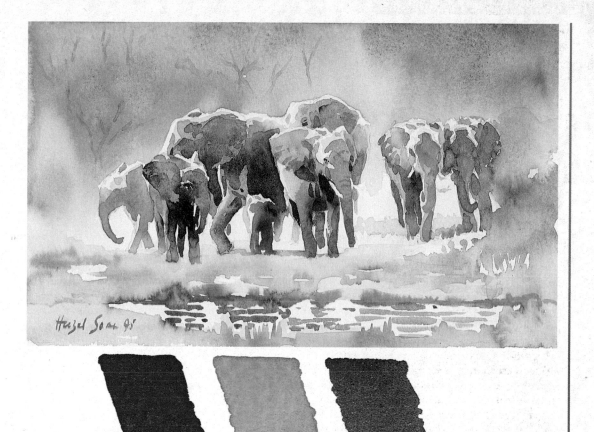

| Alizarin crimson | Yellow ochre | Ultramarine blue |

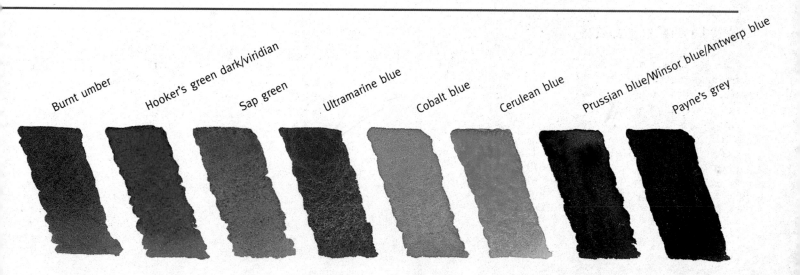

| Burnt umber | Hooker's green dark/viridian | Sap green | Ultramarine blue | Cobalt blue | Cerulean blue | Prussian blue/Winsor blue/Antwerp blue | Payne's grey |

Landscape greens

Green can be a problematic colour in landscape painting. There is a tendency to paint greens too vividly in a childlike manner. To prevent this why not mix your greens from different blues and yellows, ochres or siennas? Not only will you find yourself looking more carefully at the green to see whether it veers to yellow or to blue, but you will also find the subtle variations within the mixed colour more interesting than laying a ready made green. Try some of these colour combinations for grass greens, tree greens, shadows and so on.

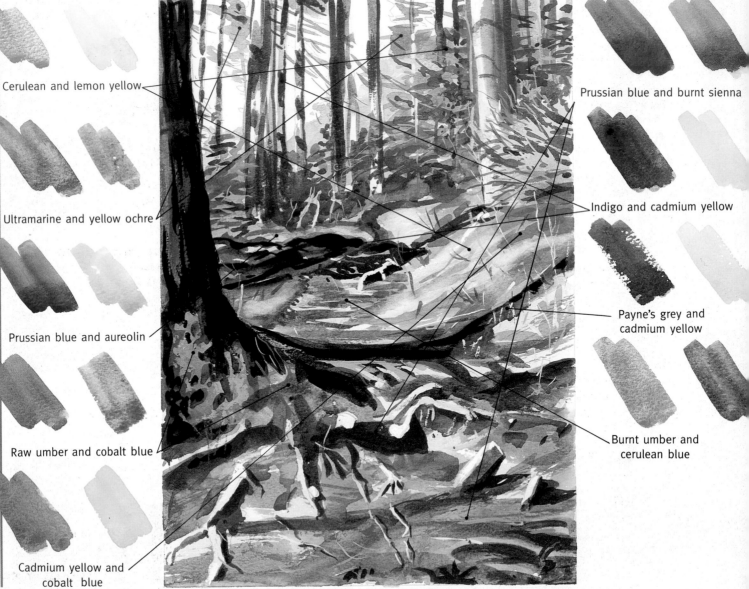

Cerulean and lemon yellow

Ultramarine and yellow ochre

Prussian blue and aureolin

Raw umber and cobalt blue

Cadmium yellow and cobalt blue

Prussian blue and burnt sienna

Indigo and cadmium yellow

Payne's grey and cadmium yellow

Burnt umber and cerulean blue

Sky blues

The sky forms a large part of many landscape paintings, and is often the first area to be painted. There are many different skies shown in the techniques section of the book. The main thing is to make sure the sky harmonizes with the land, so it is often good to incorporate the colour you have used for the sky in the landscape itself. For example, the blue of a sky could be used to make the greens of the landscape. Below are some useful hints for choosing suitable blues for different skies.

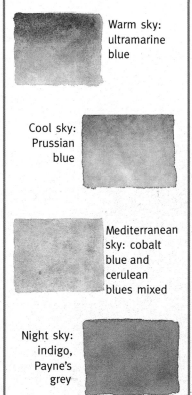

Warm sky: ultramarine blue

Cool sky: Prussian blue

Mediterranean sky: cobalt blue and cerulean blues mixed

Night sky: indigo, Payne's grey

Warm and cool colours

Colours fall into two distinct categories, described as colour "temperature". Some are "warm" and others "cool". Once you start painting landscapes you will see how important it is to assess the warmth or coolness of the colour you choose. In the Themes section of the book you will see that artists choose generally cool colours to paint winter landscapes and warmer ones for summer and tropical subjects. Red is warm and blue is cool. But some reds veer to blue and are therefore cooler reds, and some blues veer to red and are therefore warmer blues. Once you understand this you can pick a warm blue for a Mediterranean sky or select a cool blue for a winter scene.

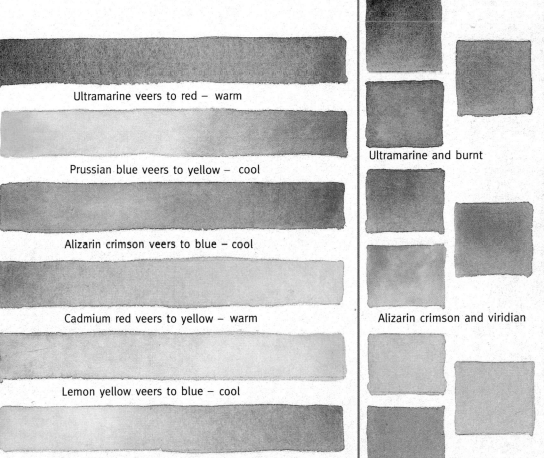

Ultramarine veers to red – warm

Prussian blue veers to yellow – cool

Alizarin crimson veers to blue – cool

Cadmium red veers to yellow – warm

Lemon yellow veers to blue – cool

Cadmium yellow veers to red – warm

Clouds

The greys of clouds are seldom neutral; they are also warm or cool. They may veer to mauve, blue, pink, yellow etc. Interesting greys can be mixed from two opposite, or complementary, colours. Try ultramarine blue and burnt sienna; alizarin crimson mixed with viridian; or yellow ochre and cobalt violet.

Ultramarine and burnt

Alizarin crimson and viridian

Yellow ochre and cobalt violet

Basic Techniques

Those who have not used watercolour before may find it useful to peruse the following pages before turning to the main techniques section.

Here you are introduced to the basic watercolour techniques such as mixing colour, laying washes, working into wet paint, and building up colours by glazing. At the end of the section, methods such as dry brushing, sponging and masking are introduced as an appetizer for the main techniques section that follows.

You may think it more useful and more pleasurable to practise these techniques in a painting rather than as exercises in themselves, but the beauty of watercolour is that even experimental daubs often make mouthwatering images, and playing with paints and brushes will increase your confidence too. Simply mixing up colour in a cool china palette with a soft brush is a pleasure for the watercolour artist.

The medium Watercolour's greatest asset is its transparency, so learn to exploit this to the full. Instead of premixing colours, try the effect of overlaid washes to build up to the colour you want. Lay your colour crisply, and avoid brushing over and over the same wash, otherwise the underwash will lift and you will have sacrificed the translucency.

Or try mixing colours on the paper by working wet in wet, so that they flow gently into one another. The effect of this is often more exciting than that of premixed colours. But always wait for the paint to dry before judging the results. Watercolour left to dry untouched is almost always more lovely than when tampered with, so don't fiddle with wet in wet work or with washes. Mistakes can often be rectified when the paint is dry, with colours lifted or moved around, and edges softened.

Diluting colour in the palette

Squeeze a small amount of pigment into the palette. Dip your brush into clean water and add to the pigment, blending a small amount to one side, or if you require a lot of colour blend the whole amount into an even solution. Check there is no unmixed pigment left in the brush before you make your stroke. If you are using pans of paint rather than tubes, rub the clean wet brush onto the pan of colour to release the pigment into the brush.

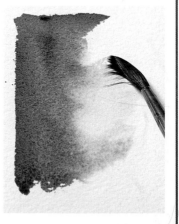

Diluting colour on the paper

Colours can be selectively diluted on the paper itself. This is a useful method when you want variations in tone when painting a sky.

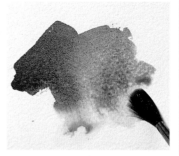

1 Paint a small wet wash of strong colour onto the paper. Rinse the brush and add pure water to the edge of the colour, drawing the strong colour out as a wet diluted wash.

2 Lay a small blue wash. Before it dries use a clean, slightly damp brush to draw the colour out in veils from the main pool of colour.

Mixing colour on the palette

An important thing to remember when mixing colours is that they look much darker in the palette than when applied to paper and left to dry. Try out mixtures on a sheet of sketching paper.

1 Having already diluted the colours in the palette, blend two together to make a third colour.

2 Ultramarine blue and alizarin crimson mixed together make purple.

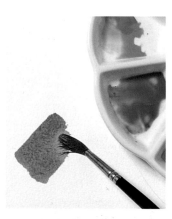

3 Alizarin crimson and yellow ochre mixed to make orange.

4 Yellow ochre and ultramarine mixed to make a green.

Mixing colour on the paper

When one wet colour is laid over another still-damp one the two blend together gently, creating a partial mix that is often more exciting than a flat application of premixed colour.

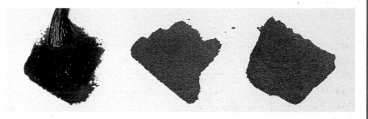

1 Paint a swatch of the palette-mixed purple in the middle. Then lay down the red and blue separately on either side and drop the other colour of the pair into it while still wet.

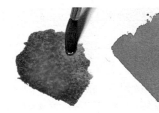
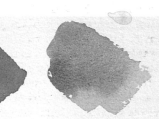

2 Now try the red and yellow mixture in the same way. Allow the paint to spread into the other colour on its own rather than trying to mix it with your brush.

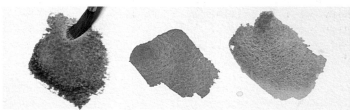

3 The mixture differs according to which colour is laid first. The green produced by dropping blue into ochre is not the same as this one, where ochre is added to blue. Both are different from the palette-mixed colour in the centre.

Wet in wet technique

If you tried the mixing on paper method you will have already taken your first steps in the wet in wet technique. Beautiful effects occur as one colour spreads into another. You will see the technique used abundantly throughout this book.

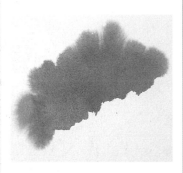

1 The clean paper is damped at the top with clear water and the paint laid just below is allowed to run into the damped paper.

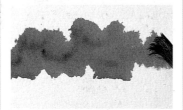

2 If the damped paper is nearly dry only a slight spreading will occur, creating crinkle edges – ideal for distant treelines.

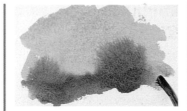

3 Paint a wash of colour. While wet bring another colour up against the edge and allow the colour to spread untouched into the first colour.

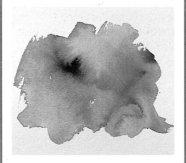

4 Blending the colours wet-in-wet may look messy when wet but do not be tempted to play with the wash.

5 Leave it to dry and it will create lovely if unexpected effects.

Dropping in colour

When a wash is wet further colour can be dropped lightly in without disturbing it. The brush is loaded with colour and only the tip is touched to the paper allowing the new colour to run down and into the first wash.

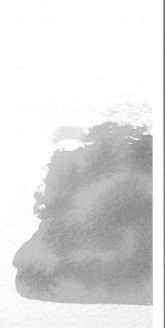

1 Sap green is dropped into a wet wash of new gamboge by letting the paint run into the colour from the tip of the brush.

2 The colour will spread out and if allowed to dry untouched will blend softly.

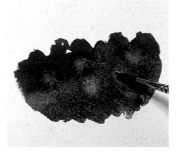

3 Dropping clear water into a wet wash will lighten the tone and create a dappled effect.

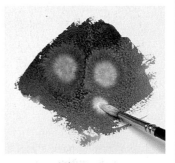

4 Dropping opaque white paint into a wet wash has a more dramatic effect.

Surfaces

Colour dries differently on different surfaces. On smooth (hot-pressed) paper the paint sits on the surface in pools of colour and often dries creating blooms and ragged edges rather than blending smoothly. Interesting effects can be made in this way.

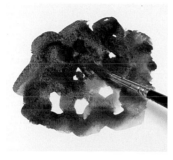

1 A blue wash is applied to hot-pressed paper, leaving white areas for red flowers to be dropped in wet in wet.

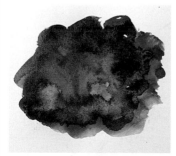

2 The colours have blended unevenly, pushing the colour into blooms and backruns. On standard watercolour paper (cold-pressed, which is rougher) these would be less obvious.

Laying a flat wash

Beginners are often encouraged to practise laying perfectly flat washes, but while it teaches you control of the watercolour it is in fact a technique rarely used to create paintings, except as an underwash for a whole picture.

1 Load the brush and lay the paint in even strokes across the paper from one side to the other. Tilting the board a little will help the bands of colour run into each other.

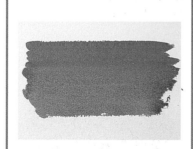

2 Never go back over the wet paint; it will usually dry flat, though it may look uneven while still wet. You can dampen the paper before laying the wash, which helps the colours blend together.

Laying a graduated wash

This is a one-colour wash that changes tone as it progresses. Again mix up plenty of colour in the palette, but this time as you lay each successive band of colour, gradually add more water to the mixture.

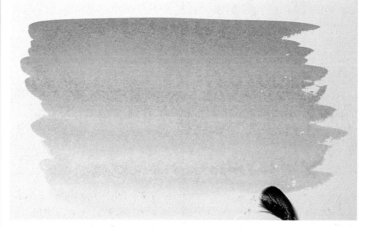

1 **On dry paper**
Try on both dry and wet paper. Start with a strong solution of yellow ochre and lighten it gradually by the addition of water to each new stroke across the paper. The last band should be almost pure water. If the wash appears slightly uneven tilt the paper to encourage the paint to flow. Do not touch it with your brush.

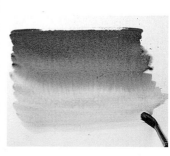

2 **On wet paper**
Sometimes a more dramatic tonal gradation is required. Dampen the paper and lay two or three bands of full-strength colour, followed by really pale colour and finally pure water for the last stroke. Again tilt the paper to encourage the flow of the paint.

Variegated washes

These are washes blending two or more colours together. A sunset might require linear bands of red, yellow and blue whereas a tumultuous sky could be depicted with blobs or splotches of different colours blended in a more irregular way.

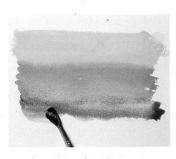

1 Mix your colours before you start. Lay the colours on dry paper in even bands allowing the wet edges to blend with each other. Resist the temptation to touch up with your brush while the wash is drying.

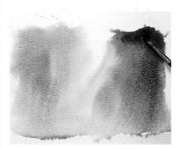

2 Dampen the paper then brush in the palest colours. Tilt the paper and allow the colours to blend.

Glazing

Watercolour is a transparent medium, so that an overlay of new colour allows the one underneath to shine through, creating new colours and tones. This is the very essence of watercolour painting and enables the artist to use few actual colours to achieve many colours on the surface of the painting. Tones can be darkened by glazing.

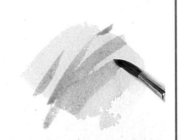

1 **With only one colour**
To glaze with one colour, lay a small wash and allow to dry. Overpaint with a few brushstrokes of the same colour.

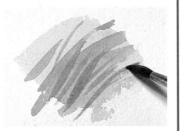

2 When dry paint more strokes of the same colour over the top. This could be used for a grassy foreground.

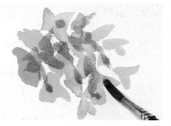

3 **Now try glazing with different colours**
Paint a few brushmarks with yellow ochre. When dry overlay with small brushmarks of sap green.

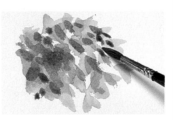

4 As the paint is drying touch in brushmarks of darker green. Already you can see how foliage might be built up in this way.

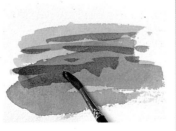

5 Glazes can be built up in layers to achieve a richness of colour. Lay a brushstroke of burnt sienna over a dried patch of yellow ochre. Paint streaks of burnt umber over the dried washes.

Glazing for shadows

Glazing is useful for describing the shaded sides of objects, or for painting cast shadows. It enables you to paint the whole object without having to worry about form until later, or to paint the landscape without having to worry about the shadows until the painting is dry. The undercolour will show through.

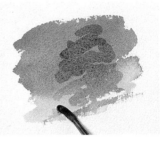

1 Wash in the sky, leave it to dry and then paint the silhouette of the tree over it.

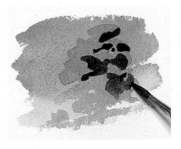

2 When the green is dry delineate the shaded areas with a darker colour. For more subtle shading you could use the same colour as the tree for your glaze.

Dry brush

If the pigment is used fairly dry a broken textural effect is created by the paint dragging over the grain (tooth) of the paper. Before applying the brush to the paper tap or blot the excess moisture from the end of the brush so that the bristles carry pigment but little water between them.

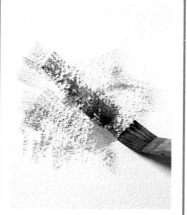

Mix your colours in the palette and prepare your brushstroke as described above. The individual hairs of the brush lay fine parallel lines which can be used for blades of grass, wood grain and other fine details.

Sponging

A small natural sponge makes an interesting texture of fine marks and dots which would be difficult and laborious to achieve with a brush. The method is particularly suitable for sparse foliage.

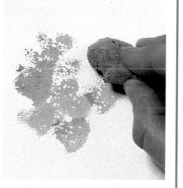

The sponge will absorb a lot of the colour, so mix plenty of creamy paint in a deep palette. Dip the sponge in the paint and pat the colour onto the paper, turning the sponge every time so that the pattern created is not repetitive.

Masking fluid

This rubbery substance is a useful resist for reserving small areas of white paper or lighter colour from an overall wash. It dries quickly and can spoil good brushes, so use an old one and wash it immediately in soapy water.

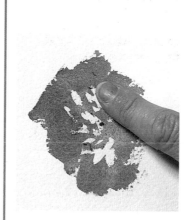

1 Apply the masking fluid direct from the bottle. For a painting, you should make a preliminary drawing as a guide.

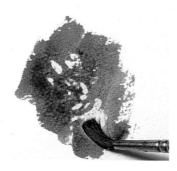

2 When the fluid is dry paint a wash freely over the masked area.

3 Allow this wash to dry completely, especially the paint that is sitting on the masked areas, then rub the masking off with your finger or a soft putty rubber.

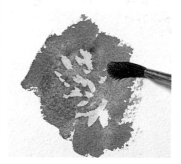

4 Further glazes can be painted over the reserved highlights. Avoid leaving masking fluid on the paper overnight or drying it with a hairdryer as you may find it lifts the surface of the paper when you remove it.

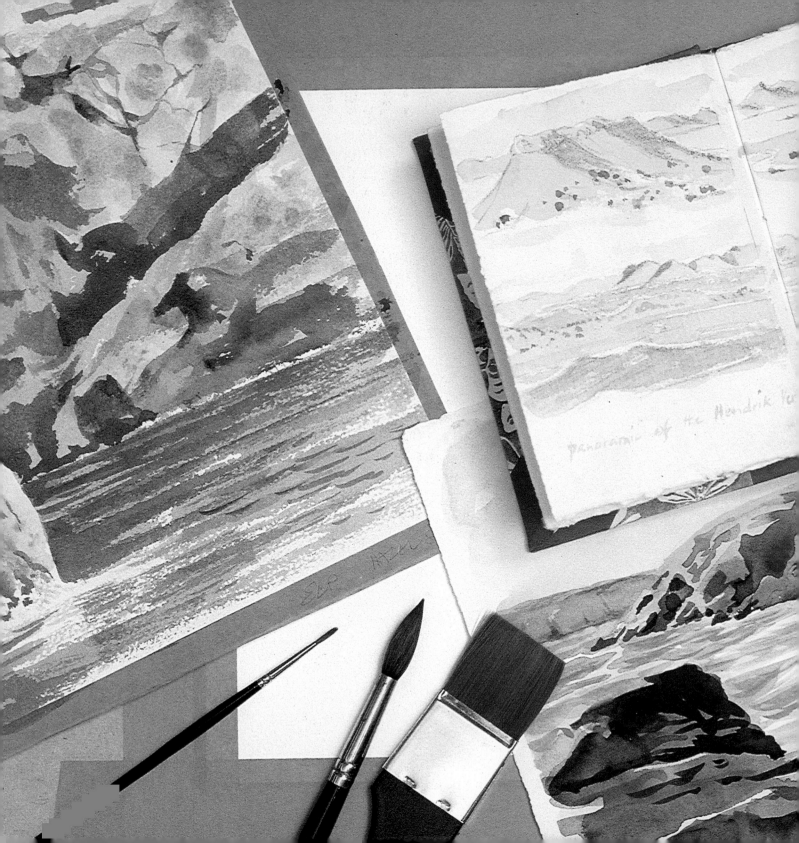

Techniques

Landscape painting covers a very wide variety of subjects, a selection of which are covered in the following pages. The section is divided alphabetically to make access to the various subjects as easy as possible. Within each section several techniques are suggested as ways to approach a similar theme. The idea is that you might take this book with you into the landscape. On finding yourself overwhelmed before the splendour of a waterfall you wonder where to begin. So why not turn to the Waterfalls section, and perhaps include Rivers and Rocks as well? You may not have thought, for example, of using masking fluid or wax resist to reserve the whites of fast-moving water. If you then need help with the sky look up Skies, and Clouds. Even if you find yourself thinking you would not have done it in the way described, at least it will goad you into a confident painting mood. There is no one right way to paint anything; the techniques shown are suggestions, and show how one or several artists might tackle a similar subject matter.

Autumn

The riot of colour -- with orange, yellow and red instead of summer green -- is the chief appeal of an autumn landscape.

Sponging/flicking Experiment with a sponge to paint the speckled effect of distant trees with partially shed leaves, or to create interesting textures on areas of foliage in the foreground and middle distance; and to suggest a scattering of autumn leaves, flick colours across the paper with a loaded brush. Protect the rest of your painting with clean paper, as flicked paint can travel a long way.

Masking To capture the effect of light-coloured leaves, reserve the shapes with masking fluid. Use little upturned brushstrokes, smaller in the background to give a perspective effect. Leave some leaves to the imagination. To add foreground interest, mask out some larger leaves and highlight the carpet of leaves on the ground with sharp dabs of masking fluid. When you remove the masking, paint over the resulting white areas with clean transparent washes, varying the colours.

Glazing Build up your foliage with separate dabs of warm colours, letting each under-colour shine through and leaving plenty of light. If the painting begins to look over-vivid, calm it down with either a light overall wash or a dabbed wash of blue or mauve.

To create depth, contrast the paler foliage with the dark trunks, boughs and branches. Use a fully loaded brush for the dark tones, letting it unload naturally as you paint to give you a variety of different tones.

> **Further Information**
> ☞
> Basic techniques, page 20.

Sponging

Dip the natural sponge into a creamy solution of pigment and press or dab the colour onto the paper to create an irregular mottled texture. Working wet on wet or wet on dry paint will produce different effects.

1 Paint the sky with a pale wash down to just below the tree line. Dip your sponge into a rich mixture of cadmium yellow and press on to the paper to describe tree shapes before the wash dries.

2 Build up the tree forms with cadmium orange and sap green, sometimes dabbing the sponge on the wet paint, sometimes on dry. Mix a darker tone to create the shadows of the trees.

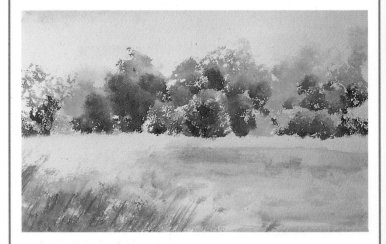

3 Wash in the grass and sponge some texture into the foreground. Add a few grass blades with the flick of the brush.

Masking

Protecting light details with masking fluid enables you to paint the composition freely and yet reserve the white paper underneath. Then you can rub off the masking fluid and touch in the details with light transparent glazes or leave white paper.

1 To reserve the lights between the leaves of a loose autumn scene, mask out the highlights before you lay wet in wet brushstrokes with a flat brush.

1 Before any colour is laid, paint the fluttering leaves with dabs of masking fluid. When all the background washes have been put on, rub off the masking with your finger.

2 Glaze the unmasked leaves with transparent colour. It will not matter if you overlap the dark background as you touch them in.

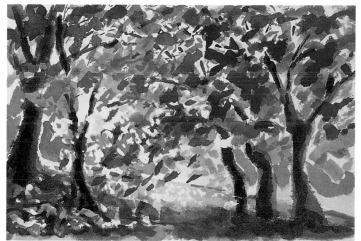

2 Add further masking across the tree-trunks to preserve the light orange leaves before you paint the dark trunks. Rub off the masking and touch in dark orange splashes of colour.

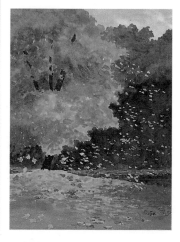

3 Paint small glazes over the leaves on the grass using new gamboge, yellow ochre, burnt sienna, and oxide of chromium (green).

Beaches

Beach landscapes conjure up many things –

holidays, chosen loneliness, freedom, romance, the

elements. Decide what you wish to convey in your

painting.

Choose warm, bright colours for a holiday atmosphere, or seek out the earth colours for wild isolation. Before you begin, assess the overall colours.

Colour and composition Sand, for example, is unlikely to be yellow; it may be a diluted yellow ochre or raw sienna, slightly pinkish, grey or nearly white. Wet sand is usually darker than dry sand, and creates intriguing reflections, which you can use to enhance the wetness.

Composition is important. Find a foreground feature to help throw the background into the distance. Sand dunes, rocks, or driftwood give you an opportunity to use some stronger colour and tone in the foreground which will help paler colours in the distance recede (see ROCKS).

Graduated washes The horizontal format of sea and sand, with sky above, lend themselves well to graduated washes. Only dampen the paper down to the crests of waves – or work on dry paper – and do not touch the wash while it is drying. Alternatively, try working on a rough-textured paper – the speckles of white paper left untouched by the pigment create natural highlights. For soft shadows in undulating sand, work wet in wet, brushing in the shadow colour while the first wash is still damp.

Texture Sand textures can be conveyed by flicking and spattering, even by using real textures, such as sugar scattered into a wash, or sand mixed with gum arabic.

> **Further Information**
> ☞
> Rocks, page 94.

Flicking

The grainy nature of sand dunes is enhanced by loading a brush with plenty of strong pigment and literally flicking it across the paper in a chosen direction by holding the brush towards the end of the handle.

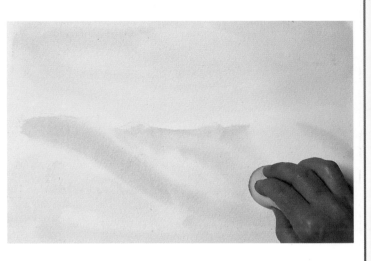

1 First lay a wash for the sky and sand dunes, dropping darker colour into the wet dunes to create undulations in the sand.

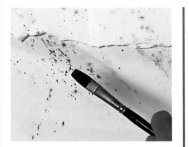

2 Protect the sky with a mask of paper, torn to correspond with the line of the dunes. Load the brush with a strong solution of paint and flick the brush diagonally across the paper.

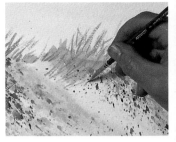

3 After flicking several different colours, remove the paper mask and touch in the grasses with quick, upward brushstrokes.

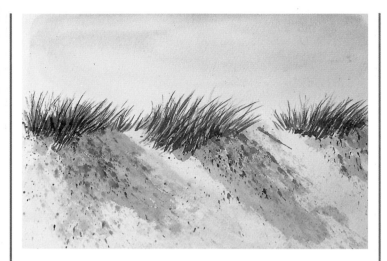

2 Darken the sea with cerulean and Payne's grey. Just before the beach wash dries, brush in a diluted wash of Payne's grey along the wet sand, letting it spread slightly.

4 Thicken the grasses with stronger colour and cast a warm mauve shadow down the face of the dune. Paint this with single strokes of a wide, flat brush so as not to disturb the flicked texture.

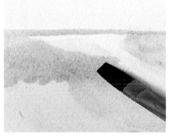

3 Brush in the rock forms while the wash is still wet and allow the colour to run into the wet sand. Darken the rocks with burnt umber.

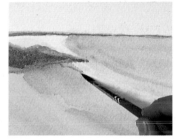

4 When the paint is dry, pick out the shadows under the wavelets with fine broken brushstrokes running along the line of reserved white paper.

Graduated washes

A delicate under-painting of graduated washes is a good base for quickly creating the subtle variations of wet and dry sand bordering the sea. Prepare plenty of well-diluted paint before you begin. A few subsequent washes and small details complete the picture.

1 Separate the sky wash from the beach by leaving dry white paper between them. Use a flat make-up sponge to lay gently graduating washes, increasing the density of colour over the sea and below the area of wet sand.

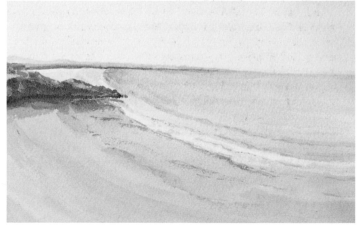

5 Paint a few more brushstrokes along the wave lines in the sea and some dry brushmarks across the wet sand and beneath the rocks to emphasize the reflections of wet sand.

Texture

Adding real textures to watercolour paintings creates a pleasant three-dimensional quality to the surface. In this example a palette knife is used to lay a textured gel mixed with paint squeezed direct from the tube.

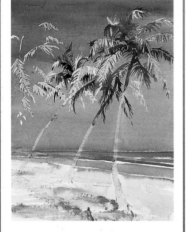

1 The trees are masked out with masking fluid and the sky and sea painted with strong vibrant washes. Paint the beach with a pale wash darkened wet in wet under the wave edge.

2 The palm fronds have been painted. Mix the acrylic texture gel (ceramic stucco) and undiluted burnt sienna with a small palette knife, and scrape the paste across the beach foreground.

3 More textured paste is mixed with sap green and laid over the washes around the trunks of the palms. When dry, a heavier impasto is scraped across the textured areas – leaving satisfying lumps of paint in its wake.

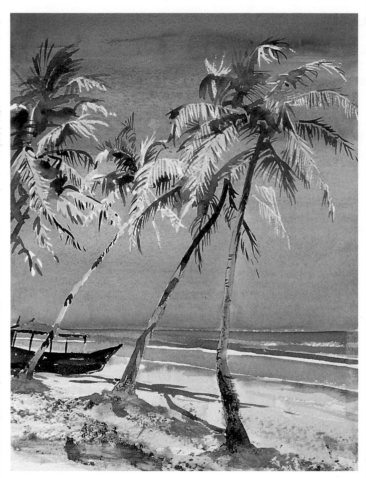

4 The gravelly nature of the foreground creates a strong sense of perspective. Paint the shadow of the palm tree across the sand to emphasize the flat white beach beyond the trees.

Bridges

As man-made features in a landscape, bridges bring a change of colour and form, making an interesting focal point for a composition.

When they are reflected in still or slow-moving water, bridges seem almost to have been designed for the artist. Before you start, think about the best angle from which to paint. A slightly oblique view showing the shadowy underside of one end of the bridge is more visually interesting than a head-on view. Begin with a pencil drawing, paying special attention to the arc of the underside of the bridge, and give yourself a pencilled guide for the reflection also.

Wet in wet If the reflection is soft, broken up by moving water, dampen the paper, then blot the ellipse of light and the areas below the reflection with a tissue. When you wash in the paint, it will spread softly to the edges of the damp area. Be ready with a tissue to blot any paint that tries to escape over the edges onto the light ellipse.

Paper masking If the bridge is mirrored in still water, the reflection will be crisp and hard-edged. One way to ensure a perfect reflected shape in a head-on view is to cut the semi-circular arch out of a doubled piece of paper, and either draw around or paint over it. Look for the shadow cast on the water under the bridge, as this will help to establish the water level. If it confuses the reflection, however, leave it out.

Pen and ink If the bridge itself has become rather "soft", firm it up with fine brush lines or with a little pen and ink drawing. Use touches of pen and ink in other parts of the picture so that the bridge is not isolated.

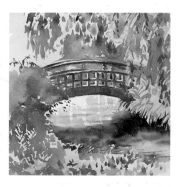

Wet in wet

Dropping paint into a wash before it has dried requires timing. In this case, the area is small and a tissue is used to mop up errant colour. Be bold with your dark mixtures as they may dry lighter than you expect.

1 Masking fluid has been used to reserve highlights. When dry, dampen the paper and lay an overall wash of new gamboge, immediately blotting out the ellipse of light under the bridge with a tissue.

2 While still damp, wash in Winsor green and Prussian blue mixed with new gamboge, and allow the colour to spread wet in wet. Leave crisp white highlights in the dried area under the bridge.

3 Dampen the river, blot the ellipse, and paint in the reflection of the underside of the bridge, drawing round the bank grasses with the tip of the brush. Drop a darker tone into the wet paint under the bank. Remove the masking, and glaze the leaves and grasses with dabs of light colour. Paint the structure of the bridge, leaving the white highlights.

Paper masking

Accurate reflected arches are
not easy to draw freehand.
Cut a semi-circle out of a
folded piece of tracing paper
and draw around it to create a
reflection that mirrors the
bridge arch proportionately.

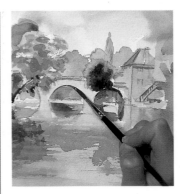

3 Draw the shadow of the
underside of the bridge
with the tip of the brush,
dropping darker paint into the
top of the arch while still
wet. Paint the reflection with
loose strokes, following your
sketch line.

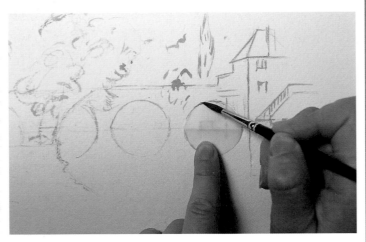

1 Sketch the composition in
light grey paint with the
tip of the brush. Lay the circle
of tracing paper in position
and sketch lightly round each
bridge arch and its reflection.

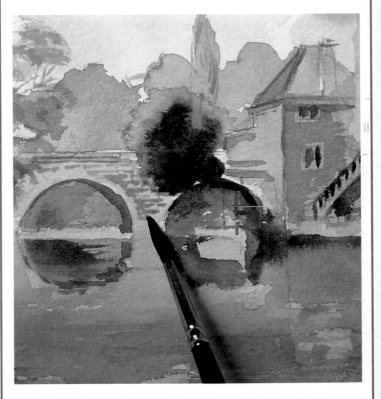

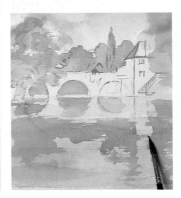

2 Wash in both sky and
foliage equally above and
below the bridge to ensure a
convincing reflection.
Strengthen the trees and lay a
light glaze over the bridge and
its mirror image.

4 Pick out brickwork details
with the tip of the
brush but mirror these in the
water with a broad stroke
rather than details.

Buildings

Buildings in landscape tell a story. A small dwelling set beneath hills or mountains may hint at an isolated life, and an ancient ruin tell of past splendour.

Buildings can also create a focal point, a foreground feature or even just a splash of colour or a regular shape contrasting with natural forms. If the building is in the foreground, the texture of its walls will be an important part of the painting. There are various useful tricks for rendering texture in watercolour.

Reserving white paper White buildings such as those adorning Mediterranean landscapes are best reserved as white paper. Define their shapes by using the colours of the landscape around them, so that they shine out like jewels against the dark terrain, then pick out details with small brushstrokes.

Windows in buildings are like eyes in a face; they add character. Touch them in with wet one-touch strokes of strong varied colour, tilting the paper so that more pigment settles either at the top or bottom. This helps to suggest the reflective nature of the glass.

Shadows Follow the same tilting procedure for any shadows under the lintel and to one side of the window, to create depth.

Settle your buildings well into the ground. Soften the land-ward edge with a damp brush, blur it with grasses or obscure it with foliage. Use the shadow cast by the building to link it to the earth.

Granulated wash Some pigments are "heavier" than others, and tend to separate out in a mixture, giving a mottled effect that can be enhanced by working on rough paper. Cerulean, manganese and ultramarine blues mixed with burnt sienna, alizarin crimson, or yellow ochre make marvellous grainy shadows. The wash must be allowed to dry undisturbed to let the pigment settle.

Wax resist Another way to achieve textures such as stonework or old paint-work is to rub candle wax over the area. The subsequent washes settle only on the unwaxed paper to give a broken-colour effect.

Reserving white paper

A light sketch will give you confidence to guide your brush boldly around the shapes of the white buildings. Mix up plenty of pigment and use a size 5, or larger, round brush with a good tip.

1 Outline the buildings with your brushwork, carrying your wash across the page before it dries around the houses.

2 Lightly paint the roofs of the distant houses to create a soft mosaic of colour. Indicate the windows in the foreground to give confidence to later darker detail. Paint the distant hills with a pale mauve glaze running almost down to the houses.

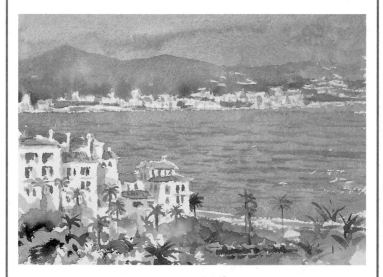

3 Finish the foreground details and glaze over the distant houses with the palest of pinks to set them back from the stark whites of the foreground.

Granulated wash

Rough paper, a size 7 brush, and tube colour are used to create a granulated wash for the stucco surface of the windmill. Use very wet paint and let the colours mix and settle undisturbed in the tooth of the paper.

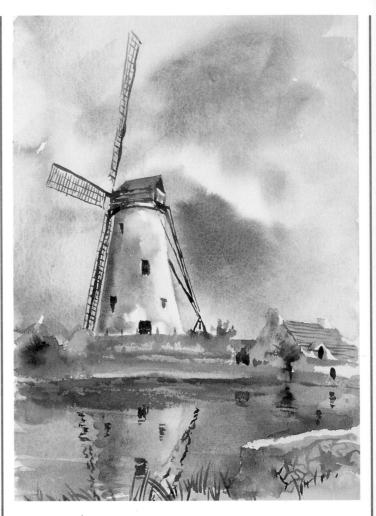

1 Ultramarine and burnt sienna have been flooded into dampened paper. When dry, dampen the windmill and its reflection and paint a very wet, loose mixture of cerulean blue, yellow ochre and burnt sienna. Watch it granulate as it settles.

2 Paint in the banks of the river and use granulating washes on the wall and cottage. Draw the sails with the tip of the brush.

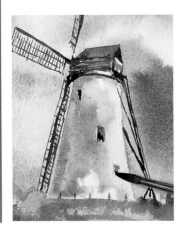

3 When the windmill is dry, paint the windows in with very thick wet paint (indigo and Indian red); tilt the paper so the paint settles unevenly.

4 Dampen the shaded side of the windmill and, with a strong swift stroke, darken that side against the sky. Lay a broken glaze over the water and paint the foreground details.

Wax resist

Use a white utility candle. Broken white highlights must be drawn with the wax on untouched paper; otherwise draw the wax over dried washes. Subsequent washes will dry in a mottled patina over the top.

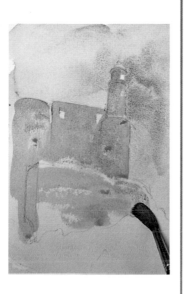

1 Lay a pale ochre and cerulean wash. When dry, draw candle wax over the tops of the parapet walls. Paint a wash of yellow ochre over the waxed areas, and see how it resists the colour.

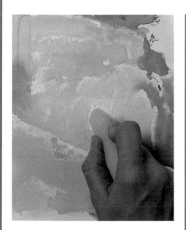

2 The foliage has been painted on dampened paper. Now apply a lot more wax quite heavily over the stonework and rocks, drawing the shapes with the candle.

3 When you lay the next wash of ochre and red-grey the textured effect becomes much more obvious as blobs of watercolour sit on the waxed surface.

4 Now you can freely paint stronger colour over the shadowy rocks while the wax preserves the tonal differences.

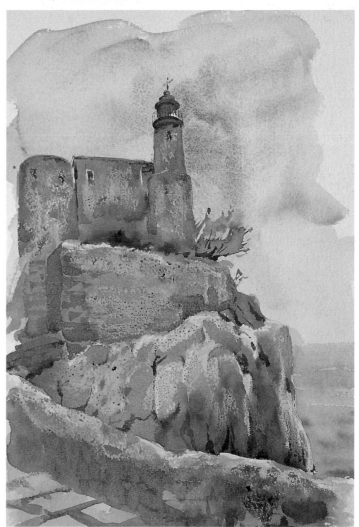

5 Linear brushstrokes, wet in wet and wet on dry, demarcate the rock shapes and edges of the building.

The blobs left by the dried watercolour create enjoyable textures.

Cliffs

Cliffs can be friendly or forbidding, tall and towering or low and crumbling, but they are always exciting. They mark the edge of a landscape, a barrier for the sea.

Form and texture are more important than colour. But try not to get too complicated; specific cracks and fissures may make it all too fussy and confusing. Look for the outline and the direction of the main forms, and build the face of the cliff with broad tonal washes, using the shadowed areas to create depth. Choose a time when the sun is at an angle to the cliff face, as this makes it easier to discern the three-dimensional forms. Use the colour of the sea to emphasize the cliffs, and leave white paper at the base of the cliffs. This can be worked into later to indicate the swirling water.

Backruns These are one of the happy accidents that watercolour painters love to exploit. It is impossible to control a backrun completely, but you can give it help. The uneven blooming and feathered edge makes it an effective technique for the surface of rock and cliff. Try dropping small droplets of water into a wash that has not quite dried to create a mottled texture. When this wash has dried, the structure of the cliffs can be redrawn on top.

Texture methods Grainy sand and scree can be suggested by flicking or spattering paint from a loaded brush over the surface of the cliffs, and lichen-like effects created by scattering crystals of sea salt onto wet paint (SEE ROCKS). After the paint has dried the salt is removed to reveal a myriad of miniature blooms. Another method is to mix the paint with soap. This destroys its ability to flow, so that it holds the mark of the brush. Linear rock structures can be described with a broad brush, and the small bubbles that develop give the impression of loose stones.

> **Further Information**
> ☞
> Rocks, page 94.

Backruns

This painting uses hard-pressed paper (HP), as it is easier to encourage backruns on a smooth surface where the paint sits in pools. Mix up rich dense solutions of pigment to avoid having to darken areas later and lose your initial effects.

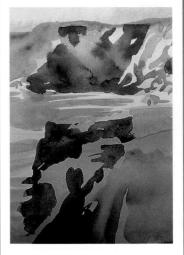

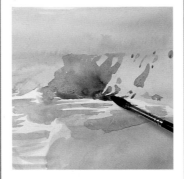

1 | With a large size 11 brush wash in the sky and cliff shapes, reserving white paper for the surf. Drop deep Prussian blue into the wet shadowy surfaces.

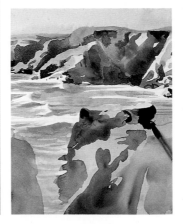

2 | Plunge pure cadmium red and alizarin crimson into the bases of the wet shadows and allow the paint to spread and bloom unconditionally.

3 | Let the dense pools of colour dry untouched, then paint in the strongest darks with almost undiluted indigo.

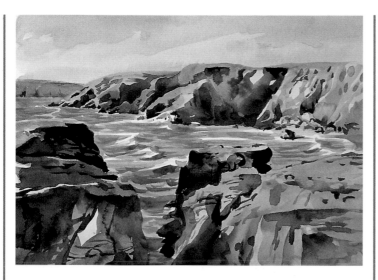

3 Mix Prussian blue and scarlet lake for the dark shadows, keeping the suds already in the brush head but without adding more. Pick out the crevices.

4 Last, delineate crevices and cracks in the formation of the rocks and deepen the shaded sides of the breaking waves.

Soap

Mixing pigment with soap enables you to work into wet paint without the brushstroke spreading. The paint dries with a slight mottling. Use a bar of white soap and rub your wet brush into it, loaded with pigment.

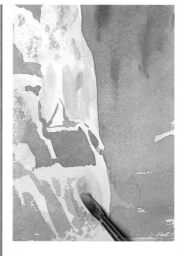

1 The main forms of the cliff face are painted with Prussian blue. Leave white paper at the base for the surf.

2 Load your brush with a rich mixture of yellow ochre and rub the brush into the bar of soap. Paint the strokes in the direction of the rock face.

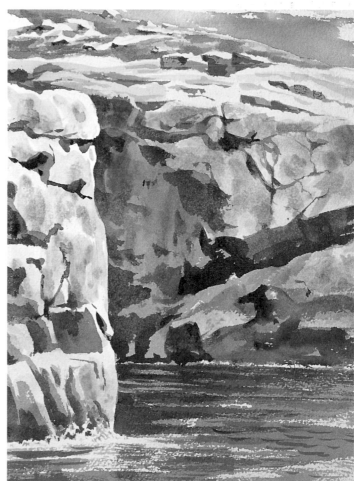

4 Rinse the brush thoroughly and paint the grass on the cliff top with a wash of blue and ochre. Describe and darken the sea with dark, dry brushstrokes.

Clouds

Watercolour lends itself to the ethereal yet solid appearance of clouds. The white paper makes the most of their luminosity, while happy accidents can be exploited to good effect.

Two things to remember are: firstly, to keep your water sparkling clean and, secondly, to avoid overworking your sky.

Wet in wet/wet on dry A mixture of hard and soft edges is an effective combination for cumulus clouds, which are often crisply defined at the tops and soft and blurred at the bottoms. Damp the paper in the areas under the clouds and keep it dry above them. Take the blue wash for the sky around the tops to describe the shapes, and drop darker colours into their wet bases to create their bulky forms.

Lifting out Alternatively, try lifting out the clouds with a dry brush, tissue or sponge while the sky wash is still damp. The paint needs to be nearly dry for the best effects or the sky colour will just re-run into the areas you have dabbed out. Clouds are always on the move; suggest wind direction by making your clouds full upwind and trailing away downwind.

The dropping-in method is also ideal for heavy storm clouds. Try not to touch the surface with more than just the tip of your heavily loaded brush. Let the colour drop gently in and spread out. Tilt the paper to help guide the flow of the paint in the required direction.

For the soft wispy high clouds, dampen the whole area, then wash in the sky leaving larger areas than you require for the clouds to allow for the spread of the paint over the damp surface.

Wet in wet/ wet on dry

Work with a large size 11 round brush to avoid getting bogged down with detail. Make sure the paper is stretched or of sufficient weight so that you can slosh water around without causing the paper to buckle.

1 Lay a wash of Prussian blue to outline the main cloud shapes. Dampen the paper above the lower clouds and wash in more colour.

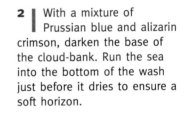

2 With a mixture of Prussian blue and alizarin crimson, darken the base of the cloud-bank. Run the sea into the bottom of the wash just before it dries to ensure a soft horizon.

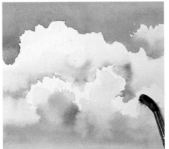

3 Wet the paper from the base of individual cloud masses almost to their tops, drop in more colour and allow to spread upwards to describe each soft shape.

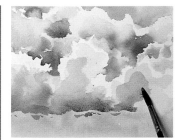

4 Darken the bases of the cloud-bank with stronger colour, wet on dry, and, while still wet, drop even more colour in from the base.

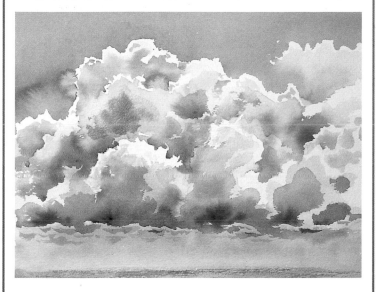

2 Lift streaky clouds out of the same wash with a clutch of cotton buds dragged across the paper.

3 Alternatively, lay a loose wash of ultramarine and wash in a base tone for the landscape.

4 Mop out the cloud forms with kitchen paper in bold, swirling movements.

5 Dampen and darken any clouds you feel need more volume, and finally, hint at the receding cloud bases above the horizon with irregular linear strokes of pale grey.

Lifting out

Using a dry sponge or a tissue to lift out clouds from a wash creates soft, indefinite cloud forms, but never restores the white paper to its full untouched luminosity.

1 Lift white cirrus-style clouds out of a cobalt and ultramarine wash with a piece of tissue before the wash has a chance to dry.

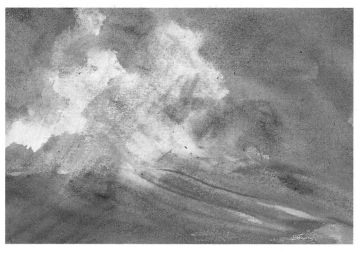

5 Repeat the process of laying washes and mopping out until you are satisfied with the resultant cloud forms.

Dropping in colour

Dropping or brushing in solutions of colour into wet paper or wet washes allows the paint to spread in the soft, almost controllable, manner so characteristic of watercolour.

1 For a simple fair-weather sky, wet the whole paper, and brush selected areas with a mixture of cobalt and cerulean.

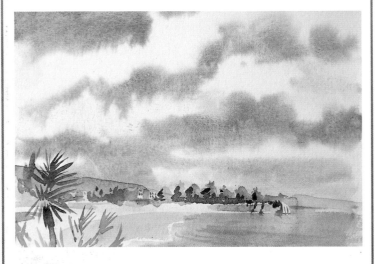

2 Lighten the colour towards the horizon and, as it is drying, move the colour gently around for the required cloud effect or simply leave untouched.

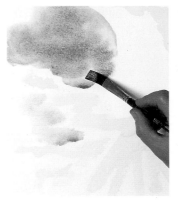

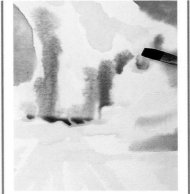

3 For more dramatic cloud effects, lay large wet washes of colour onto dry paper: Naples yellow, cerulean and cobalt.

4 Wet the heavy clouds and drop in a mixture of Payne's grey, vermilion, and indigo.

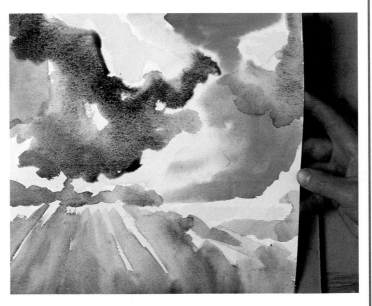

5 Tilt the paper to encourage the pigment to concentrate in the base of the black cloud.

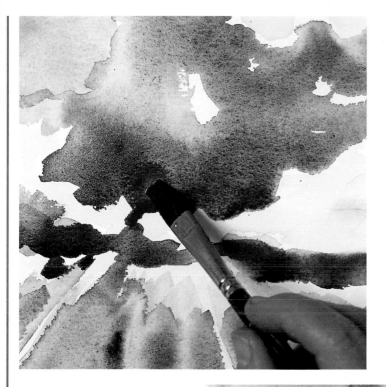

6 Drop pure vermilion into the damp base of the large black cloud and prevent it from spreading too far upward by again tilting the paper downward.

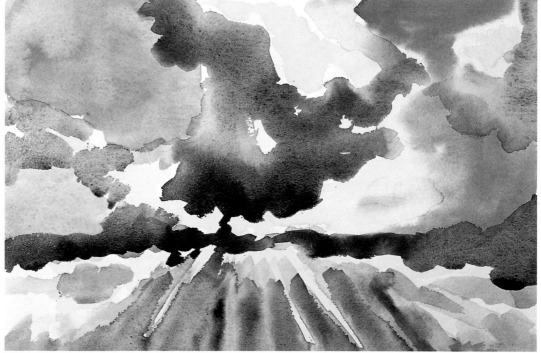

7 Drop in more vermilion and lift out the sun's rays with the side of a damp brush.

Deserts

Hot, dusty, dry and visually uneventful they may seem, yet the very simplicity of a single twisted tree in a flat desert landscape can make a dynamic painting.

To create the impression of heat, use warm colours such as Indian red, burnt sienna, yellow ochre, reds and oranges. Use stark shadows to model rocks, stones and tree trunks and, to reinforce the hot feel, try painting the sky in a similar warm colour to the landscape.

Graduated wash Horizontal washes of differing earth colours will emphasize a flat landscape. A graduated wash, strong at the top, fading towards the horizon and strengthening once again into the foreground will establish a good base upon which to build detail.

Sponging and spattering For scrubby trees, dip a small natural sponge into a pool of colour, dab it once or twice to create interesting foliage effects. Branches and tree trunks can be added before the paint has dried, so that the colours run into each other.

The random effects created by spattering or flicking paint from the brush are ideal for sand or gravel. Make the blobs larger in the foreground to help establish distance.

Wet in wet Dust and soft early-morning mists are often features of deserts. Work on damp paper so that colour spreads gently into white paper with no hard edges. Paint features emerging through the dust or mist in flat, pale tones, but in the foreground, suggest the terrain with thorny bushes or grass painted with a dry brush, or rocks and plants dark against light.

> **Further Information**
> ☞
> Pathways, page 82.

Graduated wash/ sponging/spatter

Dampen the paper all over before laying your wash, and apply the wash in horizontal strokes with a large brush. To spatter paint, hold the toothbrush face up above the paper and run your finger backwards across the top of the loaded brush.

1 Make the horizon area the lightest part of your graduated wash, reloading the brush for the foreground. Brush horizontal streaks of light red into the wash while wet.

2 Use the vehicle tracks to emphasize perspective. Paint the distant hills across the lightest area of the dried wash and use the same colour for the tree.

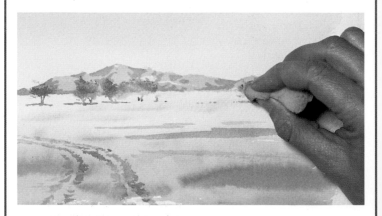

3 Mix up a dense solution of greenish pigment. Dip a natural sponge into the paint and then dab the corner of the sponge onto the paper to create scrubby trees.

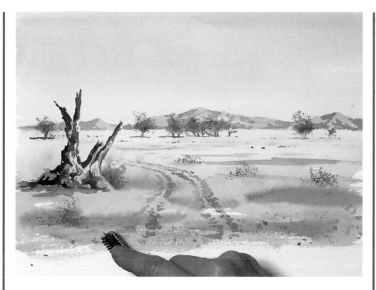

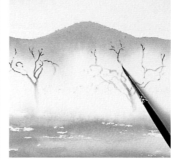

2 When dry, paint the trees emerging from the mist; paint the base of their trunks with clear water, and coax the colour gently into the water so that the colour disappears.

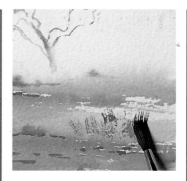

3 Create tufts of grass by dropping colour into the base of dampened patches. Using dry paint straight from the tube, splay the hairs of the brush and paint the foreground grasses.

4 Detail the tree root and finally spatter the foreground with a paint-loaded toothbrush or flick colour from the end of a brush (see PATHWAYS).

Wet in wet

You will only need to dampen the paper in the area of the mist, enough to allow the colour to spread gently but not too much to cause pools. Watch the mist as it dries to ensure that no hard edges develop.

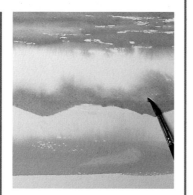

1 Lay a sky and foreground wash onto damp paper, let it dry and then wet the area in the middle again. Paint the peaks of the dunes and allow the colour to spread downwards, then turn the board upside-down to prevent further spread.

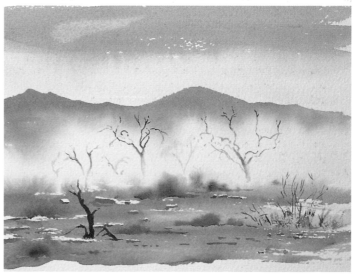

4 Small white rocks were created by reserving white paper in the original wash; give these dark under-shadows, and add the foreground tree to throw back the distance.

Distance

Like layers of fine tissue, overlaying hills gently dissolve into the sky. In a seascape, the water retreats to the palest of hues and merges with the distant horizon.

These lovely effects are caused by our planet's moisture-laden atmosphere – if you were painting on the moon you could only show distance by means of perspective.

There are three main ways of creating distance in a painting. The first is the use of tonal contrast which is usually much stronger in the foreground. The second is the use of colour. Colours such as blue, blue-grey and blue-green, recede whereas the warm reds, yellows and red-browns advance to the front of the picture. The third is perspective – the apparent shrinking of features such as narrowing roads as they go further into the distance.

Graduated wash For a distant view of the sea, or any flat land-scape where the sky and the land become one, a graduated wash is ideal. Keep it dark at the top of the page, lightening towards the horizon. Paint any distant features in flat, un-modelled brushstrokes, keeping them as simple as possible. Lift out any unwanted hard edges or dark tones with a damp brush or sponge.

Glazing If you are painting the receding layers of distant hills, mix a mauve or a grey-blue to several different strengths. Work from back to front, letting each successive layer reveal a larger area of the previous wash so that the hills grow stronger as they advance. Use darker tones as you come forward, and for the nearest hills, add a little "local" (i.e. the natural) colour.

Graduated wash

In this painting, the graduated wash is laid on dry paper to reserve some white for the clouds. Use a broad, flat 2.5cm (1in) brush and lay a pale wash, lighter at the horizon, darker in the foreground.

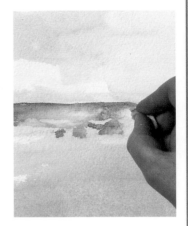

1 After laying the pale wash all over the paper, establish the horizon line with a thin horizontal wash and, to soften the sea edge, soak up the colour with a tissue.

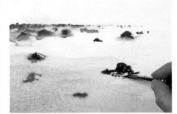

2 Paint a strong wet wash into the foreground sea and paint the rocks to establish perspective: larger and darker to the fore, smaller, paler and less distinct in the distance.

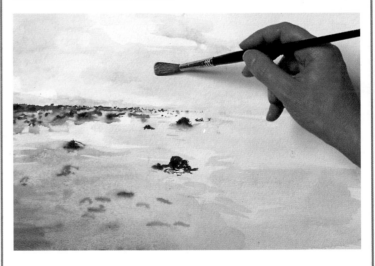

3 Add some colour to the sky with pale wet washes and touch in the distant hills with the same pale grey-blue.

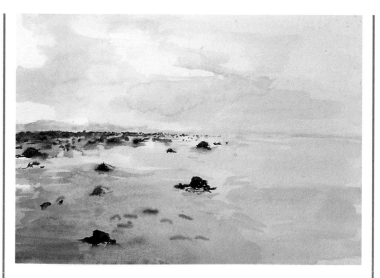

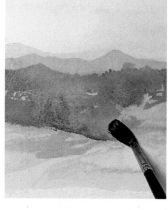

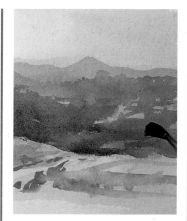

2 Repeat the glaze over dry paint, again leaving the top of the last ridge exposed. Use this wash to describe the foreground slopes.

3 Brush in the foreground; add a darker glaze to indicate the trees in the valley and hint at fields on the middle-distance slopes.

4 Details in the foreground serve to push the background into the distance – you can almost feel the curvature of the earth!

Glazing

For each glaze, mix up plenty of pigment before you lay the paint. Use a large brush and lay subsequent washes gently and with single strokes so as not to disturb the washes underneath. Use the same colour, but dilute less each time.

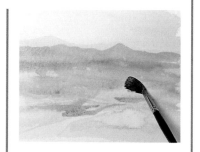

1 Lay an overall underwash to unify the painting. When dry, lay a darker wash over the top to outline the hills. When this dries, repeat the glaze but leave the furthest peaks peeping out above.

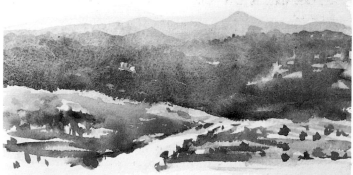

4 Touch in foreground details with local colour: browns and greens to emphasize the foreground and to help the distance recede.

Fields

It is hard to pinpoint the fascination of fields.

Perhaps they appeal because they are the man-

made face of landscape.

Or perhaps the attraction is the rich array of shapes and colours – patchwork patterns retreating up a hillside; parallel strips of freshly ploughed earth; swaying expanses of poppy-strewn golden corn.

Wet in wet Vary your technique also, using touches of wet-in-wet for soft distant features, and for hedgerows bounding the fields. In the latter case, dampen the paper above the edge of the field and run a broken line of colour along it. The colour will spread upward into the damp paper in irregular shapes like the growth of a hedgerow. Strengthen some areas with more colour while the paint is still damp.

Overlapping washes The pattern of fields in the middle distance can be built up with overlapping washes of transparent colour – ochres, mauves, greens, yellows, browns. Don't let them become monotonous – use broken colour in places to suggest texture, and bring in shadows made by clouds, trees and hedgerows to break up solid colour.

For furrowed fields, use just three tones – one pale one over the whole area, a second to delineate the furrows with fairly thick lines, and lastly a dark tone for the thin deep shadows along each furrow.

Masking Field paintings often need some foreground interest. Use masking fluid to pick out some vertical stalks of corn, either *en masse* at the edge of a pathway, or as individual stalks against fence posts or at the front of a cornfield. You can treat a few flowerheads among many in the same way. Create an immediate sense of perspective by painting larger ears of corn – or poppies, for example – in the foreground, dwindling in size as they recede until they become a mass of colour.

Three tones for the furrowed field

The three tones chosen to paint the furrows of the field must be fairly close in colour and sufficiently varied in tone. The overall underwash is your lightest tone.

1 | **Tone 1** Paint a light wash of cadmium yellow, leaving a few scattered areas of white paper peeping through.

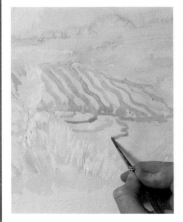

2 | **Tone 2** With a mixture of cadmium yellow and burnt sienna, draw lines to mark the field's furrows. Use the same colour, mixed with green, for the distant hedgerows and foreground tree.

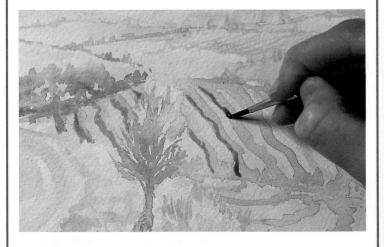

3 | **Tone 3** Mix a darker tone of cadmium yellow and burnt sienna. Create a deep shadow by drawing it along one side of the furrow. Use the same colour for the hedgerow.

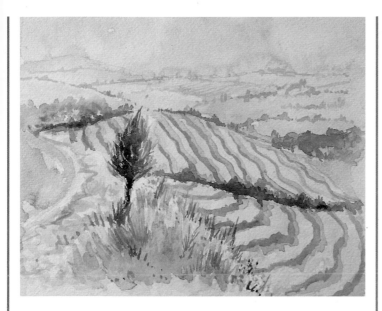

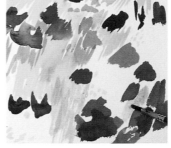

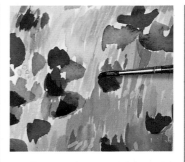

2 | Mask out a few daisy heads in the foreground. With a size 4 brush, lay diagonal strokes of colour between the poppies: yellow ochre, cerulean, green and lilac.

3 | Continue overlapping diagonal brushmarks until you have built up a lively pattern of colour. Describe the petalled heads of the poppies with small, dark red brushmarks.

4 | Tighten up the division between the fields with touches of dark violet, and strengthen the tree and grasses with the same complementary colour.

Overlapping washes

Mix a variety of bright translucent colours in the palette or work straight from pans. The variety of colours increases as each overlaps the other in a lively mosaic, suggesting the shimmering movement of grasses.

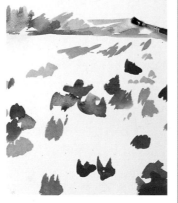

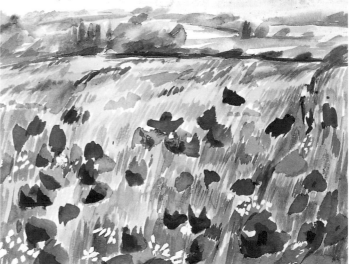

1 | Lay out your poppies in scarlet lake and vermilion. With short, lively brushstrokes paint the distant fields and trees in a variety of overlapping colours.

4 | Work the same colours into the background to marry with the foreground colours, and push shadow under the poppies to bring them out. Rub off the masking for the daisies.

Masking

Paint the masking fluid straight from the pot with an old brush. Alternatively, you can protect a good brush with vaseline by coating the hairs with it. Remove the masking only when the painting is completely dry.

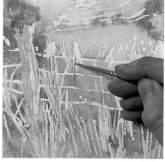

4 | Paint in the fence posts and foreground grasses with a fine brush, keeping them light against dark or painting them dark against light.

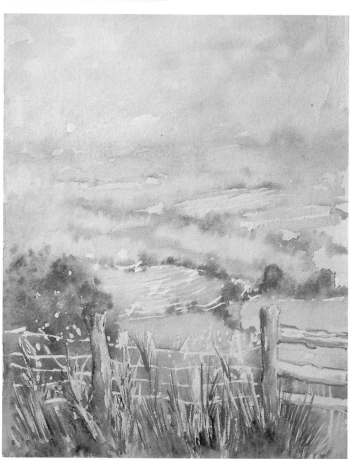

1 | Mask out the foreground grasses, fence posts and the furrows in the middle distance. When dry, paint a yellow wash over the masking and up to the sky wash.

2 | While damp, brush siennas and greens into the foreground and delineate the hedgerows and bushes by dropping colour into the damp paint.

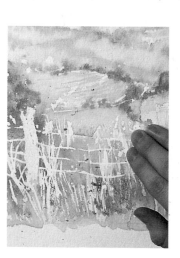

3 | Bring darker colour into the left-hand bush to contrast with the light masked area. When completely dry, rub off the masking fluid with your fingers.

5 | Dampen the fence posts and drop darker colour down one side to create a three-dimensional effect. Draw lines along the gatepost to make it stand out against the pale background.

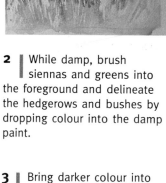

Foliage

There are no rules here – the foliage of trees, shrubs and bushes can be painted in so many ways and with so many techniques.

It is important to establish the foliage masses before engaging with detail. Half close your eyes and look for the shapes of the trees and the main lights and darks. Paint these in with broad washes in a neutral tone such as Payne's grey. If you want a soft finish, paint slightly wet in wet.

Brushmarks The most commonly used technique for painting foliage is simply the brushstroke itself. The shape and size of the head of the brush will determine the different leaf shapes, so it is worth a little experimentation beforehand. Dappled foliage against the light is very effectively painted with successive dabs of colour. Build them up one upon the other but leave plenty of white paper shining through in between.

Reserving white paper The freshest highlights are created by reserving small areas of white paper. You will need to determine the placing of these before you begin to apply colour, so make a light underdrawing.

Masking If you are using masking fluid, paint it on in leaf-like dabs with as pointed a brush as possible. The masking can be removed gradually so that glazes of colour are built up in reverse, leaving a little on until the end for pure white highlights.

Sponging A whole mass of foliage can be built up by sponging. The first layer should be fairly light and bright in colour, with successive layers going darker and less green. Sap green is an excellent green to use for foliage, mixed with Payne's grey for the darker areas.

Wet in wet/backruns Clumps of foliage can be rendered by dampening the area of the bush and dropping colour in at the base. The colour spreads upward, leaving the topmost portion of the bush as the lightest.

If you are painting large masses of foliage allow backruns and blooms to develop. The textures they create will enhance the living nature of the foliage.

Brushmarks

The brushmark itself creates the leafy foliage. Use a size 6 round brush with a good point. The body of the brush carries the loaded pigment and the tip dispenses with it as you determine what to paint.

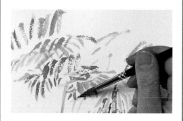

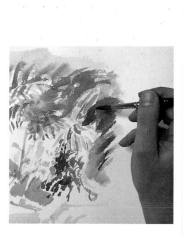

1 Paint the fronds of the rhus tree with quick single brushstrokes from the point of the leaf to the stem. Overlay lighter leaves with darker ones, leaving white paper peeping through.

2 For the areas of shadow, brush in dark splodges of monestrial green. Mix in a touch of red to kill the greenness.

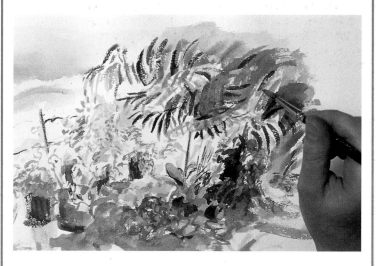

3 Continue to lay dark strokes to build up the leaf fronds and paint dashes of cadmium yellow over shadowy washes. Violet is used for the shadows under the tree.

Masking

To create gesture and rhythm throughout your composition apply the masking with a 0.6cm (¼in) hog brush in the main directions of the foliage masses.

1 | Mask the highlights on the ground, leaves and flowers. When dry, paint a very wet merging wash of viridian and sap green.

2 | Mask out further individual leaves, indicating the rhythms of growth. Brush lilac across the dried masking and into the shadowy areas.

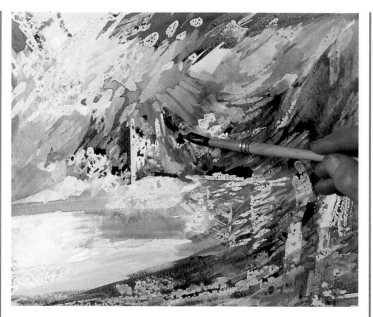

3 | More masking is laid to preserve under-colour. Wash in the deep shadows of indigo and ultramarine blue.

Wait until completely dry before rubbing off the masking with your finger.

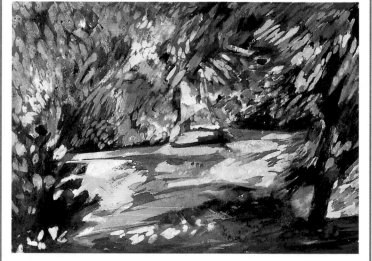

4 | Glaze over white masked-out areas with pink for the flowers and Naples yellow over the pathway. Often you will find that you add back the very colour of the masking fluid itself.

Sponging

The irregular texture of the natural sponge is employed to make broad soft washes instead of using a brush, and to create a broken, speckled texture for the foliage. A tracing paper stencil is used to paint the tree trunks.

1 | Load the sponge with rich creamy paint and dab, stroke and twist it over a wet brushed-on underwash of various greens, emphasizing the volume of the shrubs.

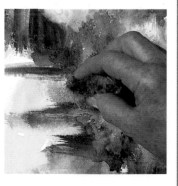

2 | Overlay the brushed shadows of the path with a deep, warm sienna taken into the base of the bushes.

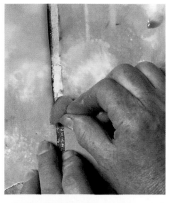

3 Cut two pieces of tracing paper and lay them on the painting with a narrow gap in-between. Hold down the paper and drag a clean, damp sponge downwards to remove the colour in a straight line.

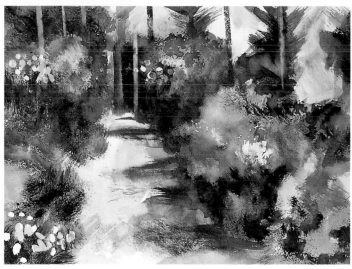

4 For the dark tree trunks, dab colour with the sponge between the stencilled gap. The regular columns contrast well with the sponged foliage.

Wet in wet/ backruns

Use a large brush to lay your wet-in-wet washes, allowing the colours to spread freely into each other. It does not matter how uncontrolled the foliage appears at first because you can tighten it up later.

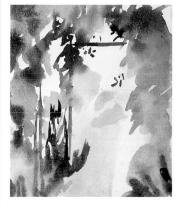

1 Hint at the structure of the rose bower, then with a flat 2.5cm (1in) brush lay greens and blues to suggest the areas of light and dark foliage. Let them merge wet in wet.

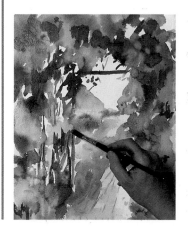

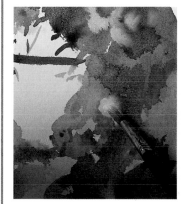

2 Load a size 5 round brush with alizarin crimson, mixed with white, and blob it into the wet washes to create the soft, round forms of the roses.

3 Crisp up the edges of the lighter foliage by wetting the darks nearby. Draw the brush descriptively around the leaves and let the paint spread softly into the wetted area.

Foregrounds

Foreground emphasis helps to create space by pushing distance further away. It also attracts the eye and takes attention from any over-worked areas in the background.

If you are taking photographs of views to paint at home, find a view of the subject that includes a foreground feature. Take two shots; one with the main view in focus, and the other with the foreground in focus. A quick sketch done on the spot will remind you of the relative proportions of the distance to the foreground detail.

From back to front In general you will find it better to work from the background towards the foreground, because otherwise you won't be able to judge the strength of tone and colour you need. But because you will need to reserve white paper for highlights and other light areas, it is a good idea to work out your foreground and lightly brush in the main features at the outset.

Fine detail A way to create small linear pure white highlights, such as those on fence wires, blades of grass or narrow branches, is to scratch off dry paint with a scalpel blade. For foreground grasses, or for the textures of wood, the dry-brush method is ideal.

Masking Use masking fluid to retain highlights on small foreground features, and reserve the white paper on larger areas by taking washes around the shapes. Rubbing masking fluid off slightly scuffs the paper surface, so you don't want to use it in areas where the freshness of the watercolour over the white paper is all-important.

Scratching off

A sharp-pointed scalpel blade is ideal for scratching off the painted surface to reveal pristine white paper underneath. The heavier the paper, the more confidently you will be able to scratch. This example uses 530gsm (250lb).

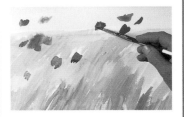

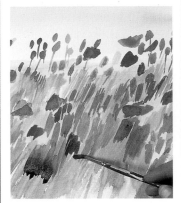

1 Lay a pale wash for the sky and background fields, strengthening and varying it as it comes into the foreground. Paint the poppies with strong positive strokes.

2 Paint dark green washes either side of imagined stems and strands of corn; this is called painting negative shapes.

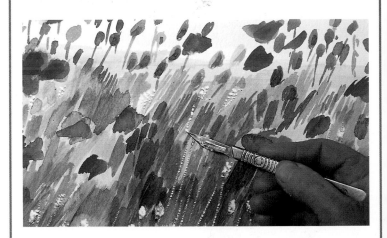

3 Scratch out stalks and pods with the point and side of the scalpel, roughen the paper with the blade and then pull out to expose the pure white paper.

Masking

An old worn-down size 2 brush is used to apply the masking fluid onto the clean paper. Let it dry completely before applying any paint. Finer features can be masked out with the nib of a dip pen.

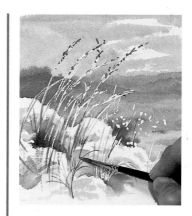

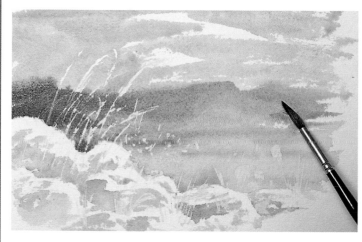

1 Reserve the tall, swaying grasses with masking fluid painted with an old brush. Wash the background over the top, wet in wet.

3 Remove the masking when the paint is dry and draw individual blades of grass, dark against light, with the tip of the brush.

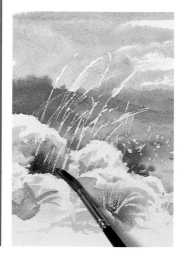

2 Touch in the hill shadows and field patterns while the wash is wet to create a soft, hazy background. Pick out broad shadows in the foreground rocks.

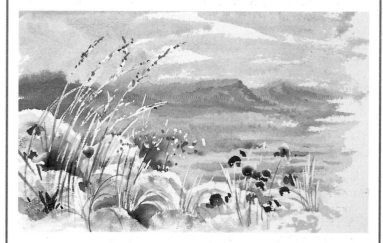

4 Wet the unmasked white of the flowers and drop scarlet lake into the bottom of each one to create a strong foreground feature.

Forests

The dramatic light thrown between tree trunks by the low sun, or the sheer magnitude of a forest seen from above, present glorious opportunities for the painter.

Be selective, remember the saying about not seeing the wood for the trees. You are under no obligation to paint every tree, so try to organize your painting to create the essence of the subject. Usually forests are deep in colour. Be bold, mix strong solutions with a lot of pigment.

Wax resist To paint a quick rendering of a forest of tall straight trunks, wax resist is an ideal technique. Draw the foreground trunks with the stem of a household candle, then lay a wash, leave it to dry and with each wash draw in the trees behind. Repeat the process, each time drawing more of the trunks, and making them thinner as they recede into the background. Wax resist is also perfect for the texture of individual trunks.

Masking Rubbed and scuffed masking fluid is useful for textures and ragged edges, and you can reserve interesting patterns of light on bark in this way. To mask out whole tree trunks, you can use torn strips of paper, but beware the paint settling at the edges.

Overlaid washes Building up the forest with layers of transparent washes makes for a rich watercolour with a lot of depth. This technique works well for both a close-up view within the forest and for a panoramic overview. With each wash some of the previous wash is left showing through, so that with very few pigments you can create a myriad of colours and tones.

Wax resist

An ordinary white wax candle is rubbed over underwashes to preserve the irregular light cast between the trunks of forest trees. Laying the wax resist enables you to work very freely with bold brushstrokes.

1 Paint a pale lemon and burnt sienna wash over the whole image. Rub wax over the areas where the light is strongest. Paint darker greens in sloshy verticals to loosely describe the trunks.

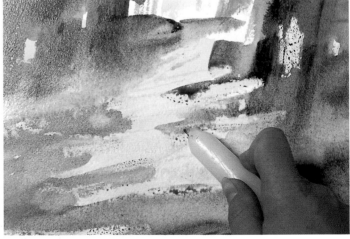

2 Wax out the light areas again while the wash is still wet, extending the wax over the light colours and tree trunks.

3 | Paint over the waxed areas with a deep sap green and strengthen the tree trunks with Payne's grey and Prussian blue.

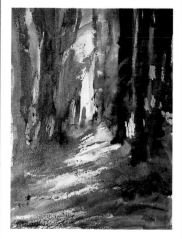

4 | Wash burnt sienna over the forest floor and up into the left-hand tree trunks. The wax resist creates a vibrant texture.

Masking with tape

Low-tack masking tape is laid on the paper to reserve the light sides to the trunks and the slivers of light sky peeping through the columns of trees. Hot-pressed paper is used to ensure crisp edges to the washes.

1 | Place the masking tape over selected parts of the forest and wash over the stuck-down tape with cyanine blue.

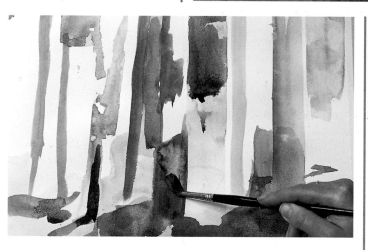

2 | Peel off the masking tape carefully and paint green, blue and grey vertical washes to describe the trunks of trees and the intervals between them.

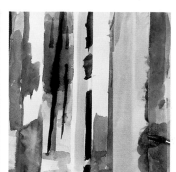

3 | Re-lay the masking tape, slightly overlapping the original positions and wash colour up to and over the edges.

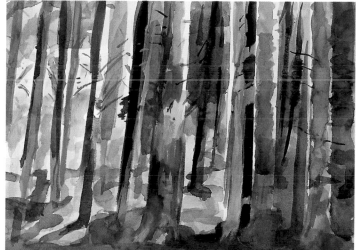

4 | Take off the masking tape and work into the trees, leaving the light sides of the trunks as untouched white paper. Use the tip of the brush to paint the small spiky branches.

Gardens

Wealth of colour makes gardens an ideal small-scale landscape subject, suiting both broad and detailed approaches.

Any of the techniques described in this book can be employed to great effect in a garden scene. There are two potential pitfalls, however. You can easily create confusion by a lack of form or composition; and you can get so carried away with colours that in the end they cancel each other out. The use of complementary colours – those that fall opposite one another on the colour wheel – will greatly enhance the brightness of your flowers. Set red flowers in blue-green foliage, yellow against mauve, and orange against blue.

Brushmarks A lively, loose impression can be created using dabbing brushstrokes for the flowers and leaves. Leave touches of white paper in between for the highlights. Pay attention to the tonal (light and dark) structure of the painting; it is easier to assess tone if you look at the subject through half-closed eyes.

Hard and soft edges Try to build the forms of flowering shrubs with light and dark versions of the flower colours. For example, dampen a bush or shrub all over, then drop a strong touch of colour into the base and along the shaded side. As the colour spreads it will create a soft, rounded form.

Individual flower shapes can be reserved as hard-edged shapes by leaving dry patches when the paper is damped in preparation for a wash. The paint will flow round these dry areas, which can be touched in with transparent colour when the wash is dry.

Alternatively the colour of the flowers could be painted first and the foliage wash laid on top, reserving the flower shapes as you paint.

Masking Light details are easily reserved with masking fluid. Flowers highlit against a dark wash can be masked out before the wash is laid. Paint on the fluid in specific shapes rather than indiscriminate blobs.

Wet in wet/ wet on dry

Use the wet-in-wet washes to create the soft, rounded forms of the topiary and shrubs. Re-wet areas that have dried with clean water. Keep the shadows on the lawn crisp edged to suggest strong sunlight.

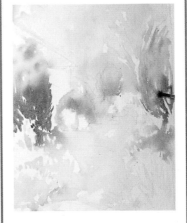

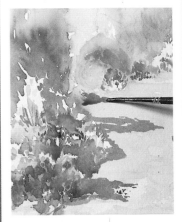

1 | Paint the main topiary forms in yellow over a pale, drying wash. Drop viridian in patches while wet and let the dark shadow colours spread upward from the base.

2 | Lay a pink wash for the flowers and drop deep yellow into that wash while wet. Before the wash dries, paint the shadows of the lawn out from the base of the shrubs.

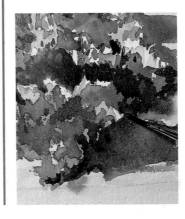

3 | Push darker shadow into the base of the bushes and across the lawn, using the tip of the brush to paint around the flower shapes with crisp edges, but slightly dampen the greenery so that the washes merge.

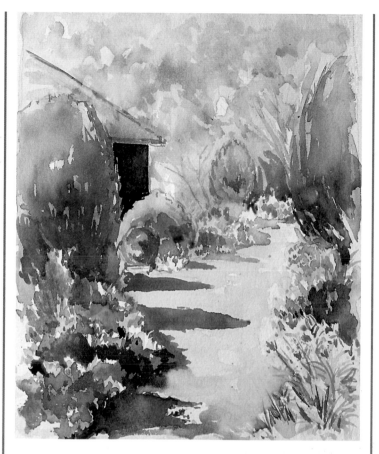

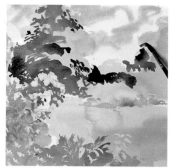

2 Build up the background and general foreground quickly, in the knowledge that the flower and leaf details are protected with the masking.

3 Paint the dark shadow across the lawn and darks into the clumps of flowers.

4 Rub off the masking with a putty rubber only when you are sure all the dark washes are in place.

4 Paint the deeper shadows on the lawn and trees over the dried washes, and then use clear water to spread the colour gently with the brush.

Masking

Masking fluid is painted in specific flower and leaf shapes with a small brush so that a general unifying green wash can be laid over almost all the composition. If you are in a hurry this will save a lot of time!

1 Over dried masking, paint a sap green wash landscape with cerulean dropped into a dampened sky.

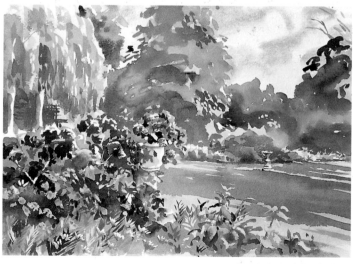

5 Touch in the exposed areas of white paper with transparent pinks, yellows, mauves and blues to identify the flowers.

Brushmarks

Use a size 10 round brush with a good tip and a smaller size 4. Let the shapes they make as you first lay down colour remain as intact as possible – in other words, let the brushmarks keep their own identity without too much pushing around!

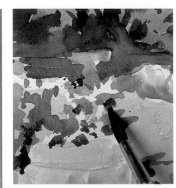

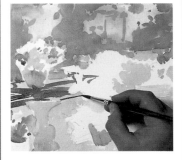

4 Use the size 10 brush and, with lively dabs of colour, paint the foliage and flowers. Leave white paper in-between for the glimmers of sunlight.

1 Lightly sketch out the composition and lay a wet-in-wet wash all around the pots on the patio.

2 Paint a mid-tone background of trees over dry paint, retaining the brushmarks. Use a finer brush to draw in the shadows across the patio.

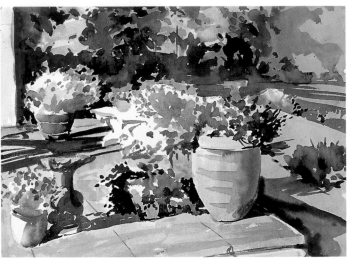

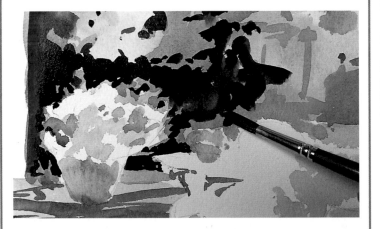

5 Strengthen the shaded sides of the pots, and boldly darken the unlit sides of the foliage with a mixture of Payne's grey, sap green and Indian red.

3 Darken the background trees with Payne's grey. Make the paint quite strong to bring out the sunlight on the potted plants.

Grass

The rich green carpet that covers so much of the landscape looks easy to paint. Yet it presents problems, mainly because the precise colour is difficult to ascertain.

The easiest way to decide is by comparison; ask yourself if the grass is more yellow, more blue, darker or lighter, than a tree or other green landscape feature. It pays to take your time, testing the mixture before applying. Trying to correct an incorrect colour takes much longer than laying the initial wash.

Rather than paint one uniform wash, vary it slightly to suggest the contour of the ground. When the wash is dry, a few horizontal brushstrokes of the same wash will add interest.

Colour There are few grass greens you can use straight from the tube, though sap green is a good strong colour, and Hooker's Green Dark is appropriate for shaded grass. Try mixing various blues and yellows, for example cerulean blue mixed with lemon yellow gives a really verdant green for small highlit areas and Prussian blue mixed with different yellows, including yellow ochre, makes a number of very versatile greens.

Sgraffito To describe individual blades of grass in the foreground, try scratching into dry paint with a scalpel blade to reveal the wash or white paper underneath. Don't do this if you want to lay further washes on top, as it will scuff the paper. A less defined effect can be created by scratching lines out with your thumbnail just before the wash dries.

Masking To reserve light-coloured foreground grasses or grasses growing up against walls, rocks or fence posts, mask out individual blades with masking fluid using a fine brush or the nib of a pen.

Dry brush Positive clumps of grass can be painted with a flat dry brush or the splayed hairs of a round brush. Use a couple of different colours to create depth and keep the dry pigment quite strong.

Sgraffito

Using the blade of a knife to scratch through the surface colour to reveal the one underneath is termed sgraffito. With watercolour it invariably means scratching through to reveal the white paper, but with gentle pressure the underwash can be exposed.

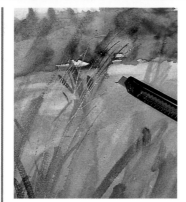

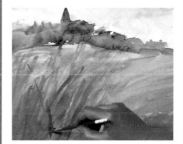

1 Paint the field and grasses with successive washes to build up a strong dark body of colour. At least one wash can be rubbed in with a tissue to ensure the paper is well stained.

2 While the paper is still slightly damp, scratch out narrow gestural lines not so as to lift the damp paper but just to make a pathway through the paint.

3 When dry, be much more forceful with more selective knife strokes in order to lift off the surface of the paper and reveal white marks for the blades and ears of grass.

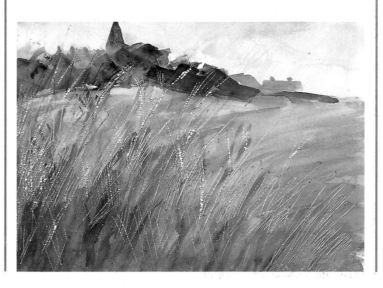

Masking

A fine brush is needed to reserve individual blades of grass. The swaying motion of the river bank is followed with the strokes of masking fluid laid over subsequent washes of green.

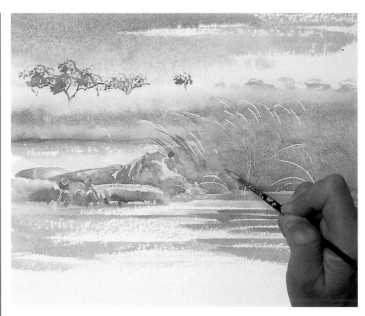

1 Mask out a few grass stems with gestural strokes from a fine brush to determine the lay of the grass. Lay the first grass wash in cerulean and new gamboge.

2 When dry, mask out more grass blades by crisscrossing the other masking. Sponge in the distant trees.

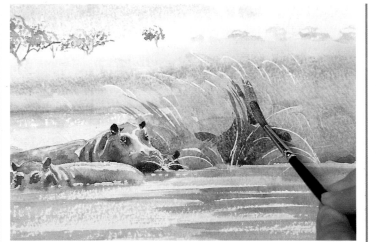

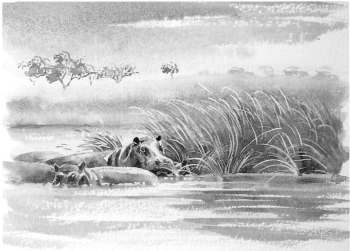

4 Rub off all the masking and tint the untouched whites with a yellow ochre glaze, leaving the grass heads shimmering white.

3 Lay another greeny-grey wash and, when this dries, mask for a third time. With the last wash, push the dark tone into the base of the grasses.

Dry brush

Mix dry paint straight from the tube or pan. Drag your brush across to load it with paint and then splay the hairs of the brush out into a fan shape. As you brush this across the paper, fine multiple lines of colour are laid.

3 | Add yellow ochre in dry brush strokes and then use white gouache, straight from the tube, to draw down individual blades of grass with a fine brush.

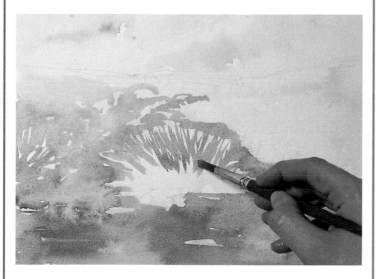

1 | First wash in the landscape to create a light base for the dry brushwork. Sap green is a useful grassy colour.

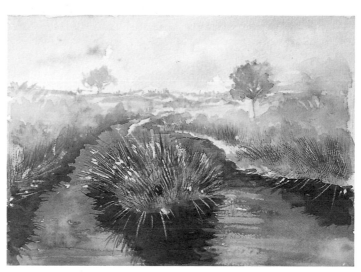

4 | Take the white blades across the dark reflections beneath the bank and the grass island.

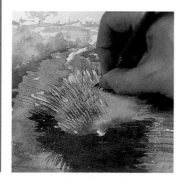

2 | Using a size 4 brush, load it with dark green paint and fan out the hairs. Brush the colour onto the island of grass with upward strokes of the brush.

Harbours

The lively buzz of a fishing port, or boats peacefully bobbing in a quiet bay, form the subject of many fine watercolour paintings.

Try not to get too bogged down in small details; look for the main shapes so that you can convey the impression of the boats. Quick horizontal dashes of colour will probably look more like distant yachts packed into a marina than hours spent carefully drawing every last deck and shackle.

Reserving white paper The essence of watercolour painting is the glow of transparent washes painted over white paper. Painting on a rough paper is ideal for capturing the shimmering, dancing highlights of light on water. The pigment settles in the "troughs", leaving scattered highlights throughout the dried wash. The less wet the paint the more effective the "tooth".

The sparkle of white yachts, masts and reflections are most effectively delineated by leaving white paper. Reflections from white buildings also look fresher if created in this way. Lost highlights, such as masts, can be picked out in the final stages with opaque white paint.

Wax resist A light application of candle wax beneath washes will create a broken-colour effect suggesting choppy water. It will "sit" only on the top of the paper grain, partially resisting the paint, which will settle unevenly. Wax could also be used over a rather too-uniform wash, with further colour laid on top.

Wet in wet The reflections of boats can be painted by wetting the bottom of the hulls and the water below, dropping in a darker colour and letting the paint run downward. If you want a definite waterline dampen just the area below the hull, paint your colour in along the waterline of the boat, and let it seep downward into the damp paper below. Use the same technique for the reflections of harbour walls and other buildings.

Reserving white paper

The vibrancy of the white paper both under and between the colours is the secret of the freshness of watercolours. In this painting, experiment with a large 5cm (2in) flat brush, without any preliminary drawing, to create a lively composition.

1 Lay the sky wash around the tops of the buildings. With the edge of the brush, block in the shadows of the buildings and the hull of the boat.

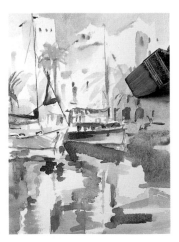

2 Draw the palm trees with the side of the brush and then use a finer brush to pick out the boat details, windows and doors.

3 Brush in the reflection with bold strokes, remembering to leave areas of untouched paper to reflect the buildings. Strengthen the shadows and trees with a darker colour.

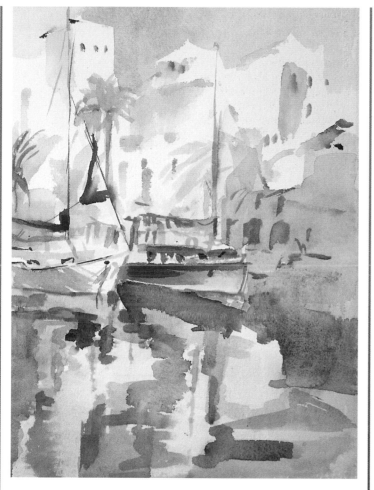

4 Lay the palest of blue washes as a transparent glaze over the water to unify the reflection and to make it slightly darker than the image it reflects.

Wax resist

A white wax candle drawn in streaky movements over the light areas of a painting will quickly preserve exciting irregular highlights when covered with further washes.

1 Paint a light overall wash of yellow ochre. Block in the buildings loosely with Payne's grey. While the paint is wet, wax the left-hand side of the sky. When you paint a further wash over this, a soft-edged streaky effect is created.

2 Wash yellow ochre over the waxed water and use a touch of burnt sienna in the middle distance. Mix Payne's grey and burnt sienna together to paint the silhouetted buildings and reflections.

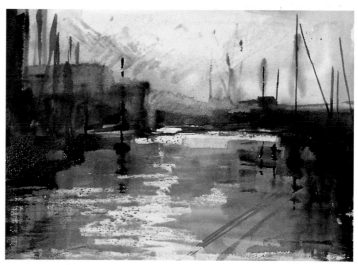

3 Pick out the masts, boats and their reflections with the edge of the brush. With a limited palette you can create a vibrant painting.

Hills

Hills have a strong emotive appeal, inviting you to explore what lies beyond, as well as creating a series of lovely and intriguing shapes.

Choose the time of day carefully, as the direction of the light changes the appearance of the hills. When the sun is overhead or directly in front, they will be flattened, with their forms hard to decipher. Oblique sunlight will cast shadows that describe the forms, while low sun, setting behind the hills, will silhouette them, allowing you to see them as simple shapes.

Wet in wet Softly rounded forms can be painted wet in wet. Drop darker colour into the valleys before the wash has dried. If the paper is dry, dampen it beyond where you want the paint to run to ensure soft edges. Create the structure of the hills by modelling from dark to light. Lighten the top of a rise and darken the dip beyond if you want the hill to stand out more.

To suggest an upward slope, dampen the paper above an imaginary line that represents the angle of the hill. Drop colour into this along the slope line and let it extend softly upward into the damp paper. Clumps of grass and changes in surface created in this way will then also describe the lie of the land.

Glazes We recognize hills mainly by their contours. Draw the shapes carefully, either using a pencil first or going straight in with colour, using the tip and edge of your brush as you lay the washes. Successive transparent washes (glazes) are an effective way of building up layers of overlapping hills.

Wet in wet

Be aware how damp your paper is as you lay each brushstroke into the preceding wet wash. Test it with the brush tip to see how far the paint spreads and wait if it spreads too far.

1 Paint a pale pinky wash over all the paper, and darken at the bottom. While wet, brush in the hills.

2 Use a warm, strong colour in the foreground, letting it spread softly into the drying wash above.

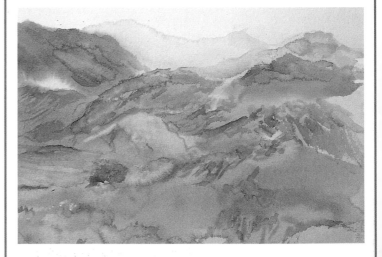

3 Use small washes to describe the hill forms, working into them while they are wet, contrasting light against dark to separate the masses. With a small brush, draw directional lines into the hills while the paper is damp.

Glazes

Glazes are thin transparent washes laid one over another. Leave the top of the previous wash exposed each time to create the advancing hills. The colour of the top wash will be the sum of all the previous washes underneath.

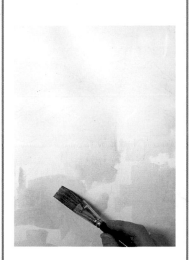

1 With a large flat 1.2cm (⅝in) brush, lay an underwash of pale pink to provide a warm tone under the greens.

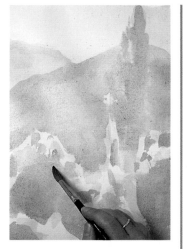

2 Lay the background hill wash over this followed by another slightly darker wash of Hooker's green mixed with red.

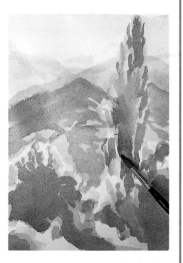

3 Lay further glazes, making the middle-distance hills and foreground trees darker. For soft, crinkly edges, lay the next glaze just before the previous one dries.

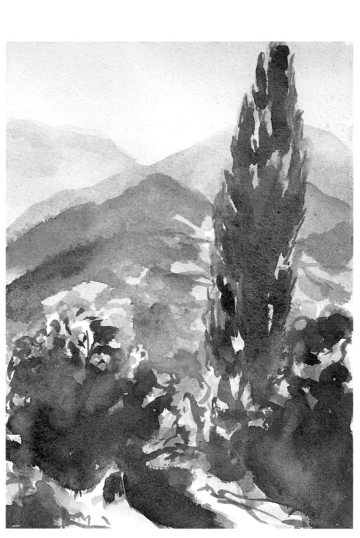

4 Paint a dabbing wash of monestial green to describe the tree and shrubs, and with a lemon yellow wash, lay a final glaze over the sunlit leaves.

Islands

Simple but exciting paintings can be made by breaking an ocean horizon with the shape of an island, or silhouetting it against a sunset.

Or you can use an island as a compositional device to enliven a background. For distant islands use a one-touch wash with a well-loaded brush to describe the whole shape. For small dotted islands, paint the form and the reflection with your first stroke or wash, then glaze over the reflection again to create the shoreline.

Graduated wash A strong simple statement is made by painting a graduated wash from sky to sea, leaving the area around the horizon as the lightest part. The island shape and its soft reflection then mark the horizon.

Wet in wet This is the perfect method for reflections of islands in still waters. Dampen the paper only below the island, using a tissue to dry any dampness on either side, as this would make the reflection spread horizontally. If you want the reflection to mirror the island precisely, apply the wash when the paper is nearly dry, as this gives you more control.

Reserving white paper To hint at white sand along a shoreline, reserve white paper in a narrow strip above the sea. Small white buildings on the shoreline can be suggested by reserving an irregular line of white paper.

Over a graduated wash/wet in wet

A simple sky/sea painting is transformed by the inclusion of the island. Use quick wet-in-wet brushstrokes made with a large 5cm (2in) paste brush.

1 Lay a graduated wash of cyanine and ultramarine blue, darken the sea and introduce green into the shallows.

2 Take a line of brown across the horizon as a base for the island. Blot out any excess water with a tissue.

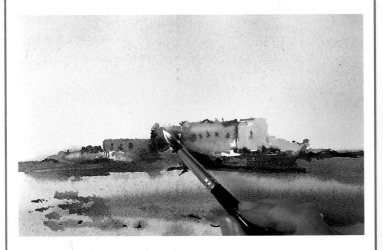

3 Paint the island with a mix of yellow ochre and white gouache to give it substance. Drop neat white into the dark shadow areas of the fortress to increase opacity.

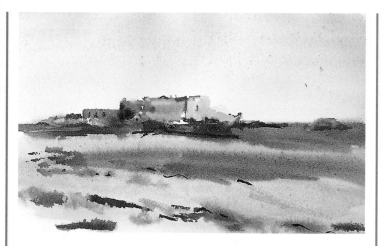

4 A simple dynamic painting has been achieved with relatively few brushstrokes.

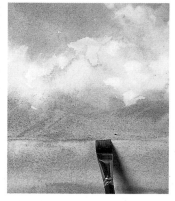

2 Introduce yellow ochre into the distant mountains. Keep the sea very washy, and soften the tops of the distant hills with clear water.

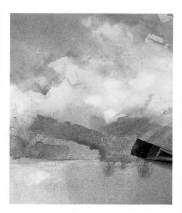

3 Paint in the island in olive-green and ochre with a well-loaded brush, and lay it in strong diagonal strokes on the drying background.

One-touch brushstrokes

Again, a simple background sea/sky wash is laid and a dramatic island brushed into position with three simple strokes of a flat brush. Be bold and avoid the temptation to fiddle with the stroke after it is laid.

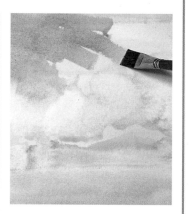

1 With a flat brush, paint a loose wash of cerulean, cobalt and green. Wash out the clouds with clear water and blot with a tissue to retrieve the white paper.

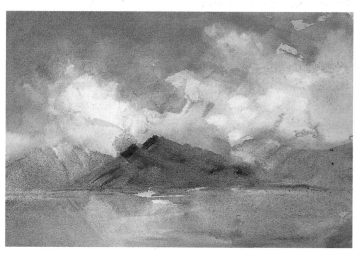

4 As the colour dries, touch more olive-green into the island peaks with the edge of the brush.

Lakes

There are few more appealing subjects than reflections in still water. Then a breeze comes up, ruffling the water surface, and the image is erased.

To ensure a convincing reflection it is best to paint, or at least to sketch in, the landscape first, so that you can match the reflection to the actual shapes. If the water is mainly light with dark reflections, leave it as blank paper initially. If there are light reflections in dark water, reserve white paper for the reflections and wash in the water early on to preserve the unity of the painting. Or alternatively, use a dry brush or tissue to lift out the reflections from the colour used for the water before the wash is dry.

Glazes Vertical washes of transparent colour laid with a flat brush will create clean downward reflections. If you want to reserve a horizontal ripple line, mark it softly with pencil as a guide. Masking fluid could be used, but may leave rather insensitive shapes.

To lay ripples over a wash, use thin horizontal glazes of diluted white gouache. This will create a glassy film which looks just like light reflected on water. Brush the paint on lightly and leave undisturbed.

Wet in wet For those lovely reflections that seem to blend into the water like curtains of chiffon, slightly dampen the paper and brush the colour in below the shoreline. Guide the flow of the paint by tilting your paper, then leave to dry before retouching.

If you have used plenty of pigment in the wash for the shoreline, you can draw this down into the water with a slightly damp brush. Alternatively, use a dry brush to pull the wash down when still wet, or dampen the paper beneath the shoreline and let the wet colour spread. This technique is suitable if you wish to soften or lose the shoreline.

Glazes/opaque paint

With a size 6 round brush, overlay thin transparent washes of dilute colour to build up a shimmering scene of colour. Use white gouache to draw the ripples of the lake in after the glazes are dry.

1 Block in dilute washes of Naples yellow, greens and lilac in a generalized fashion. Use vertical strokes on the shoreline, contrasted with short diagonals in the foliage.

2 Paint glazes of thin colour in patches over the dried washes. Darken the area below the waterline with a glaze of purple.

3 Draw in the ripples with white gouache. Use it fairly thickly as it will dry lighter than it appears while wet.

4 Strengthen the darks in the foreground to frame the background. The glazes create an almost stained-glass effect.

Wet in wet/ lifting out

Soft, runny reflections in watercolours are created by dropping the paint into a wet wash or by wetting the paper with clear water and then brushing in the paint. Always wet a wider area than you require to prevent hard edges developing when the colour meets dry paper.

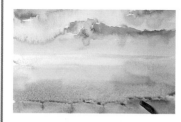

1 Using a size 11 round brush, paint in a pale Prussian blue sky onto dry paper and brush yellow ochre and Indian red into it while wet. Wash the same colour scheme into the lake.

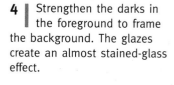

2 When dry, paint the dark shoreline silhouette. Dampen the paper under the lakeside down to the ochre, and leave a sliver of white paper to mark the edge. Brush the reflection gently into the damp area, so mirroring the shapes on the shore above.

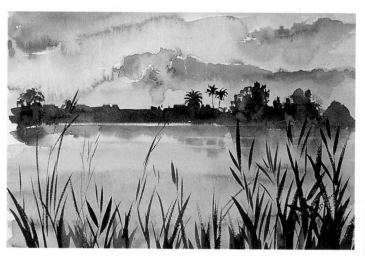

3 Just before the reflection dries, lift out the horizontal ripples with a slightly damp brush. If the paint has dried already, rub the ripple with a damper brush or the edge of a tissue.

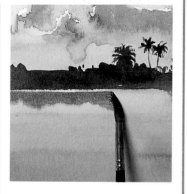

4 When the paint is dry, brush in the reeds in indigo and Prussian blue, with single strokes for the leaves.

Mist

Hills or fields fading gradually into the mist, or a soft blanket turning trees into pale silhouettes – these seem an invitation to paint.

They look easy, but are deceptively so, requiring thought, careful planning and very little actual painting. Keep your palette of colours simple, avoiding bright hues and any strong contrasts of tone or hard lines – mist softens everything.

Wet in wet The most useful technique is the wet-in-wet wash. For an overall hazy appearance the whole paper can be dampened so that the entire image is soft. For patches of mist, such as that rising from a river, the paper need only be dampened selectively. Objects seen through the mist can be painted in afterwards when the paper is almost dry, using one-touch strokes so as not to disturb the wash.

To paint a landscape dissolving in misty layers, paint from back to front, building layer upon successive layer, patiently waiting for each to nearly dry before applying the next. Too wet and the colour will run formlessly; too dry and the edges will be hard unless you are using very thin washes. Keep to one colour, using progressively deeper tones.

Washing off This can be a troubleshooting method, but is also a technique in itself. If the colour is too strong, or tones too contrasty, wash the paint off with a large brush. You can even run it under the tap, but for this you must use a heavyweight paper (300lb). Some colours will stain the paper, but these can be rubbed vigorously to give a wonderful old-leather look. If only one or two objects are at fault, lift some of the colour off gently with a brush or corner of tissue.

White wash Another way of giving your image that misty feel is to use a large brush to drag a thin solution of white watercolour (Chinese white) gently over the painting – or you can apply it evenly with a sponge. Remember the paint will dry less white than it looks when wet, and will add a certain opacity to the painting.

Successive layers

With just one colour you can build up a misty landscape in layers. Each wash is dry before the next is painted. Do not alter the consistency of colour – successive layers create the slightly darker tones.

1 Lay a wash of ultramarine and burnt sienna. When dry, brush in the distant ships, softening reflections with a clean damp brush.

2 Paint each layer over areas of the one before to build up a gradual deepening of tone.

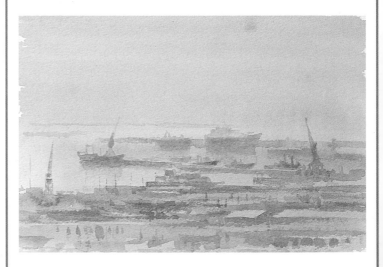

3 Using small strokes, pick out darker features such as the hulls of boats, dock-sides and windows in the warehouses.

Wet in wet

To create rising mist in the valleys, lay successive washes onto paper dampened only at the base of the wash. If a hard edge occurs, soften it with a brush loaded with clean water, before the paint dries.

1 Dampen the paper in the valley areas of the painting. Brush in the colour, allowing it to spread softly into the white paper at the bottom of each wash.

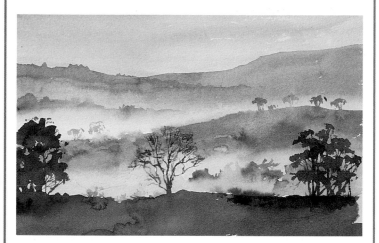

2 Paint each layer of hills into the white area, just before the previous wash dries. Touch in the tree forms in silhouette.

Opaque glaze

With a 5cm (2in) flat brush, lay a glaze of semi-transparent white gouache over a dry painting. Mix plenty of paint to an even, milky consistency.

1 Paint the landscape wet in wet, with bold playful strokes, letting the colours spread softly.

2 Overglaze with white gouache laid in horizontal stripes, allowing them to merge of their own accord. Lift out any area that picks up too much white with a tissue.

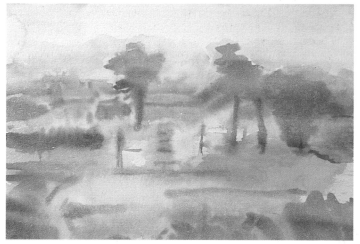

3 Blot the darker trees before the white dries so that they appear to loom out of the mist. Avoid going over the painting too much or you will lift out the colour.

Mountains

Few people can fail to be moved by the awesome majesty of mountain landscapes, and for the artist they provide a challenge and a thrill that no other subject can match.

Unless the mountains are flattened by mist or distance it is important to establish their solidity. The low angle of the winter sun enhances their splendour by casting dramatic shadows, which also make it easier for the artist to paint convincingly three-dimensional forms.

After sketching in the mountain shapes, suggest their volume by means of cast shadows and shaded crevices. You can either begin with broad washes in a neutral tone, or go straight in with your shadow colours, keying the rest of the painting to them.

You will also want to suggest their size, and you can give a sense of scale by including some familiar feature such as a person, climber's hut or a group of houses nestling beneath the mountains.

Hard and soft edges The combination of hard and soft edges created by painting an area dampened in some parts only is very pleasing for a wild landscape. Evergreen trees merging into each other at the bases but carefully drawn at the top look more interesting than starkly painted individual trees one against the other. Paint ledges and rocks with crisp edges, but let their bases merge into the mountainside wet in wet. Interesting textures for trodden snow can be created by scumbling.

Reserving white paper The beauty of snow scenes is that you don't have to do much painting to create an interesting image – a welcome relief when your hands are cold. Reserving white paper is the best way to "paint" white, with angular blue shadows describing the forms. For crisp white peaks, draw the shapes by taking the sky wash around them, using a large round brush with a good tip.

Hard and soft edges

Mix washes without too much water to enable you to work quickly on dried paint so that the brushstrokes remain hard edged. Use clear water to soften hard-edged areas.

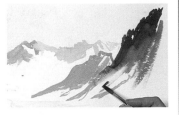

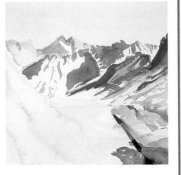

1 Paint the distant mountains over a damp, greenish sky wash. As the mountains come forward, lay linear brushstrokes over soft, dried washes.

2 Build the outline of the crags with single brushstrokes, describing the rocky slopes of the mountain. Paint a very wet wash of ochre for the foreground scree slope.

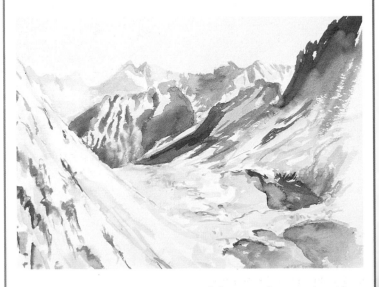

3 Scribble loose detail into the scree surface with the tip of the brush while the wash is wet. Dampen the base of the central mountain with clear water to make the colours spread softly.

Reserving white paper

It will help you to lay more confident shadow shapes if you sketch the mountain scene lightly to begin with. The untouched white paper is the strength and the freshness of the painting. Do not fiddle, and be certain of where the mountain shadows fall.

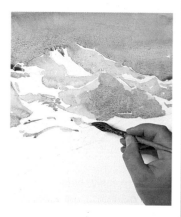

1 Paint a cobalt-blue sky, following the mountain ridge. While drying, use the same wash plus a little Payne's grey to paint in the shadow shapes of the mountain.

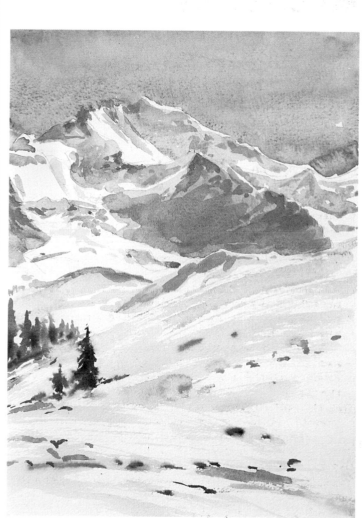

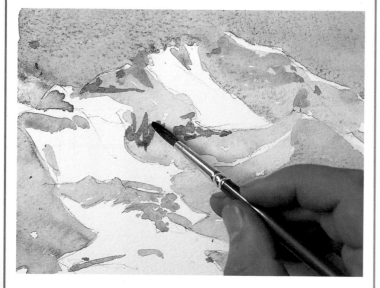

2 When dry, use light strokes of the same colour, plus more Payne's grey, to create the surface variations, peaks and ridges.

3 Into the pale wet wash on the mountain slope, drop small pools of cobalt blue and Payne's grey to show lumps of snow and ice. Dampen the paper slightly before drawing in the fir trees with downward strokes. Let them bleed softly.

Scumbling and masking

To scumble paint onto a surface you should mix up dry paint, load the brush, and with a twisting, dabbing motion of the brush head "grind" the paint onto the paper. Repeat the process for a delightfully varied texture.

1 Mask out the sharp edge of the mountain against the sky. Wet the paper, and lay a wash of Antwerp blue and Payne's grey. Lift out the colour with tissue where it floods over the mountain top.

2 Paint the mountain shadows with the same two colours. Scumble dry sepia, with twisting movements, onto the rocks and peppered snow in the centre.

3 With a dilute but dry mixture of Antwerp blue and Payne's grey, scumble the area of trampled snow in the foreground. Repeat the process, patting and twisting the brush head.

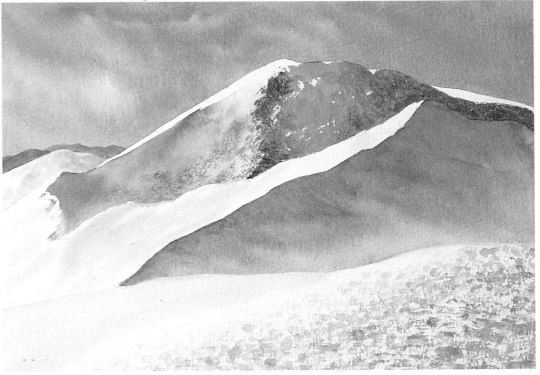

4 Remove the masking with the finger. Wet the white area and drop in Antwerp blue for soft shadows in the undulating snow.

Night

Even the smallest amount of light, whether natural or artificial, will break up the darkness to create exciting effects for the painter to try.

Moonlight shimmering on still water, street lights reflected from a lakeside road, the lit windows of houses against dark trees, or the last loom of light above hills as dusk succumbs to advancing night – all these would make promising subjects.

You will need to build up dark colours, so a wash all over the paper is a good way to start. Mix up lashings of paint before you start, so as not to get caught short, and make the wash darker at the top and bottom and lighter around the area broken by lights.

Reserving and masking Reserve white paper for bright areas such as the moon and its reflections, or for small pinpoints of light – distant street lights, for example – paint on little dots of masking fluid. Lay your dark washes boldly over the top, and when dry rub the masking off very carefully. Touch in the colours of the lights with transparent dabs of yellow, red and orange accordingly.

For the soft glow of moonlight on water, painting over wax resist breaks up the colour to give a gentle, fluid reflection.

To create the haze you see around lights, or around the moon, try using dry white gouache over the wash in a "scumbling" method, scrubbing it over the watercolour with a bristle brush. This will lighten the area around the light, but some of the underlying colour will show through. Alternatively use a sponge, dabbing the white on in layers. To tint the haze use a dry colour as well.

Masking and scumbling

For tiny lights it is often easier to use masking fluid than to try to reserve the white paper. When the masking is removed, soften the hard edge by scumbling white paint around it with a dry brush.

1 Mask out the streetlights and reflections. Wet the paper and lay a loose dark wash, leaving the area above the cottages untouched. Drop yellow ochre into this area and its reflection.

2 When dry, add the profile of the dark houses, softening the skyward edge by dropping clean water above the area to be painted and letting the indigo run into it.

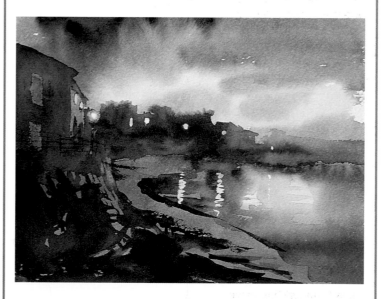

3 Build up the darks, wash on wash. Rub off the masking and tint with dilute cadmium yellow. Scumble around the circle of the foreground light with gouache.

Reserving white paper

The untouched freshness of white paper is the brightest way to create lights in watercolour. Wet the paper all over, but draw around the moon as you do and down either side of the reflection, so that those parts of the paper remain dry.

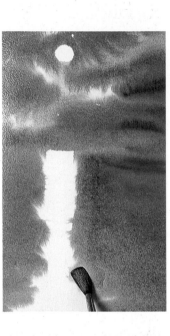

1 Flood a rich mixture of indigo and ultramarine blue into the dampened paper, helping it around the moon with the brush and coaxing little ripples across the reflection.

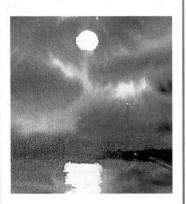

2 While damp, add the horizon feature in deep indigo, letting it spread into the sky and water.

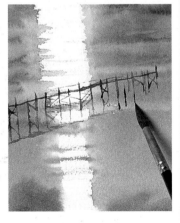

3 Sketch the pier and its mirrored reflection with dark strokes over dry paint. Dampen and blot the reflection.

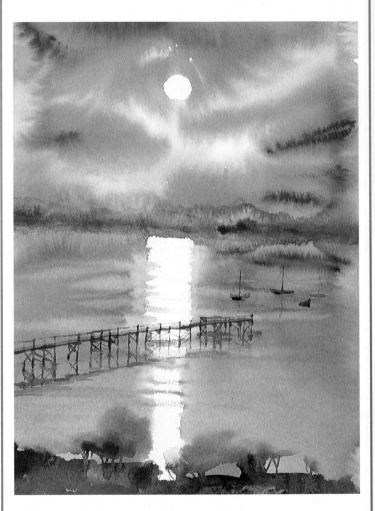

4 Touch in the boats with indigo, using the tip of the brush. Where the foreground crosses the moon's reflection, exchange the indigo for red and ochre.

Lifting out and opaque white

Soft lights can be retrieved while a wash is still damp by lifting out the colour with a clean brush or tissue. If the paint has dried it will need rubbing with a damp brush. For larger areas "massage" the area with a clean, damp sponge.

1 | Lay a pale pinky wash, leaving the moonlit surfaces as white paper. Block in the dark areas with an underwash of Payne's grey, monestral blue and ultramarine.

2 | Strengthen up the dark areas, working wet in wet and wet on dry. Lay a dark wash over the sky.

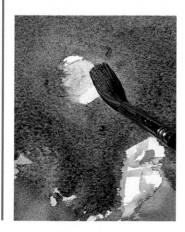

3 | Before the sky wash dries, lift out the moon and its halo with a clean, slightly damp brush, to reveal the pinky wash underneath.

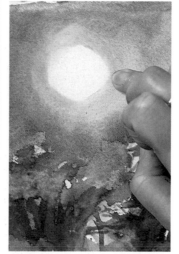

4 | Add white to restore the luminosity of the moon, and rub this with your finger softly around the edge of the moon in order to create the halo.

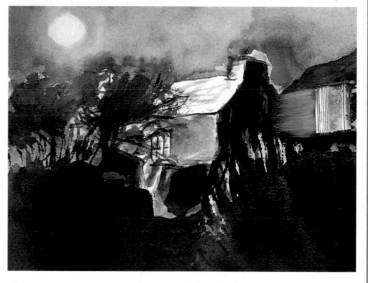

5 | When dark colour dries, it may appear dull. A brushload of pure ultramarine will create vibrant colour in the shadow of the house and nearby bushes.

Panoramas

Often a sketchbook page will seem too small to capture the awe-inspiring effect of a panoramic view stretching around you on all sides.

So why not change your format? Either open your sketchbook out and paint across a double-page spread, or crop your paper to make an elongated rectangle. You will find that the composition immediately begins to fall into place.

Wash in the sky and distant landscape with broad, free strokes. Try to "feel" the sweep of the land, and let your brushstrokes suggest the twists and turns in the contours of hills and valleys, rivers and roads.

Brushwork Build up the landscape with graduated washes and overlaid brushstrokes, using the shape of the brush to describe forms. A flat brush is useful here; have a look at some of Cézanne's watercolours of Mont St. Victoire, in which he used short, flat brushstrokes of transparent colour right across the valley floor to the foot of the mountain. Horizontal and vertical strokes can suggest fields, houses, roofs and trees. More precise detail can be added later, or you may find that the brushmarks have established your view quite satisfactorily.

Wet in wet Soft rounded forms such as trees and bushes can be indicated by small wet-in-wet blobs. Touch the colour in along the lines of roads, rivers or hedgerows to anchor them to the earth, and let the colour spread upward in soft irregular shapes. You can model these forms while still wet, with further drops of colour, or add more colour wet on dry.

Overlaid brushstrokes

Delicate lightweight brushstrokes, together with small glazes laid one upon the other, make up a quick interpretation of an enormous subject. Keep your paint solutions on the drier side to enable you to paint quickly over dried brushstrokes.

1 | Use the shadows to draw the structure of the range of hills with a neutral colour.

2 | Build up the mountain shapes with small directional brushstrokes. Wash in the valley with a loose narrowing zigzag, and suggest details with the tip of the brush to create a sense of distance and scale.

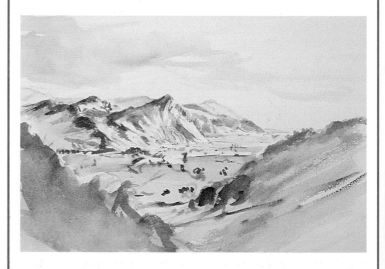

3 | Darken the foreground to frame the valley and lay blobby brushstrokes to mark the trees, enlarging them as they come closer.

Wet in wet

Use a large 5cm (2in) flat brush on damp paper to create the broad sweeps of the land without getting bogged down with detail. Change to a smaller brush to hint at details with small, persuasive brushmarks open to free interpretation.

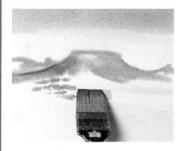

1 Lay a variegated wash of cerulean and pink over wet paper. When almost dry, brush in the flat-topped mountain with cerulean and raw umber, testing the dampness with the tip of the brush before you lay the wash.

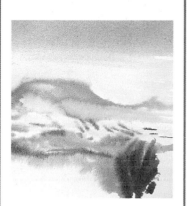

2 Paint small directional brushstrokes into wet washes across the middle distance to vaguely describe the lie of fields, hedgerows, etc. Drop darker colour into the wet paint for the foreground tree.

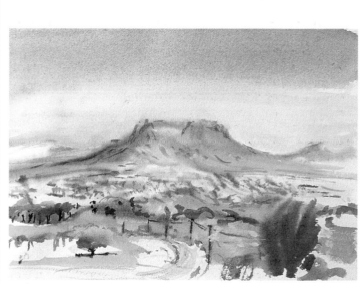

4 Create the swerve of the road with a sweep of Naples yellow. Hint at trees and bushes with simple directional brushstrokes, using stronger tones in the foreground.

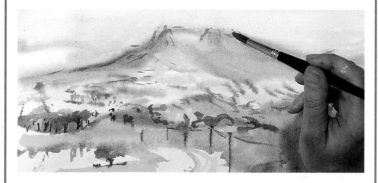

3 As the wash dries on the mountain, draw in linear details with dryish paint. Mix a little red and ochre with white to create a pinky colour in the middle distance.

Pathways

A path winding off into the unknown evokes a sense of mystery. Someone looking at your painting will wonder where it goes or what is around the bend.

However quickly you make your preliminary drawing, whether with pencil or brush, concentrate on the perspective of the pathway as it runs away from you.

Whether a pathway is bordered by flowers, trees or bushes, shadows cast across it will always help to create interest and establish its horizontal surface. A leafy shadow falling across the track will also help to pull the foreground towards you. Even if there is no direct sunlight, breaking the surface with different tones will make it more interesting, or you can introduce features such as scattered stones to create foreground interest. Close-up features framing the pathway across the front of the picture plane "invite" the viewer into the picture, to seek out brambles, branches, leaves and flowers that you can use in this way.

Spattering/flicking Spattering or flicking paint along the surface of the pathway will enliven a dull wash. Use the colours already in your painting, so that the spatter does not look too obtrusive, and encourage larger blobs of paint to fall in the foreground and smaller ones in the background as the path recedes.

Hard and soft edges Both the borders and the actual pathway will benefit from a mixture of hard and soft edges. Break border lines with an occasional soft edge, either by dampening the paper in places before you lay your wash, or by lifting out with a damp brush or sponge later. Let flowers or foliage bounding the path fall freely across the line of the pathway to make its linear shape less regular.

Spatter/flicking

Mix up liquid solutions of paint in the palette. Dip an old toothbrush into the colour and hold it across the area to be spattered. Draw back across the loaded brushhead with the end of a brush, releasing the speckles over the paper.

1 Lay the basic composition with loose warm washes, reserving the line of the pathway.

2 Protect the rest of the painting with paper, and spatter the triangle of pathway with burnt sienna sprayed from the toothbrush. Flick larger blobs of ochre from the head of a loaded paintbrush by tapping the end. Peel back the paper protection to reveal the spattered pathway.

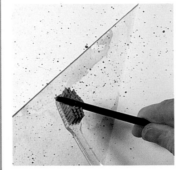

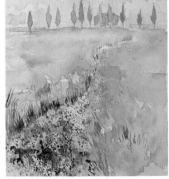

3 Remove the paper protection and flick some burnt umber and some clean water onto the pathway.

4 The burnt umber merges with the water and softens the spotty pathway. Define the border of the path with grasses.

Hard and soft edges

Drop liquid colour from the tip of the brush into wet washes to create soft, merging colours. Alternate with brushstrokes and small washes painted over dried paint to form a contrast of edges.

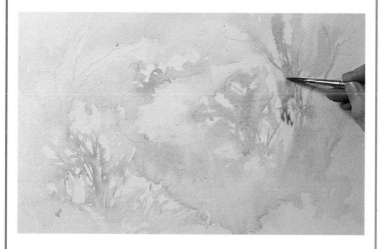

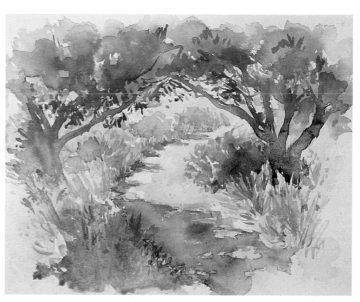

1 Draw the composition with a light yellow wash. While wet, draw in viridian brushstrokes and let the colours spread. Paint a warm pink wash over the pathway.

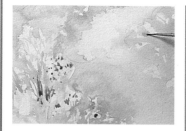

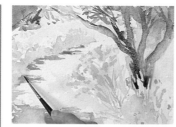

2 When nearly dry, build up different colour washes of light violet, light green and cadmium red on the flower borders. Let them merge wet in wet, marking the pathway with soft edges.

3 Wash in the trees and dot in blobs of yellow while the paint is wet. Lay a shadow wash across the path with a similar colour on the tree trunks.

4 Lay a deeper wash of ultramarine and permanent rose over the shadows, dropping ultramarine into the wet wash to vary the tone. With short linear strokes, define the foliage in the foreground.

People

A figure in a landscape will immediately attract attention, so try to paint it well, or it could spoil the whole effect.

The secret is to treat the figure in the same manner as the rest of the painting; overworking it or giving it too much detail will make it stick out like a sore thumb. If you are unsure about the scale cut a little figure out of low-tack masking tape, wash over it in the colour you will be using, and stick it gently in the position you think is right. When happy draw lightly around it, marking the top and bottom, and remove.

Once the size is correct in relation to the painting decide what the overall shape of the figure is. Practise painting figure silhouettes from life, and keep them to hand. If you are painting a view with a figure, which moves before you have finished, you will have a record of a similar shape which you can add to the painting when you wish.

One-touch brushstrokes One-touch brushstrokes to indicate a figure's stance are the most lively, but they take practice and courage. The artist, Ian King, teaches his students to paint an "M" over a "W", topped with a small blob for the head, to create effective standing or walking figures; this is a very handy formula. Colour for clothing can be painted either in the initial strokes or brushed in later to retain the overall tone. Touch in small highlights with white paint.

Back views and hats are a great help as they avoid the necessity of painting faces – and these attract the eye even more than the overall figure. If you need to indicate facial features keep it to simple shadows for the indentations of the face.

Reserving white paper The highlights on a figure's clothing help to describe the forms of the body beneath. Carefully mark these highlit shapes when sketching your figure and try to reserve the white paper by painting crisply around them.

Figure silhouettes

With very quick, dryish brushstrokes believable figures can be swiftly painted in action. Lively, imprecise lines look more alive than rigid, carefully drawn people. Gesture is important; look for shape. Your people don't have to be accurate to be effective.

1 Lay a pale wash for the sky and wash in the trees while wet. Leave the snowy hill as white paper. Sketch the figures in lightly with a brush in grey, and emphasize movement with the brushmark.

2 As the colour dries, paint a dash of colour into a couple of figures for variation. Now go over them with a darker colour, but leave some of the undertone peeping through.

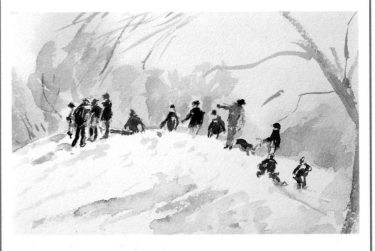

3 Strengthen the background trees slightly against the figures, and brush in the foreground tree.

The figures are lively and descriptive with very little painting.

One-touch brushstrokes

In this example use a quick touch of white gouache to indicate the body of the man walking his dogs. For the white to stand out, a dark background is necessary. The head and legs are, likewise, quick strokes of the brush.

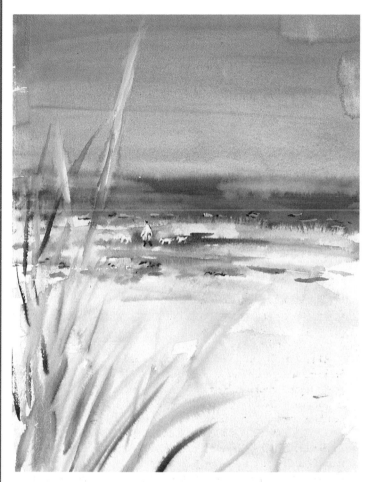

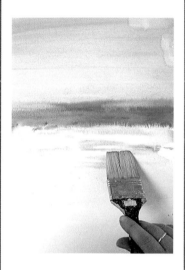

1 Wash in the beach landscape with a large flat brush, wet in wet. Let the colours gently spread but guard against losing the horizontal stripe of the sea.

2 Darken the shoreline with sideways strokes, before the background dries. Brush in the foreground grasses with a no. 10 round brush, using Naples yellow and white.

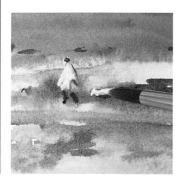

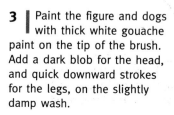

3 Paint the figure and dogs with thick white gouache paint on the tip of the brush. Add a dark blob for the head, and quick downward strokes for the legs, on the slightly damp wash.

4 Hint at the face with the tiniest dash of burnt sienna and white, and use dark dashes for the hands. Note how the addition of the figures makes the painting come alive – it now tells a story.

Reserving white paper

To retain the fresh highlights of untouched white paper, a sketch of the body shapes before you start may be necessary. Then you can confidently "draw" the paint around the shapes without hesitant breaks in the wash.

3 With the tip of the brush and a strong dark colour, paint the shadows along the shaded sides of the limbs and faces.

1 Wash in a basic background wash of cerulean and yellow ochre around the highlights of the figures.

2 Paint the shadows on the clothes as you build up the general tonal play of the painting. Think of the figures as part of the landscape.

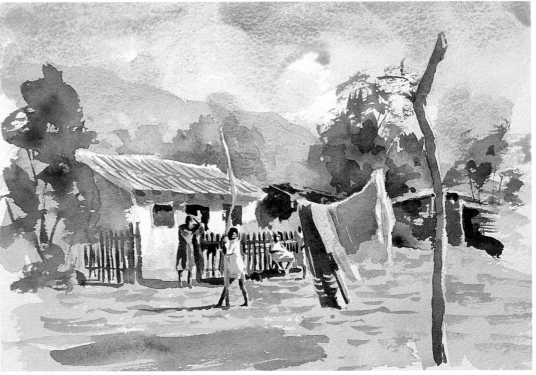

4 Where local colour is needed on the standing woman's clothes, use a dilute glaze of orange. Stronger colour is used on the washing. Erase any pencil lines that obscure the freshness of the white paper.

Rain

Blurred images and puddled reflections may not sound much fun, but watercolour paintings of rain are a pleasure to paint and a delight to behold.

While rain is falling objects become blurred, so you want the soft effect created by wet-in-wet washes, working either with one continual wash, or with successive layers of wet in wet. Rain is a marvellous excuse for running the colours of different objects into one another. Soft reflections in wet paths or roads can be dropped in before the wash is dry.

Painting a rainbow Setting a rainbow in landscape successfully is tricky, but one way to do it is to start by lifting the colour out of the sky wash, making an arc shape with a damp sponge. You can then paint in the colours while the area is still damp, to produce soft gradations. To shine in a painting, the rainbow must be considerably lighter than everything else, so if the sky above is light, use artistic licence and make it darker.

Reserving white paper After rain the landscape glistens, with shiny highlights everywhere. The secret of painting the shimmering light of puddles, wet leaves and so on, is to reserve white paper. These must be the lightest parts of the painting, so any other whites need to be toned down with a pale wash to allow them to shine out. The reflections of objects in puddles are usually still, and are best painted with well-defined transparent washes broken up by white-paper highlights.

Masking with a pen To suggest streaks of rain in the foreground, use masking fluid applied with a pen, which will give really fine strokes. Draw them along a ruler to help you maintain a direction. If they look too obvious when the masking is removed, wash them over with a pale uneven wash.

Rainbow – lifting out

The lifting out technique can be used to soften edges, diffuse and modify colour and also to create highlights. Paint can be lifted out using a dampened sponge, although the success of this method depends on the colour to be lifted and the type of paper you choose. Bockingford, Saunders and Cotman papers are all excellent.

1 Lay an overall wash of purply grey, and lift out the arc of the rainbow with a sponge while still wet.

2 While the arc is still damp from the lifted wash, paint in the colours of the rainbow in bands. Paint red then yellow, encouraging orange to be created by their merging. Likewise, paint cerulean blue next to yellow; green will be created by their merging. Lastly, paint violet next to the blue.

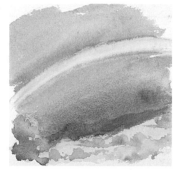

3 Create a sideways light on the land as the sun shines across the landscape onto the dark clouds.

Reserving white paper

Although the puddle on the dry ground is reserved with white paper, because the still water mirrors the sky, it may in fact have to be painted darker in parts than the landscape itself. Contrast dark against light and light against dark at the edges of the puddle.

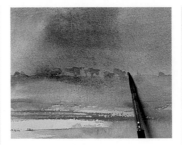

3 Paint the horizon details slightly darker than the rain-cloud. Use the side of the tip of the brush to paint unspecific tree shapes and trunks.

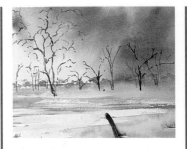

4 Draw the dead trees against the sky with the tip of the brush. Wash into the puddle the mirrored tone of the sky, letting the darker colour run to the bottom.

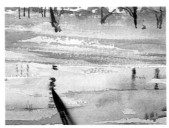

5 As the water wash dries, draw down the tree reflections in soft-edged, straight or slightly wiggly lines.

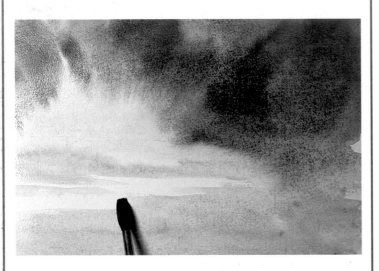

1 Wet the area of the sky and land, reserving white paper for the puddle. Brush in a vigorous variegated wash of ochre, light red, Prussian blue and burnt umber.

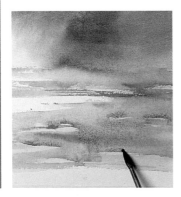

2 Take light red and ochre across the landscape and around the puddle. While wet, drop touches of sap green into the base of wash bands and let them spread upward to form clumps of soft grass.

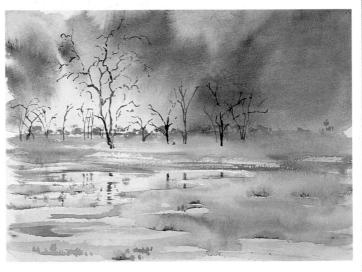

6 Darken up the clumps of grass by wetting the paper and dropping more colour in with the tip of the brush. To make the water look wetter, touch in the reflections of the grasses in the puddle.

Wet in wet

Wet all the paper so the underwashes are soft. Flood your colours into gradually drying paper so that the background trees only spread very slightly compared with the foreground greens. Make greens more grey with a touch of alizarin.

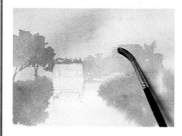

1 Lay a Prussian blue wash, wet in wet, leaving the roadway untouched. Drop differing greens into the Prussian blue wash.

2 Describe the Landrover with dark specific shapes. Draw in the reflection of the vehicle on dry paper, leaving white spaces between the broken strokes.

3 Touch in the luggage and the passengers. Paint the zebras crossing the road in a mid-grey tone with the side of the tip of the brush (i.e. block them in rather than fill them in).

4 Paint the foreground tree trunk, draw in the zebras' stripes with white gouache and darken the manes with grey. No prizes for guessing the title of the painting!

Rivers and Streams

Water in movement makes an enticing watercolour subject, whether a wide, peaceful river flowing gently through meadows or a busy brook cascading down hills or racing round rocks.

Painting water requires planning. It is important not to over-work the paint. Work out the composition so that you know exactly where you want to reserve white paper.

Tone and colour Contrast of tone is essential to suggest the depth and transparency of water. Dark reflections with light ripples of reserved white paper will help to establish the surface. Pay attention to perspective; the narrowing of a river running away from you will create depth in the painting. Use stronger foreground tones and paler tones in the distance.

Look at colour carefully also. Some parts of a river may reflect the blue of a sky, but never assume water is blue; you will see wide colour variations depending on reflections, the play of light, and what lies on the river or stream bed.

Wet in wet Dissolving colour wet in wet is the ideal technique for reflections. Mix up strong solutions of colour for the dark, shaded reflections under the banks, and allow backruns and other chance watercolour effects to add life.

For clumps of grass and gently sloping river banks, dampen the paper above the river's edge and drop colour in at the waterline, letting it spread softly upward.

Wax resist To suggest flow lines in the water, or a surface ruffled by wind, wax resist is a useful technique. Draw the flow of the river with a candle. When you paint over it the watercolour only adheres to the unwaxed areas, looking like sparkling water.

Masking You can create subtle running-water effects by half rubbing off your masking fluid, or scuffing it directionally. Several layers can be built up, with more fluid removed before each wash.

Overhanging reeds and grasses can be masked out to keep them light against a dark wash. The ripple of the waterline can also be reserved in this way.

Wax resist

Use an ordinary candle to lay wax over light washes. Further paint will not adhere to the waxed areas, so you can freely wash darker tones over the top. Exciting broken textures are created by the paint globules drying over the wax.

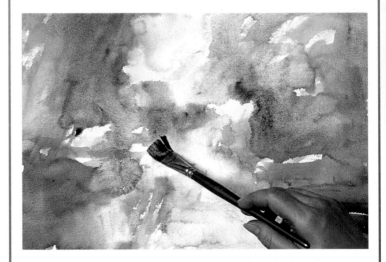

1 Paint a washy background of greens and blues, leaving the passage of the river and the sky lighter than the rest.

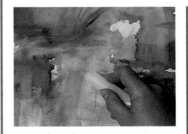

2 Lay wax quite strongly over the centre of the river and the parts of the foliage you wish to keep light.

3 Paint further washes right across the waxed areas and the rest of the painting. When dry, apply more wax on the water to hold the mid-tone.

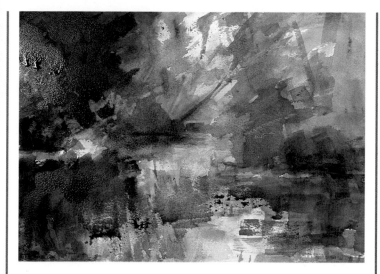

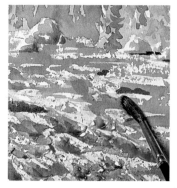

3 Scuff the masking again so that more of the paper is exposed and wash over with a glaze of dilute blue. Paint in the shaded sides of the trees and rocks.

4 Paint strong dark colour over the wax to pull the trees and their reflections together.

Scuffed masking

With a putty rubber, rub and scuff the dry masking in on itself so that it pulls away in rubbery strands but is not removed. Paint over the masking and repeat the process several times to create a "marbling" effect.

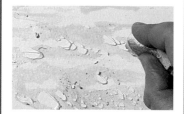

1 Mask over the white water. When the fluid is dry, scuff the masking in the direction of the river's flow.

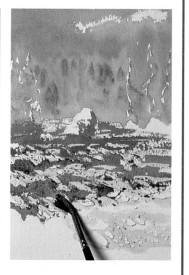

2 Paint Prussian blue over the masking, pushing it well into the hollows of white paper between the strands of scuffed masking. Brush in the distant trees.

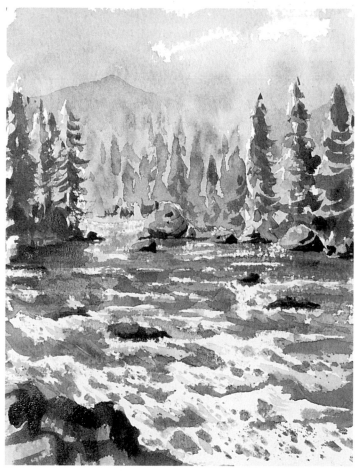

4 Rub off the masking completely when dry and paint pale directional brush-strokes to emphasize the flow of the river. Strengthen the rocks and trees.

Roads

Roads snaking over hills or running straight over flat plains create a focus for the eye, and help to define the forms of the landscape.

When you first sketch the road, do so without looking down at the paper, letting your pencil or brushline follow its flow. The fluidity of that first line will keep the painting alive.

Shadows cast across the road by trees and so on are a great help in defining the flat surface. Lighten the shadows as they recede. A shadowy foreground cast by the leaves of an overhanging tree will enliven a dull foreground and enhance the perspective effect.

An overall underwash that encompasses both the road and the landscape bounding the road will keep the painting unified in colour. Paint the surface of the road horizontally rather than vertically so that you can strengthen the bands of colour as you come forward and vary the surface wash.

Bodycolour If you find that the edge of the road is too monotonous, break it up by painting overhanging grasses with opaque bodycolour (gouache). Darken the shadows underneath to create depth. White bodycolour can also be used to paint in road markings. Any of these devices, or a road sign, can create an interesting focal point.

Lifting out If the road is rolling over hills the crests will be lighter than the hollows. Use a damp brush or sponge to lift out the colour in these areas, and soften any too-sharp delineations between the road and the verge in the same way.

For the impression of a distant road running through the landscape, wet a brush, sponge, or piece of tissue and lift out the colour from the landscape, rubbing firmly in the direction of the road's flow. If you wish to tint it, wait until the paper is thoroughly dry.

Bodycolour

Mixing white paint (either gouache or watercolour) with watercolour pigments increases opacity. Overlaying glazes of these semi-translucent colours gives a solidity to the painting, and a matt effect ideal for this road.

1 Mix a little white gouache in with the colours used to lay the washes. Use the brush side to make horizontal and vertical marks. Scratch off paint on the distant road for a broken highlight.

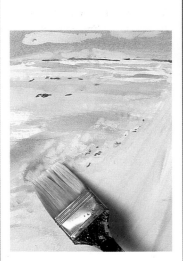

2 Pat small patches of white paint for the scrubby landscape over the darker wash on the left-hand side. Use streaks of white down the length of the road to help create perspective.

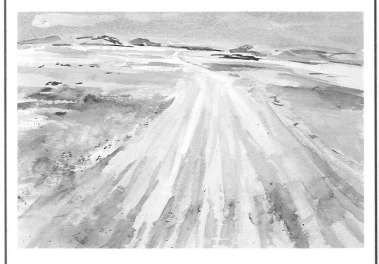

3 A little spattering and smudging creates foreground interest. Pick out the distant hills with a few dark brushstrokes.

Lifting out

Tissues, dry brushes, sponges and blotting paper can be used for lifting out colour from a wash before it dries. A soft-edge light is created in this way. Some colours do, however, stain the paper; others, if you mop them immediately, will lift out completely. A tissue will pick up more colour than a brush.

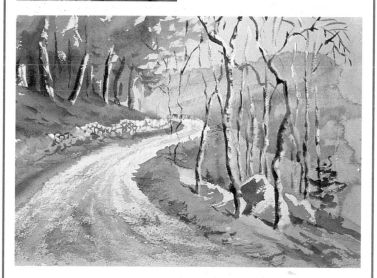

4 Spatter some speckles of colour into the foreground. When dry, flick some colour onto the area and move around with a dry brush. While still damp, lift out the "wheel" marks to emphasize the sweep of the road.

1 Lay an overall wash of yellow ochre. Lift out the distant road with a tissue, and the foreground road with a large dry brush, thus retaining a little more of the colour in the foreground.

2 Block in the main colour washes of the painting, reserving the underwash of ochre for the rocks and tree trunks.

5 Pick out the birch trees with white gouache. Touch in the branches with the tip of the brush.

3 Drag dry paint across the surface of the road, using it to describe the camber. Emphasize the bend in the road with dry, longitudinal brushmarks.

Rocks

The varied shapes, forms and textures of rocks offer a wealth of possibilities. Once you have established the structures you can have fun experimenting with texture.

Brush in the main dark areas with a neutral tone, looking carefully at the shapes they make, as these describe the three-dimensional forms. If the rocks are gently rounded, further washes can be applied wet into wet, but for angular forms you need crisp, hard edges, so wait until each wash is dry and build up the forms in successive planes. Keep it simple initially: select three tones from pale to dark and build the structure of the rocks with these. If the rocks have an overall pinkish tinge this colour could be used for the first wash.

Wet in wet Working wet in wet on individual rocks and boulders will create exciting textures. Once you have achieved an effect you like, wait for the area to dry before adding more colour; if you disturb the surface too much while still damp, your painting will lose its freshness.

Texture methods Crystals of sea salt sprinkled into wet paint make a fascinating patina that imitates lichen-covered rocks (see CLIFFS).

Painting over wax – candle or white wax crayon – creates another texture suitable for weathered rock (see BUILDINGS), and you can make the paint behave in interesting ways by laying other water-repellent substances, such as turpentine or oil on the paper under a wash.

Sponging paint onto the paper is a quick and easy way to liven up the surface and suggest texture, and for more random effects, blobs of colour can be flicked on; this is a useful way to introduce other colours in an irregular way.

Further Information
☞
Cliffs, page 38.
Buildings, page 35.

Variegated wash

Merge colours, wet in wet, to create an under-painting. While the variegated wash is wet, colour can be dropped in. The structure of the rocks is drawn on top and the rocks take on individual colours in a total harmony.

1 Sketch the rocks and lay a washy mixture of viridian, mauve, Indian red, and ultramarine. Drop and flick more colour into the wet wash.

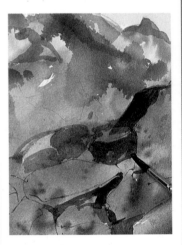

2 With line and small washes of indigo, itemize the individual rocks and the gaps between them.

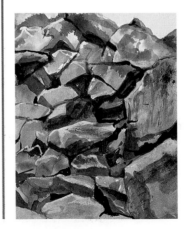

3 Use brushstrokes of white gouache to pick out light ridges and faces on the angular rocks. The rocks tumble together as a whole, but appear to have been painted in different colours.

Wet in wet/ sponging/spatter

Create rotund forms by dropping colour into the shaded sides of wet washes on the rocks. Once the structure is realized, surface textures can be overlaid by applying dry paint with a sponge and spattering paint from a loaded toothbrush.

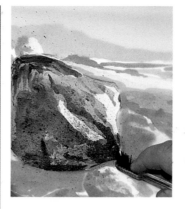

3 | Cut the boulder shape out of tracing paper. Load a toothbrush with dark paint and spatter the paint from it across the rock surface from one corner.

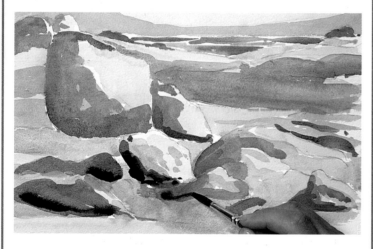

1 | Sketch out the landscape. Lay your washes to build up the tonal structure of the composition. Drop indigo into the wet, shaded sides of rocks, allowing it to spread.

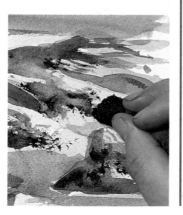

2 | Having established the lights and darks of the rocks, sponge indigo across the edges of light as if the grainy surface were turning away from the light and casting small shadows.

4 | Apply paint with a sponge to the dark foreground rocks and, with wetter paint, pat it onto the middle-distance rocks for a softer effect.

Salt crystals

Painting the rocks wet in wet, but creating the texture by scattering salt crystals into the wet washes, gives a similar subject a totally different look. The crystals soak up the pigment from the wash and leave a gentle patina on the surface.

4 When dry, dust off the salt. Lay a wet wash of darker colour into the shaded areas and scatter more crystals into the wet paint.

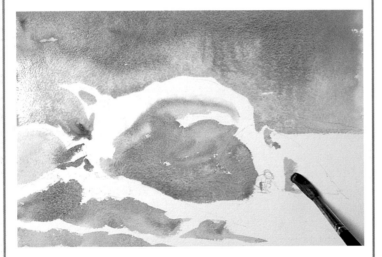

1 Block in the shadows of the rocks with blue, and wash in yellow ochre while wet. Let them merge.

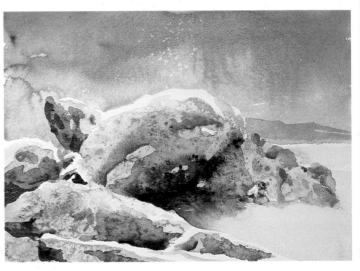

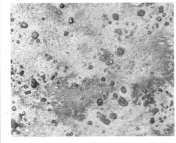

2 Scatter crystals of salt over the rock surface while still very wet.

3 You can actually watch the colour separating away from the crystals as the pigment is absorbed by the salt.

5 Dust the crystals off when they are dry and touch in the little boy playing in the sand to suggest scale.

Seas

The sea – relentlessly pounding on a stony shore or gently lapping on bleached sands – is a highly evocative subject; a good seascape is a painting to treasure.

The movement of water is tricky to paint unless you understand it, so spend some time watching the sea. Divide your sketchbook page into four and sketch or paint the life of a wave as it rises, curls into a crest, breaks upon the shore, and then backwashes towards a new wave to repeat the process. You will begin to see a pattern, and, when you come to plan your picture, you will be able to decide at which state of formation you want to paint a wave. You will be surprised at how much you can paint from memory.

When you paint, use your brushstrokes to imitate the movement of the sea, making long horizontal strokes for distant waves, and short triangular peaked strokes for the closer waves.

Variegated and graduated washes If you paint the sea and the sky using a graduated or variegated wash, dampen your paper only down to the crests of the waves. The wash will stop at the dry paper, leaving a crisp edge. Continue your wash under the froth with darker transparent colour, lighten it across the sand, and break it with bands of white spume. Using a rough paper will leave small flecks of white showing to suggest "white horses" in the distance.

Spattering/scratching To paint the plumes of spray thrown up by the sea as it crashes against rocks, spatter masking fluid from a toothbrush onto the area at the outset. When you rub it off at the end, use a little tone to suggest three dimensionality within the white spray. Alternatively, spatter white paint over your washes; it will also sink into the darker washes slightly, providing varieties of tone.

The spume of broken waves can be created by scratching off dry colour with the side of a blade, and small flecks of foam and lines of spray can be lifted out with the point of a scalpel.

Graduated wash

Mix plenty of colour in the palette and, laying your wash in horizontal strokes, gradually lighten it by adding water to your colour as you go down the page. To darken the whole graduated wash, wait for it to dry before painting gently over it in the same way.

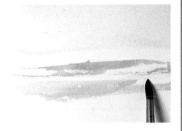

1 Wet the paper and lay a graduated wash of ultramarine and cobalt violet down to the crest of the wave. Drag dry paint in under the breaking waves.

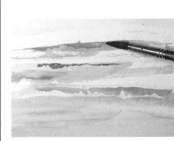

2 Draw darker shadow lines under the crests and wash in the shoreline.

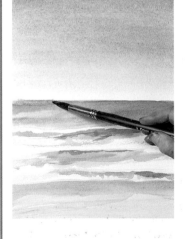

3 Take a wash of darker colour along the horizon and into the distant sea. Strengthen the sky with another graduated wash to balance it with the dark horizon.

Variegated wash

Use a selection of earth colours, merging wet in wet as a variegated wash for the sky and sea: yellow ochre, Indian red, burnt umber, Prussian blue and indigo.

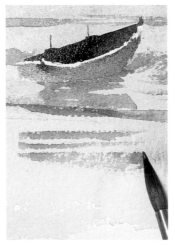

4 Describe the boat with two tones and sketch in the reflection in the sand with dry, horizontal strokes.

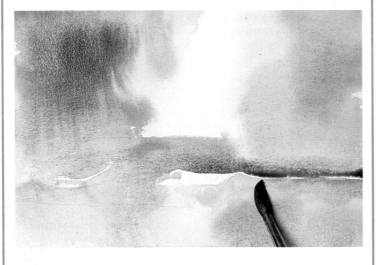

1 Wet the sky down to the crest of the wave and drop in a variety of earth colours to create a brooding sky and a dark sea. Repeat the colours of the sky in the wet shoreline.

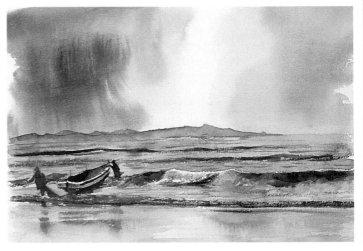

5 Pick out the silhouettes of the men with well-loaded, one-touch brushstrokes of neat indigo. Darken the rising wave with the same colour, and strengthen the shoreline reflection to match the sky.

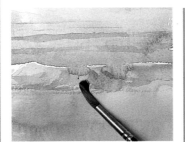

2 Mark out the distant waves with horizontal washes of indigo. Wash ochre and Prussian blue under the arching wave.

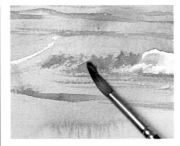

3 Use dry brushstrokes to suggest the curve of the wave as it tumbles over, making them darker as they reach the broken spume at the base of the wave.

Spatter/ scratching off

White foam can be restored or created by spattering thick white paint from the head of a flat brush or a bristle brush. Scratch off the surface of the paper to reveal the pure white paper underneath a painted area so that you can create streaks of windblown surf.

3 Spatter thick white gouache from the head of a loaded brush. Spatter the paint from one point to give a pivotal direction to the spume.

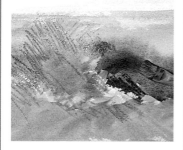

1 Brush the dark underside of a crashing wave into a damp, greenish wash.

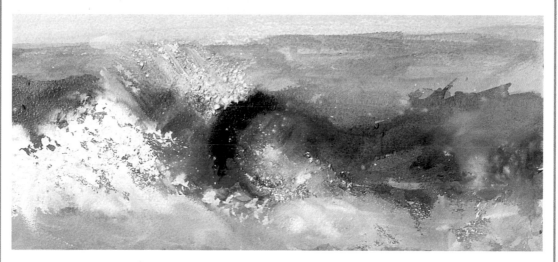

4 Scratch off the painted surface of the paper on the turning crest of the wave in an upward, diagonal direction. Darken under the curl of the wave with neat Payne's grey.

2 Create dynamic movement in the tumbling surf by vigorously scratching with a knife and brushing across the wet paint.

Skies

The sky is the light source for the land, so the two are inseparable. But even on their own, skies make great paintings, with just a touch of foreground to link them to the earth.

Ultramarine, or a mixture of cobalt blue and ultramarine, would be suitable for tropical or Mediterranean landscapes, while cerulean and Prussian blue are cooler blues ideal for the temperate zones. Cobalt blue makes a cheerful blue sky.

Look carefully at cloud colours also; at certain times of day there is a good deal of yellow and brown among the greys and near-whites. Ultramarine and burnt sienna mixed together make a warm grey for the shadowy parts of clouds, but there are no recipes for cloud colours, as they vary widely. Try out different colours, linking sky to landscape.

Washes For a clear blue sky the graduated wash is the perfect technique. Dampen the paper and brush in stronger colour at the top. Use a large brush and tilt the paper to help the paint flow smoothly. Absorb pools of water at the sides and bottom with corners of kitchen towel.

Skies of several colours, especially stormy skies, are effectively painted with a variegated wash (see STORMS). For the effect of sheets of rain or shafts of sun, dampen the whole sky area, paint a band of colour along the top, and tilt the paper to encourage the colour to run downward in soft streaks.

Wet in wet This is a superb technique for painting panoramic skies. A little control is necessary to ensure that the tops of clouds are hard edged on dry paper and the bases softened with wet-in-wet washes (see CLOUDS).

> **Further Information**
> ☞
> Clouds, page 40.
> Storms, page 104.

Graduated wash

Stretch the paper and prepare plenty of colour before you begin. Use a size 12 round brush or a large flat brush to lay the wash in horizontal strips. Gradually dilute the paint as the wash is applied.

1 As you lay the strips of colour, let them merge with each other without over-painting the previous strip, and dilute the colour as you go.

2 With a size 7 brush, paint the landscape washes over the dried sky wash. The red-orange landscape contrasts well with the Antwerp blue of the sky.

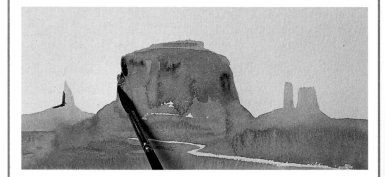

3 Lay another wash of darker colour for the central massif and mark in the shadows.

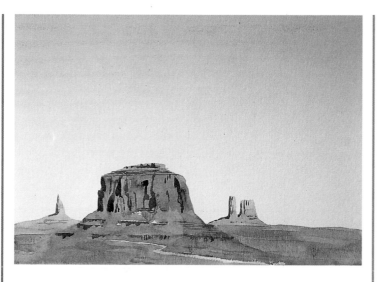

2 Paint the sky in big, sweeping curves on dampened paper, tilting the board so the colour runs in a diagonal direction.

3 When dry, wet the clouds again and paint another streaky wash, now tilting the paper downwards so that the colour settles in the base of the clouds.

4 Pick out the shadows in the landscape features so they stand out well against the light horizon.

Tilting/lifting out (cloud and sun effects)

Tilt the board as you lay the cloud washes to create a flowing movement to the clouds. Lift out the sunbeams with a dry brush while the paint is wet. Lift out the sky above the hills with the rubbing movement of a damp brush.

1 Turn a graduated wash upside-down so the darker colour is at the bottom. Mask the shoreline and wash in the hills. Lift out the sunbeams while wet with a dry brush.

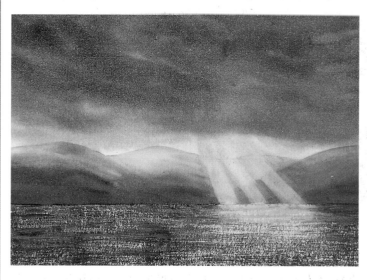

4 Lift out the colour behind the darkened hills with a damp brush, and dry-brush the colour onto the sparkling sea.

Snow

Snow transforms a familiar landscape, with white carpets and branches of trees outlined in white to create a magical filigree effect.

The best way to paint snow – or rather not to paint it – is to leave it as white paper, using the shapes of the shadows or undulations to describe the forms of the landscape. Reserve the white paper generously; it can always be painted over later but it cannot easily be restored. Be inventive with shadows: blues that granulate, such as ultramarine and cerulean, make interesting textures, while cobalt blue is a clean fresh colour ideal for the luminous shadows caused by reflection from a blue sky.

Wet in wet A thick covering of snow softens the forms, so to paint the soft rounded shapes, work your shadows wet in wet. Dampen the area well beyond the reach of the shadow so that no hard edge develops from the spreading wash. Use small touches of wet in wet shading around features half buried in the snow to suggest the thickness of the blanket around them. Drifts of snow can be shown by hollows on the leeward side.

Masking/spattering For lines of snow resting on fences and branches, use masking fluid, and, when you remove it, suggest the thickness of the snow by a narrow band of wet in wet shadow washed along the bottom edge. Falling snow reserved with masking fluid looks a little too obvious, so instead, spatter white paint in a controlled manner from the top of the sky downward. To render a wild blizzard, direct the spatter diagonally or horizontally across the page.

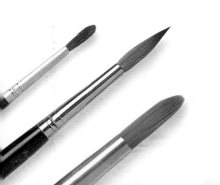

Reserving white paper/wet in wet

A lightly brushed sketch with pale grey will enable you to lay the washes boldly and still reserve plenty of white paper for the snow. Soften the landscape by blobbing the colour into wet washes.

1 | Lay a warm sky wash around the tree shapes and above the ground. Start to build up the foliage with wet, greeny-grey, blobby washes.

2 | Paint the shadows on the snow with cobalt blue. Encourage the colour to settle in the base of the wash by tilting the board.

3 | Wash in patches of warm mauve/grey for the winter trees. When dry, pick out the tree branches with the tip of the brush in lively strokes. Add a few intriguing footprints!

Masking and spatter

Use masking fluid to reserve white paper for the snow on the branches. Dip a toothbrush in white gouache mixed to a creamy consistency, hold it face down 1–2.5cm (½–1in) above the painting and release speckles of paint by drawing your finger swiftly back across the bristles.

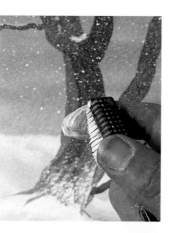

3 Darken up the tree, using dry brushwork at the base. Spatter thick white gouache over the top half of the painting with the toothbrush.

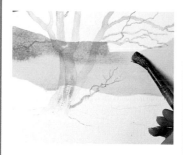

1 Sketch the tree form in light grey. Mask the snow-laden branches. Lay a streaky wash of ochre and light red over the sky and let it dry.

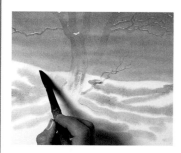

2 Dampen the sky and wash a mix of light red and cobalt blue over in streaks. Dampen the snow and use the same wash to draw in undulating shadows.

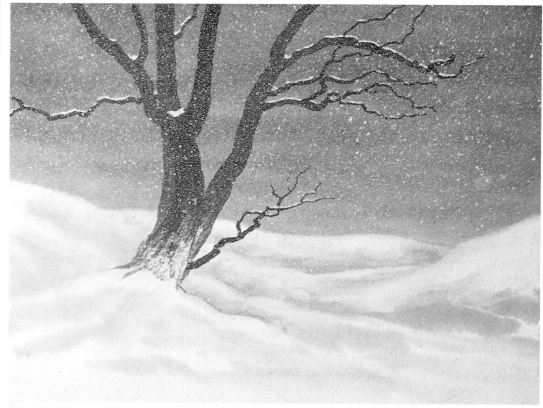

4 Rub off the masking fluid to reveal snow-laden branches. One wonderful wintry painting!

Storms

The tumultuous sky at the height of a storm; rain-drenched trees swaying under the force of the wind – these are exciting to watch and paint.

Storms are energetic, so try to suggest movement with agitated brushstrokes, or work wet in wet to convey the dynamism of clouds moving across the darkened sky.

Variegated wash Stormy skies shift and change with the speed of the wind, so a variegated wash is ideal, as the colours themselves move as you lay them. You need to work carefully to prevent a blurred muddle. Choose colours which will provide lights and darks and retain light passages between the dark clouds to create depth. A useful palette might be diluted raw sienna for the lights and mixtures of burnt umber, Indian red, Prussian blue and indigo for the darks.

If the dark parts are drying too light, drop more pigment in while the wash is still wet. Blooms and backruns that develop may enhance the effect, but if they don't look right leave the wash to dry and lift out unwanted edges with a damp brush.

Lifting/scratching out To lighten clouds or suggest sunbeams, use a tissue or dry brush to lift out colour while the wash is drying. You will probably need to do this several times, as the wet colour will seep back into the shaft of light (see SKIES).

Trees and foliage may be dark in the foreground and softly lit in the middle distance. This effect can also be created by lifting out with a tissue or sponge. Lightning streaks can be scratched out with a fine blade.

Further Information
☞
Skies, page 100.

Variegated wash

This variegated wash is laid on dry paper to maintain control of the light areas between the storm-clouds until softening them at the end with opaque white. Strong dark colours are dropped into wet washes and allowed to spread.

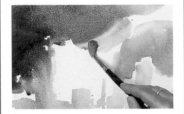

1 Mark in the outline of the buildings with blue-grey. Boldly wash in the clouds with a size 10 round sable brush, leaving white lights in between.

2 Paint a yellow wash into some of the light areas and drop darker colour into the cloud bases, wet in wet. Strengthen the urban landscape below.

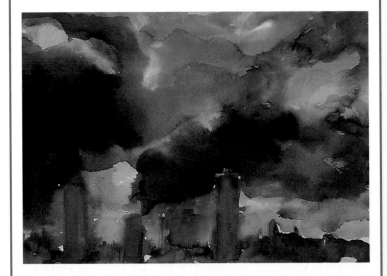

3 Use white bodycolour to create semi-translucent light areas between the clouds. Dab and blot freely throughout the painting, if required.

Scratching out

Use the side of a single-edged razor-blade to scratch out the flashes of lightning from a dark stormy sky. The darker the background, the brighter the revealed paper will appear. Use a heavy paper.

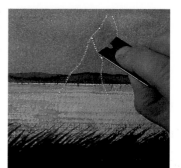

3 Brush in the foreground grasses. Make sure the paper is completely dry before scratching out the streaks of lightning with the edge of the razor-blade.

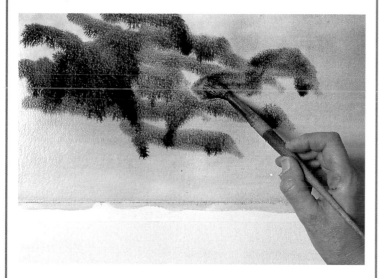

1 Lay a wash of Antwerp blue. Mask the shoreline with tape. Wet the sky area and flood in big sweeps of Payne's grey. Let it dry, and strengthen it in the same way.

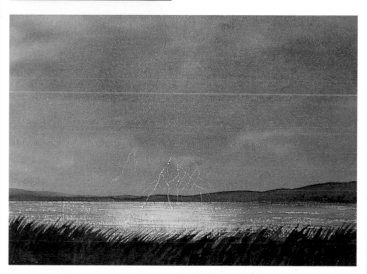

4 Be firm with the blade in order to reveal good, clear, white lines against the dark stormy sky.

2 Paint the dark hills and create the sparkling water by dragging dry paint across in horizontal streaks.

Sunlight and Shadows

There is probably no subject quite as appealing as sunlight and shadow, and it is most pleasant to paint outside on a warm sunny day under the shade of a tree.

Look carefully at the colours of shadows. They are rarely grey or black; they veer towards blue or mauve, crimson or green, as they are coloured by both the surfaces on which they fall and by reflection from adjacent objects. Analyse their shapes; like clothes draping a person's body, shadows can be used to describe the forms over which they lie.

Reserving and masking To build up a convincing balance of light and shade, establish the shaded areas of your composition at the outset. This enables you to retain the light and shade pattern that first attracted you to the scene – the shadows will move as the day wears on. Sunlit areas can initially be reserved as white paper, which can be tinted later with a pale transparent wash if the white looks too glaring when the other colours are in place.

Masking fluid can be used to reserve the "negative shapes" between multiple shadows cast by the leaves of trees – the small patches of sunlight. Be specific with your shapes; also mask out highlighted details that stand in front of darker areas so that you can lay the dark washes with confidence.

Glazing An alternative to marking in the shadows at the start is to lay them on with transparent washes over the colours of the landscape. The colours beneath will shine through the transparent wash, creating exciting passages of watercolour. If there is reflected colour, use a wet-in-wet wash. While the shadow wash is moist, drop a little colour into the side next to the colour of the object causing the reflection and let it spread.

Reserving white paper

The bright white paper left unpainted in the sunny landscape creates a strong contrast of light and shade. A light warm glaze of yellow is laid in patches to add to the glow.

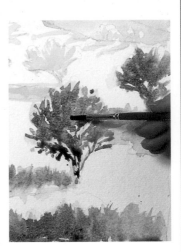

1 Draw out the dark tree shapes and shadows with an underwash of ochre and cadmium yellow to establish their positions. Paint very wet alizarin and ultramarine over the trees and shadows; then drop cerulean blue into the wet paint.

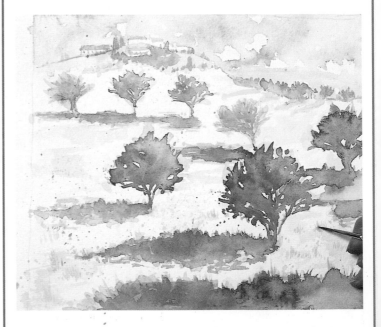

2 Drop spots of clean water onto the foliage masses to soften them. To make the white paper glow, touch in small washes and brushstrokes of cadmium yellow.

Glazes

Thin glazes of greens, yellows and pinks are built up in dabs so that the colours overlap and shine through from underneath. The shaded areas are washed over with a glaze of ultramarine blue. A fresh, lively effect of dancing colour is created.

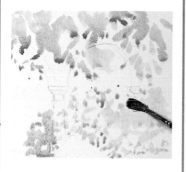

1 Build up the foliage with small, dabbed brushmarks in thin clear washes of colour.

2 Lay colours over colours in transparent blobs. Wash in the foreground. As you paint the sky, take the blue into the shadows of the columns.

4 Wash a thin transparent glaze of ultramarine blue over the areas darkened by shadow, painting around the shapes of highlit leaves and flowers.

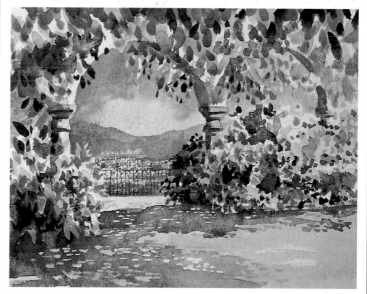

5 Brush in the foreground shadow, and strengthen the deeper shadows with Prussian blue.

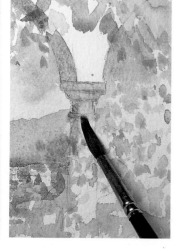

3 Paint a glaze of yellow ochre over the blue, shaded side of the columns. Build up the foliage with more dabs of colour, one across another.

Masking shadows

Use masking fluid applied with a brush to create light and shadow quickly.

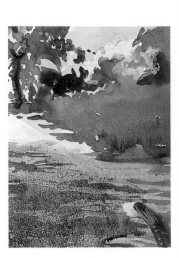

1 Lay the masking fluid liberally to reserve the dappled light between the shadows. Mask out areas of foliage you wish to reserve.

2 Paint the background foliage with sap green, Payne's grey and burnt sienna, and lay a dark wash over the masked area. Let it dry completely.

4 Wash in the flower colours. Soften the hard edges of the masking in the sunlit areas of the foreground by wetting it with a pale lilac wash, which is dabbed off while still wet.

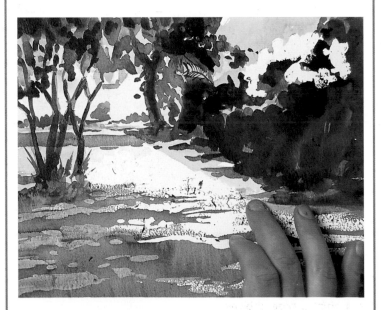

3 Rub off the masking fluid with the finger to reveal the white paper underneath.

Masking and tonal contrast

To protect your brush, coat the hairs with vaseline before dipping it in the masking fluid. Masking out ripples ensures movement in the water is retained under subsequent washes.

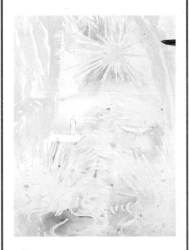

1 Paint the masking fluid over the sun and its reflection and the ripples in the water. Flick some masking onto the paper for splashes of water. Lay a pale background wash.

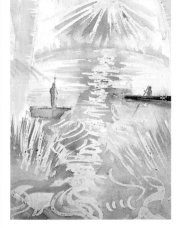

2 Strengthen the colour scheme with strong contrasting colour washes. Paint in the boys in the boats and their soft reflections.

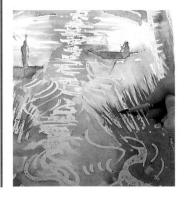

3 Pick out palm fronds and grasses with strong greens, building up the trees to frame the sunlit area.

4 Darken the foliage with successive layers of descriptive brushstrokes. When thoroughly dry, remove the masking fluid with the finger.

5 Paint a glaze of blueygreen over the hardedged shapes in the dark shallows, left by the masking.

Sunsets

The glorious descent of the sun is a subject that cannot fail to appeal, but it is a difficult time for the artist, as it all happens so fast.

The sunset doesn't end when the sun has gone down. The clouds turn redder and the whole sky glows. Rather than trying to capture the very moment when the sun is sinking, spend that time watching the sunset. Make a pencil sketch of the composition of the sky, with colour notes about the lightest and darkest clouds, and the colour they appear in front of the sun, then do the actual painting after the sun has gone. The arrangement of the clouds will remain similar.

Reserving paper If you are including the sun, remember that it will be lighter than any other part of the painting, and reserve it from the colour wash at the start. Either leave a circle of white paper undampened when you lay your wash, or mask out the sphere with masking fluid. The edges can be softened later with a damp brush if necessary, and can be interrupted with foreground silhouettes and clouds across the sun. These are often tinged by the bright orange light, and this colour change in an otherwise dark landscape adds an exciting touch.

Wax resist Reserving the sun with candle wax gives a delightfully soft, slightly blotchy effect rather like the patterns seen by the naked eye if you have looked a little too long at the sun. But remember that you cannot paint over the wax later with any clouds or foreground features.

Variegated wash A variegated horizontal wash is the classic technique for a sky changing from red, through yellow to blue. Prepare all the colour solutions separately in your palette before you begin.

Soft, fluffy clouds should be dropped in when the wash is nearly dry to preserve their shape. Test at the edge of the paper so as not to ruin the centre of the painting by dropping colour in when the wash is still too wet. Light clouds can be lifted out with a tissue while the washes are wet.

Lifting out

Soaking up colour with a tissue, or loosening dry washes with a damp bristle brush and then dabbing them with a tissue, enables you to lift light clouds out of a darker wash without having to plan them beforehand.

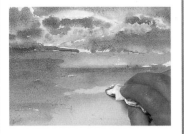

1 Loosely paint the cloud forms. Drop in darker colour, wet in wet. Lift out cloud layers with a tissue before the wash dries.

2 Loosen the edges of dried washes with a damp bristle brush before lifting out the colour of background clouds with a tissue.

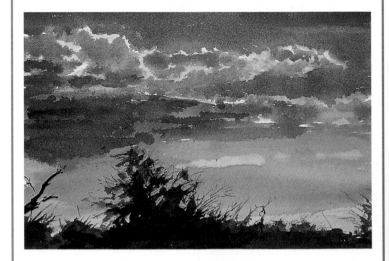

3 Touch in the landscape with indigo, but use Indian red for the branches that glow orange against the molten sky.

Graduated wash

Mix up plenty of burnt sienna in the palette, and lay the wash on dampened paper. Grade the wash so that it is darker in the middle around the horizon, i.e. light, darker, lighter.

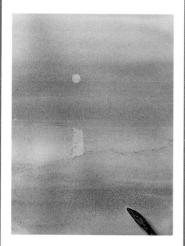

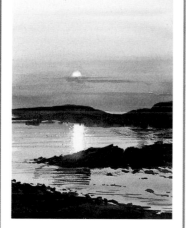

1 Mask out the sun and the reflection. Lay the graduated wash and, while damp, wash in some ultramarine blue to cool the colour of the sea. Next, darken the horizon area, while wet, with more burnt sienna.

2 Touch a little burnt sienna into the dark rocks. Paint the ripples with horizontal dry brushstrokes and, after rubbing off the masking, tint the edges of the reflection and the sun with yellow.

Variegated wash

Work down the paper with single applications of colour and no reworking. Drop in narrow lines of cloud while wet, and lay rocks and foreground when dry. Note that the sea will reflect the colour of the sky.

1 Dampen the paper and lay alternate bands of Indian red and Indian yellow, introducing violet. While wet, draw thin horizontal clouds with the tip of the brush.

2 Create the cloud-bank on the horizon with a band of raw sienna and indigo, painted while the wash above is still wet. Only paint the sea wash when this is dry. Touch in the rocks with a rigger.

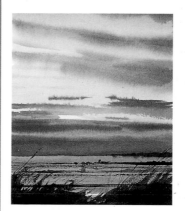

3 Paint the wavelines with a lighter tone than the rocks, and brush in the grasses with dry brushstrokes.

Trees

To paint trees successfully you need to look at the whole shape first. You will be surprised how little detail is then needed.

Seek out the large shapes and masses that characterize the tree or group of trees. Loosely wash in the silhouette, leaving gaps for the sky to peep through, especially near the outer edges and between the trunk and large branches.

You can give a realistic impression of trees using only three tones, so half close your eyes to find the main areas of light and dark. Use small brushmarks for the suggestion of leaves. To imply the casual elegance of palm trees paint the fronds by shape rather than individual leaves. Again, three tones should be enough.

Pen and ink To paint branches and twigs, you can use a special brush called a rigger; pen and ink is also an effective method and gives a crisp touch to the painting. Try to catch the angles of growth, or the main foliage masses. As branches criss-cross play dark against light to create depth. Take care not to restrict line work to only one area of the picture or it may look disjointed.

Sponging/dry brush Dry paint dabbed onto the foliage masses with a natural sponge is a quick way of suggesting the texture of foliage, and a sponge-applied wet wash will lend life to heavy summer foliage, creating an irregular leafy edge.

The bare tracery of winter trees can be rendered with a dry brush or by the splayed hairs of a wet brush. Look at the networks of branches as a whole and use directional strokes of the brush to indicate growth patterns. Link trunks and branches together with the same colour; greys and mauves are convincing colours for winter trees. Dry brush can also be used for the feathered fronds of tropical trees.

Pen and ink

Use a dip pen and waterproof Indian ink. The definition achieved with the pen is used to draw the composition with gestural lines in order to describe the tree shapes and foliage masses. Thin glazes of colour are used to build up the colour in the painting.

1 Sketch out the painting with the dip pen, lightly at first, and then go over it with a thicker nib. Flick some ink on the foreground bushes.

2 Paint a series of different washes over the dried ink and let them blend, slightly wet in wet. The colours will overlap the drawing and are not confined by it.

3 Wash a glaze of viridian onto the dark side of the trees, again ignoring the edges.

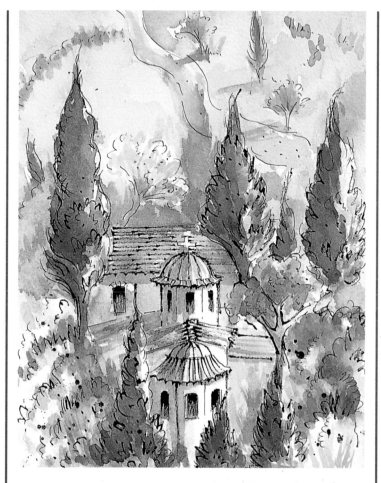

4 Take down the greenness of the trees with a loose wash of rose and Winsor blue, touching it across some of the white areas as you go.

Sponging

Mix up a pool of colour in the palette and dip a slightly damp natural sponge into the paint. Dab it gently over the tree, repeating the process when the previous layer has dried.

1 Lay a wash of cadmium yellow, pale and cerulean blue over the painting.

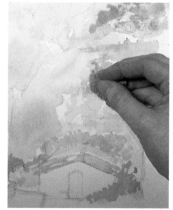

2 Apply a mixture of viridian and yellow with a damp sponge to build up the general shape of the foliage.

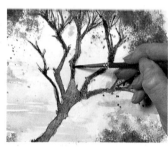

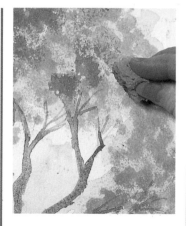

3 Add cerulean to yellow-green and pat over the dark and mid-tone areas of the trees. Sketch in branches.

4 Sponge an even darker tone into the dark shadows and draw down the branches while still wet. Darken the trunk with colours that key into the foliage.

5 Lastly, sponge some yellow ochre on top of the dark foliage to add patches of opacity.

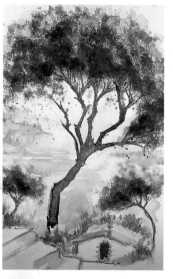

Dry brush

Applying dry paint to the surface of watercolour paper creates a broken texture as the tooth of the paper picks up the colour but the troughs are left untouched. The paint is mixed with just enough water to enable it to leave the brush.

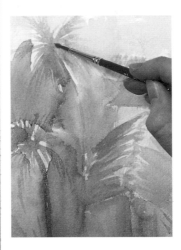

1 | Lay a variegated wash of rose, yellow and cerulean for the background. Sketch in the shapes of the trees with fairly wet paint.

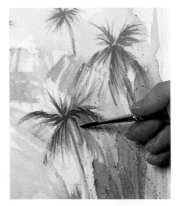

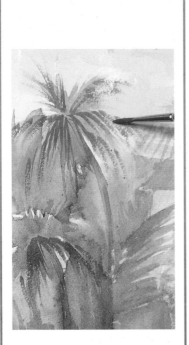

2 | Paint the palm fronds with dry brushstrokes, drawing them outward so that the leaves taper.

3 | Apply cadmium yellow to the leaves with more dry brushstrokes and then darken them up with slightly wetter, well-defined lines.

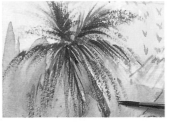

4 | Lengthen the fronds with long dry brushstrokes, running the dry colour down the trunks and into the foreground grasses.

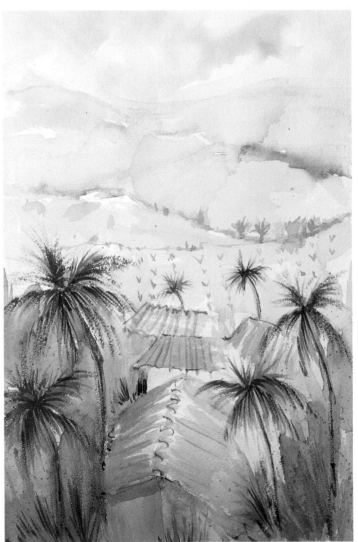

5 | The finished picture is alive with colour. Movement is suggested by the impression of blurring, created by the dry brushmarks.

Waterfalls

The sound of rushing water, the power, the speed, the spray . . . the subject is daunting, whether majestic Niagaras or small, clear brooks tumbling down into swirling pools.

For the artist the subject is enthralling. The secret of painting moving water is to look for the patterns. Do a couple of line sketches of the flow of the water, keeping your eye on the direction the water is taking around and over rocks. Do not look down at your sketch as you draw or you will lose your way. Watch how the water weaves in and under itself, sometimes almost plaiting itself. Leonardo da Vinci told his students to make studies of the flow of hair to understand the movement of water.

Reserving/masking For a large volume of white water, reserve white paper, and indicate the movement with light directional brushstrokes. If the body of water is small, use masking fluid for the strands of running water, the waterlines alongside rocks and so on. When the fluid is dry pull some of it off by scuffing it with a putty rubber to break its solidity. Laying washes over this creates delightful running-water effects.

Wax resist The joy of painting tumbling water is that you don't have to be very accurate. Painting over wax resist will create random splotches of colour that look like the surface of frothy, broken water. Drawing the flow of the water with the candle will enhance the direction. Alternatives to candles are white wax crayons or oil pastels.

Spattering/flicking Where spray careers up against a background of dark rocks, spatter or flick some masking fluid in the direction of the spray before you paint, or spatter opaque white as a final stage (see SEAS). Where the background to the spray is itself white water, gently spatter colours you have used for the water over the area.

Further Information
☞
Seas, page 97.

Masking

To avoid hard-edged waterlines created by masking fluid, scuff the dried fluid in the direction of the flow of the fall. Colour is then pushed in-between the loops and strands created, and repetition of the process creates a mottled effect.

1 Mask over all running water areas. When dry, scuff the masking with a rubber in a downward direction. Wash ochre all over and begin to push colour into the scuffed areas.

3 Push darker colour into the scuffed masked areas and build up the landscape around in overlaying washes. Darken the rocks.

2 When dry, scuff off more masking to reveal some of the white paper and the blobs of colour from the previous wash.

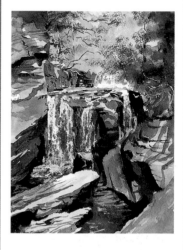

4 When dry, rub off all the masking and lay a pale blue glaze over the vertical shaded areas of the waterfall.

Wax resist

Applying wax to the paper prevents colour from settling. Because the wax sticks unevenly to the tooth of the paper, painting over a waxed area will leave a broken patina. Draw the wax in the direction of the fall. Remember that once you have laid the wax on an area it will no longer take colour.

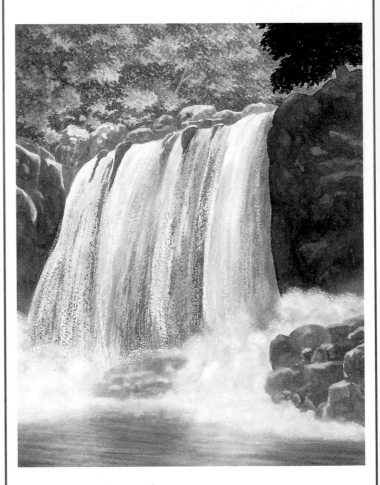

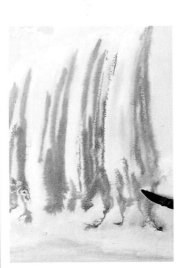

1 Wet the waterfall area and gently stroke down the flow lines of water with Payne's grey and a size 12 sable brush. When dry, apply candle wax in downward strokes.

2 Wet the paper again and lay more strokes of Payne's grey. When dry, apply candle wax more vigorously. This way the tonal structure of the falls has been established before the wax prevents further paint adhering.

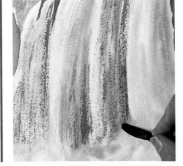

3 Paint sepia and light red over the waxing until the contrast is sufficient to show the rushing water. Paint the rocks at the base on slightly damp paper to suggest mist.

4 Scratch out speckles of white paper with a scalpel to "fuzz" the edges of the spray against the dark rocks. Paint the trees and strengthen the rocks.

Spatter/ dry brush/flicking

A combination of dry brush, wet in wet, spatter and flicking creates a lively painting of white water. Plan the composition before you begin.

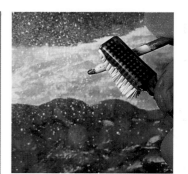

4 Hold a loaded toothbrush face down across the dark rocks, and draw the handle of a brush back across the bristles to release a spattering of white paint.

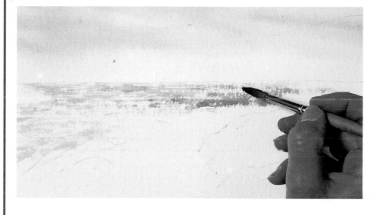

1 Brush Antwerp blue into a wetted sky. Paint the area of broken water with a dry brush and horizontal brushstrokes.

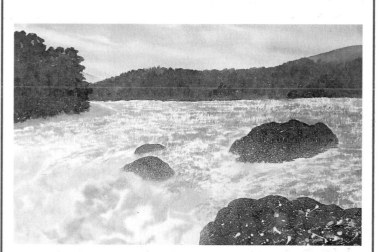

5 Flick white paint across the front rocks to create larger splashes of water in the foreground.

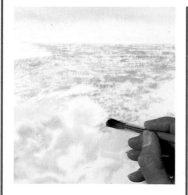

2 Wet the foreground foam and float pale Payne's grey into it, wet in wet. Dry brush to the edge of the foam.

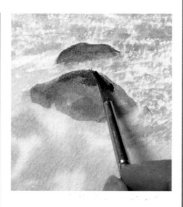

3 Paint the background and rocks with strong contrasting darks, overlaying different tones with a small brush to vary the texture.

Winter

Painting is not just a summer occupation. Bare winter trees, soft light, mists rising from rivers at dawn, and frosts outlining twigs and leaves all make wonderful subjects.

Cool colours capture the essence of a winter landscape. However clear the skies, they are paler and colder in colour than summer skies. The hard ground has lost its warmth, and ochre replaces lush greens. Cerulean blue, Payne's grey, Prussian blue, yellow ochre, viridian, alizarin crimson, burnt sienna and burnt umber are useful colours for your winter palette. Frost and snow are all better off left as the white of the paper, with surrounding colours used to delineate them (see SNOW).

Wet in wet To paint mists rising from the ground, dampen the paper above the ground and let your top wash seep into it gently. The soft band of white paper left in between looks just like a winter mist (see MISTS).

A delightful textured effect for a loose wintry sky can be created by painting outside in below-zero temperatures. The thin wash of watercolour actually freezes on the paper, and when it thaws, lovely ice patterns form in the wash. A hot flask of tea will help you try out this somewhat unpredictable method.

Dry brush Bare winter trees can be painted with a dry brush, giving the tops of trees a scrubby look. To suggest the barren, ground of winter, dry brush over ground washes is effective, and you can use opaque paint to lay a covering of frost.

Scratching/sponging An alternative method for a frosty surface is to scratch paint off with the side of a blade. This creates a rough texture which enhances the impression. Thin white branches and small highlights can also be lifted out with the point of a scalpel.

The straggling foliage clinging to a few branches in winter can be rendered by the irregular texture of dry paint applied with a sponge (see TREES).

> **Further Information**
> ☞
> Mists, page 72.
> Snow, page 102.
> Trees, page 112.

Scratching off

You will need to use a heavy paper not less than 300gsm (140lb) to be able to scratch boldly into the painting. Use the side of a single-edged razor-blade to pull out the colour and reveal the white paper underneath. The darker the background the more effective the scratched marks will be.

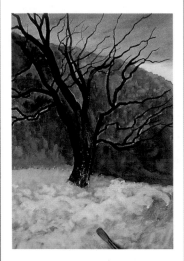

1 Paint the silhouette of the tree against a dark background hill. Lay opaque white in curved swirls over the greenish grass in the foreground.

2 When the paint is dry, scratch out the contours of the trunk with bold strokes and use upward and downward strokes to scratch out the colour from the brown hill.

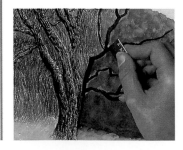

3 Continue to scratch out the colour, but leave the left-hand side of the trunk and the undersides of the branches as black paint to create three-dimensionality in the tree.

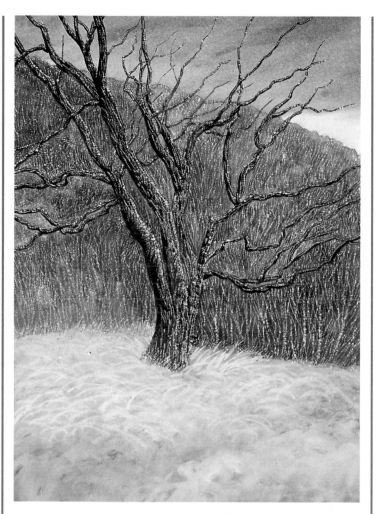

Sponging

Dip a natural sponge in raw umber mixed with Payne's grey. Press it and drag it to suggest the sparse treetop foliage of winter trees.

1 Wash in the sky, reserving white paper for the buildings. Use a touch of lilac near the horizon. Block in the landscape.

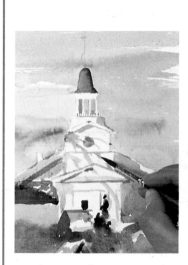

2 Drop in darker colour for the landscape foliage while the wash is wet. Draw in the details of the church and the shadows of branches across the fascia and rooftops.

4 Use longer strokes of the blade above the grass to suggest the frosty stems of bushes. Paint white body colour in swirling strokes over the grass.

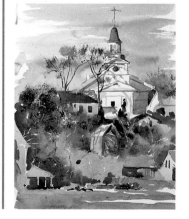

3 Paint the tree trunks against the skyline and in the village. Dip the sponge into the palette and dab the colour onto the trees with a patting, dragging and slight twisting movement. Softly sponge the trees behind the church and, with drier darker colour, apply sponging to the dark area to the left.

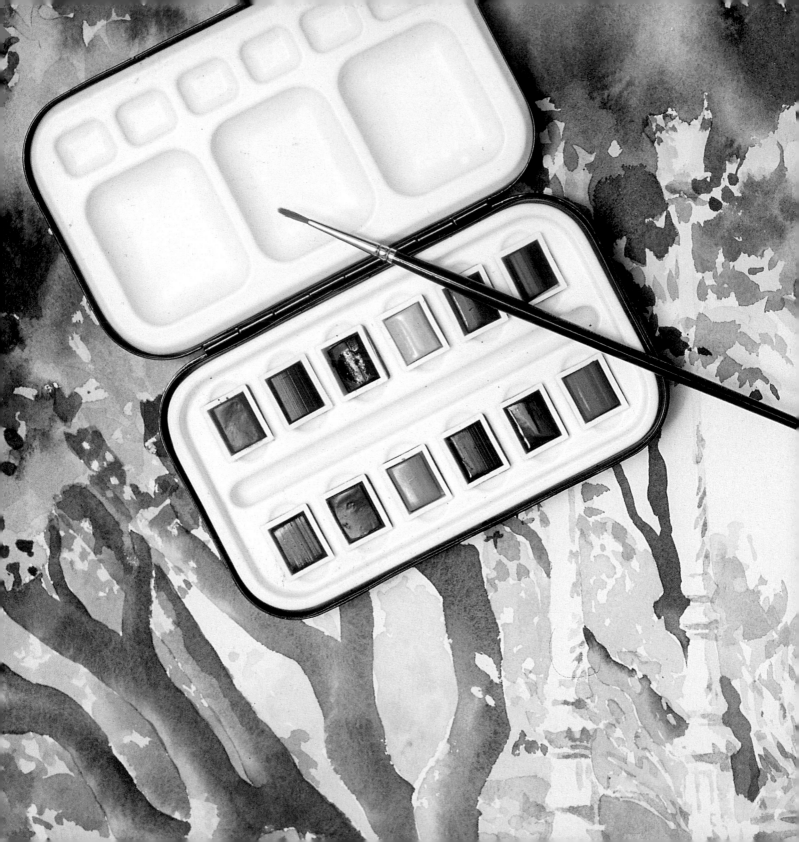

Themes

The following pages show a gallery of paintings, in which you can see many different pictorial approaches to landscape, as well as a wide variety of subject matter. The paintings are grouped under separate themes, the first dealing with landscape influenced by man. In the later Wilderness section you will see how some artists have interpreted the unfettered landscape of the wild through more unusual compositions and techniques. The second section explores waterscapes – rivers, lakes and streams – while the major subject of seascape, which includes rocky coastlines and beaches, is given a section of its own.

Landscape

The landscape, enhanced, tamed or marred by human influence, is probably the most accessible outdoor theme for the artist. Different choices of colour and technique are explored through seasonal variations.

The success of a painting cannot be measured, nor accounted for, by the study of technique alone. There is a mystery in each painting that is hard to pin down or describe. Atmosphere and mood may be created by the choice of colour, tone and composition, and are strengthened by the techniques employed to apply the watercolour. Most paintings call on more than one technique to create a successful image, but what really makes a painting work is something to do with the artist's personality, the spirit in which it is painted, and the mystery of being able to transfer three dimensions into two dimensions and yet suggest three-dimensionality. In the following paintings, attention is drawn principally to one main technique in the painting, while others are described in the text; but these descriptions do not adequately explain the reason why the painting works.

The beauty of watercolour is that more can often be said by suggestion than by actual detailed description. The paintings in this section employ a number of techniques to emphasize seasonal colour and change, tonal contrast, and wetness. In general, the artists have distilled their subject matter to avoid unnecessary distractions and often contrast very loose painting with crisp-edged features to hold the composition together. As you study the paintings, cover different areas of the picture with your hand and try to decide if one particular area is more essential than another; that is, would the painting work without this section?

Different papers and brushes also help to create original effects, but more often it is the actual gesture of the brush-stroke that contributes to the personality of the painting. Notice how freely, almost carelessly, paint is sometimes applied, and how effective this abandon can be.

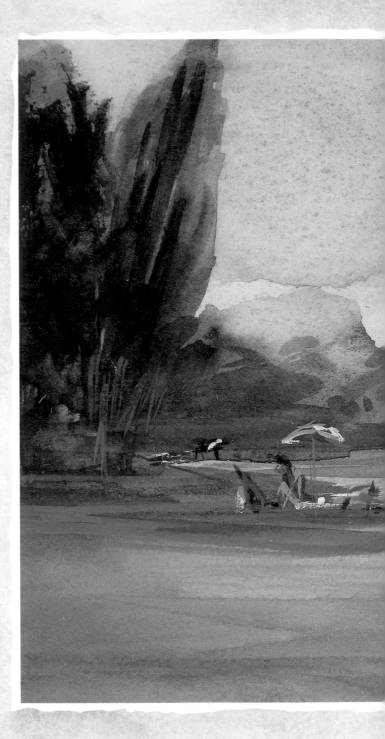

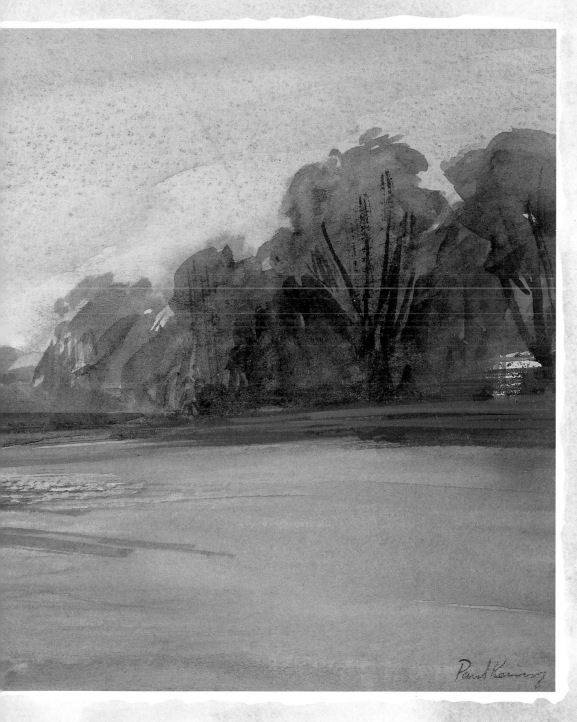

PICNIC AT HENLEY
Paul Kenny

The carefree, heady days of summer are epitomized in this lazy summer scene. The picnickers are suggested by brushstrokes of bodycolour painted over a broadly brushed background. The sky wash of cerulean or manganese blue has granulated and settled into the tooth of the paper, creating an interesting texture to the sky.

The vitality of the painting rests in the dynamic horizontal brushstrokes of thin bodycolour drawn across the painting with a flat brush. The painting is small and has been painted quickly; rather than having to decide where to reserve white highlights, the artist has restored them with white gouache.

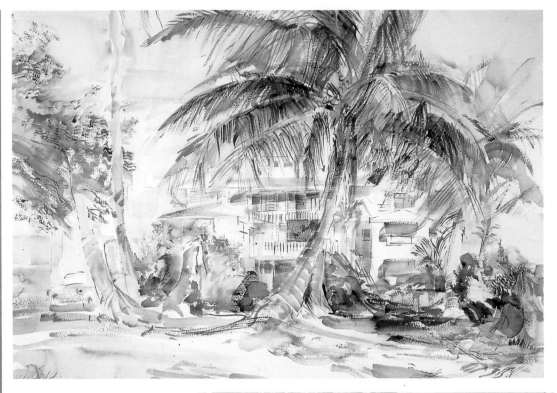

ENVIRONS OF PAMAJERA NO 105
Alex McKibbin
This lively tropical painting is built up with swift, clean glazes of colour. The suggestions of detail are drawn in with small, gestural linear brushstrokes on the fronds of the palm trees and on the balcony rails. Dry brushworK is used over the white paper and the glazes, allowing the undercolour to shine through. Note how the segments of the trunks of the palm trees are shaped with rounded strokes from a flat brush.

PATH TO THE SEA
Charles Penny
Small dabbed brushmarks combine to create this lively, cheerful corner of the Mediterranean. Three-dimensionality is achieved in this mosaic of colour by pushing dark tones in under the light colours of the foliage. The composition appears free and spontaneous, but the opposing diagonals of the flower bank and tree trunks create a V-shaped window through which the distant houses are viewed, making a very strong composition.

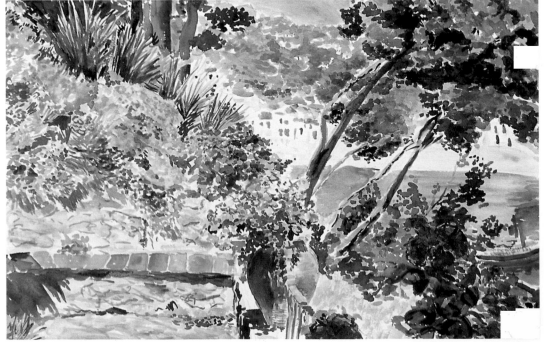

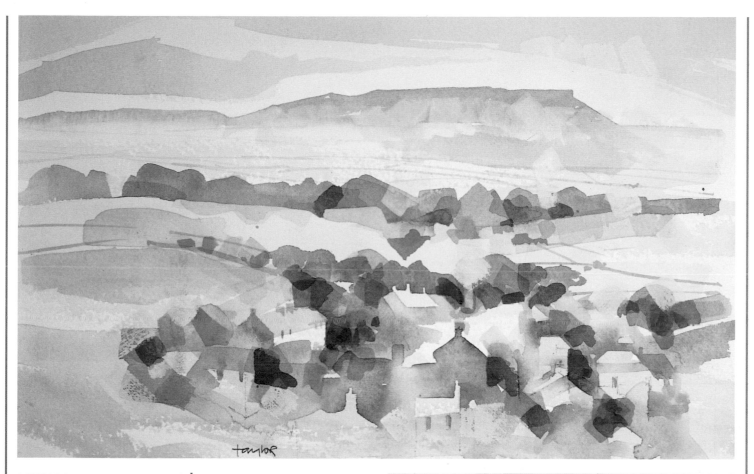

ASKRIGG
Bill Taylor

Patches of colour are laid with a flat brush to create this painting of a village nestling in the hills. A pleasing combination of translucent earth colours overlay each other in an abstracted pattern of almost geometric brushmarks to hint at, rather than describe, the shapes of the houses, roofs and trees. This is an excellent example of showing how little need be actually painted to suggest much more.

FIELDS TOWARDS LEWES
Annie Wood

Soft and splotchy, and apparently painted with gay abandon, this delightful summery painting is, in fact, carefully built up with successive washes of colour worked into each other while wet. The strong pencil lines that sketched out the composition prior to painting now serve to describe the furrows of the field.

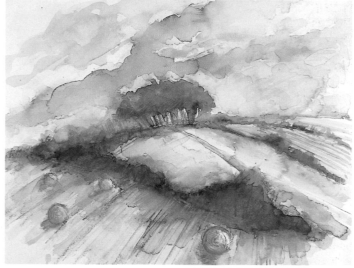

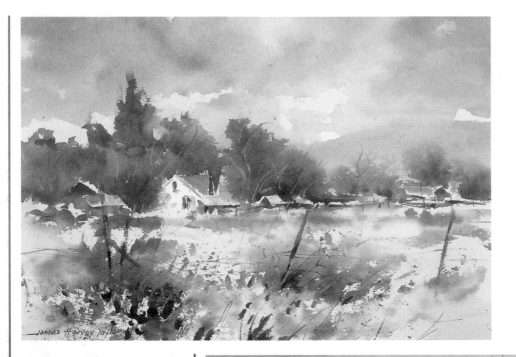

AUTUMN IN GENOA
LaVere Hutchings

The artist has sketched out the composition fully before masking the tree trunks and grasses. The colour is then built up in thin washes, freely applied, wet on dry and occasionally wet in wet. After removing the masking, some areas, such as the trees in the middle distance on the right and the foreground grasses lying in the shadow of the tree on the left, are washed over with thin glazes of transparent colour.

SEPTEMBER COLOUR
James Harvey Taylor

The overall atmosphere conveyed by this autumn landscape is one of serenity and gentleness. The right-hand trees dissolve wet in wet into the background, and autumnal colours merge softly wet in wet within the tree shapes themselves. The reserved white paper for the buildings blends crisply but gently beneath the trees. In the foreground, the paint is spattered, splashed and splodged in a perfectly controlled "frenzy" to create areas of light and shade in the wild meadow grass.

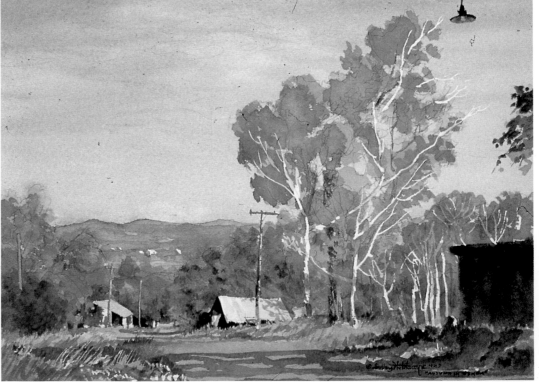

RETREAT
Jann T. Bass

The swathe of white paper reserved for the path, trees and building makes a vibrant contrast with the rich bronze colours of the landscape, creating a dynamic composition out of simple elements. The slight variations of colour within each of the main washed areas are essential to the life of the painting.

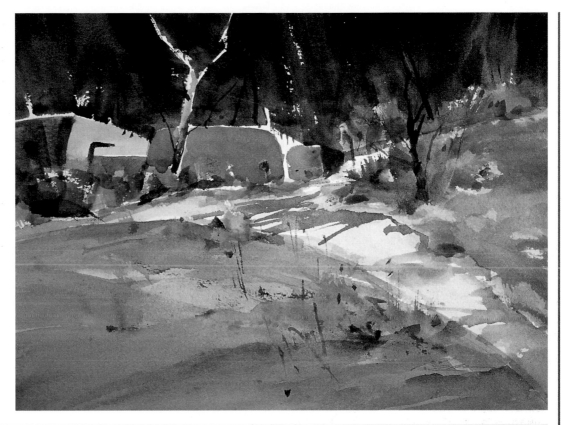

TRAVELS WITH A DONKEY
Paul Bartlett

This fearless little sketch is brimming over with humour. The ink is not waterproof, so the artist has avoided smudging the inked areas by leaving white paper around them. These irregular shapes add charm and character to the quality of the painting.

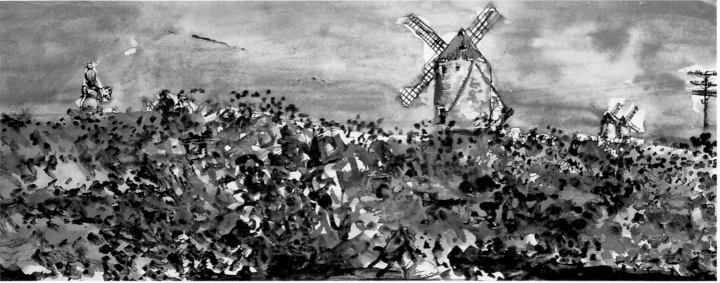

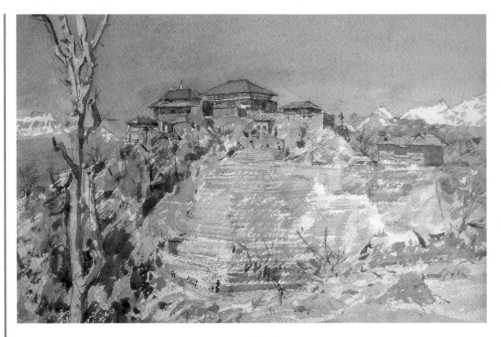

NEAR GOORKHA, NEPAL
Ken Howard
The clear, cold sunlight of a Tibetan temple perched high in the mountains is crisply portrayed with swift brushstrokes in a well-chosen blue. Dry brush is used to describe the stepped pyramid climbing up to the temple. Dabs and linear brushstrokes paint the foliage. The buildings themselves are carefully drawn, and the shadows of the roofs describe their three-dimensional forms. The orange figures reinforce the dramatic scale.

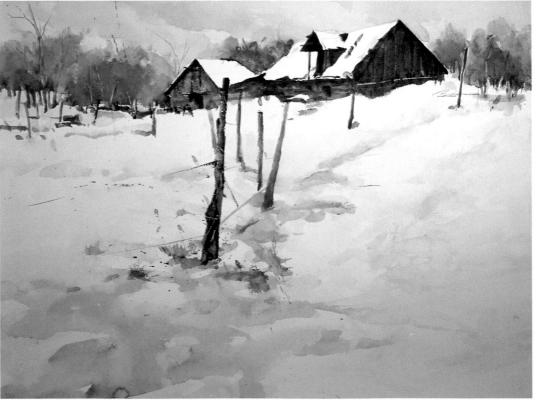

MOUNTAIN WINTER
Jann T. Bass
The high horizon and the large area of reserved white paper create an interesting basic composition. Minimum colour is introduced to achieve a contrast of tone that makes a strong statement. The artist then washes loose, sploshy shadow into the foreground area, which highlights the virgin white of the hill.

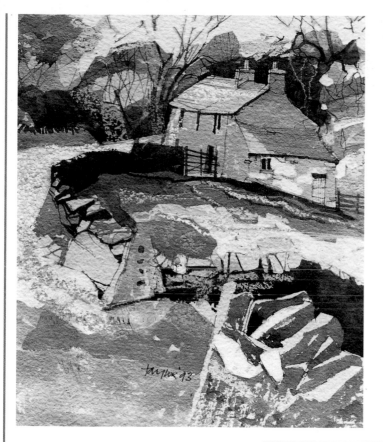

NINEBANKS
Bill Taylor

The rough creamy coloured paper provides a warm overall light to this painting of thawing snow. The composition is sketched in with black ink or paint, which is diluted to create the cast shadows. The palette is limited. White is then brushed broadly over the snow-covered areas, picking up the grain of the paper and making bluey greys where it lies over the neat and diluted black.

SNOW AT MORSTON
Alan Oliver

The colour of the sky influences the wintry mood of this peaceful painting. The artist has tilted the sky wash while wet to create gentle downward runs. The trees are then brushed in wet in wet, while the white paper is reserved to add crisp edges to the buildings. The snow-covered fields are separated from the pathway by the thinnest of washes, preserving the luminosity of the bright snow under the grey sky.

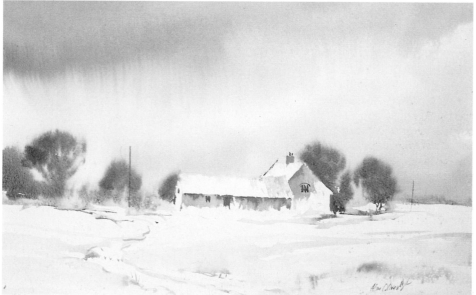

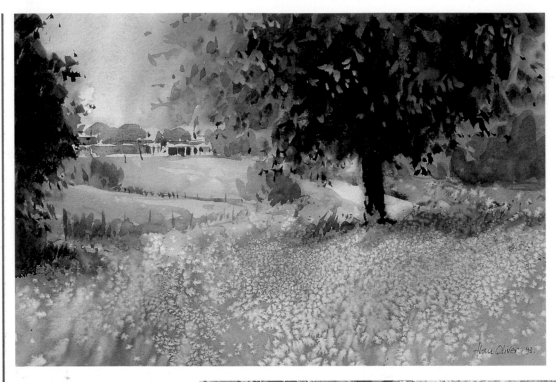

DISTANT FARM
Alan Oliver

The freshness of spring is brilliantly carried out in this painting. The individual blooms that make up the carpet of flowers are made by scattering salt crystals carefully over the wet paint so that larger blooms are created in the foreground and smaller ones appear further back. The light leaves on the tree are dabbed on with gouache bodycolour, making lights against the dark foliage and darks against the sky. (See ROCKS, SALT CRYSTALS.)

PATH THROUGH THE WOOD
Alan Oliver

Another lively composition by the same artist imaginatively portrays the pointillist effect of new spring growth through the use of spattered and flicked colour. The areas of light and dark are carefully delineated to enable the artist to spatter greens, yellows and blues in "controlled random" across the painting. The loose, vertical tree trunks and the hard-edged horizontal shadows pull the composition together. (See PATHWAYS, SPATTER.)

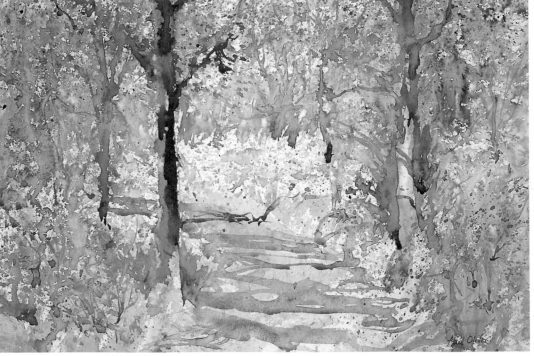

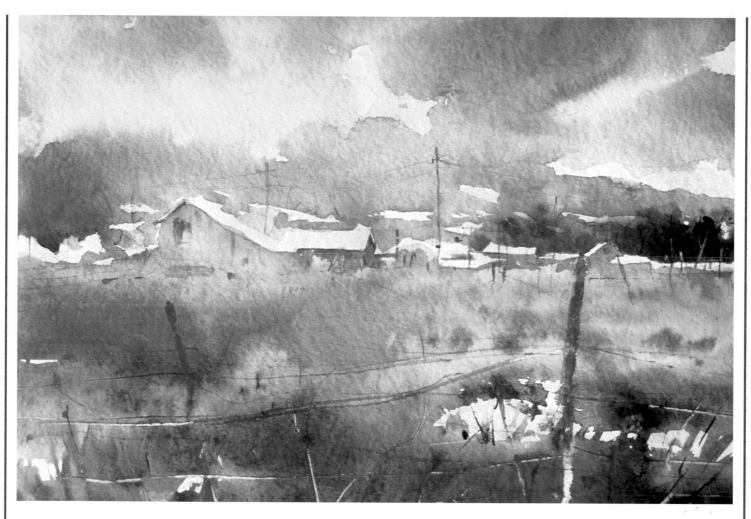

LANDSCAPE IN BLUES
James Harvey Taylor
This painting has all the *joie de vie* reminiscent of spring, with abundant colour beneath a tumultuous sky. If you cover the buildings, the painting is almost abstract. The shapes of reserved white paper are skilfully chosen to describe the rooftops, and the colours are well contrasted.

PUMPKIN MARKET
Naomi Brotherton
This charming night painting shows how bright painted lights can be if they are set against a sufficient tonal contrast. The streamlet was reserved as white paper, and then tinted with coloured reflections so that it remains light against the dark ground. The brightness of the light shining out onto the fresh produce is enhanced by the complementary (opposite) colours of blue and orange.

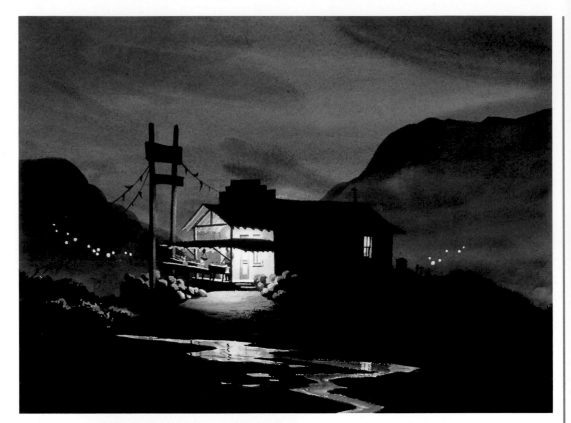

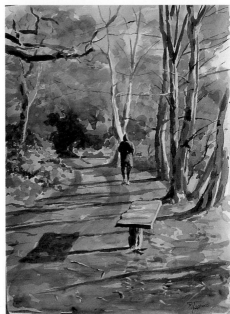

AUTUMN WALK, TRENT PARK
Mark Topham
The enjoyment of this painting is held in the long shadows cast by the low winter sun and the rich overall colour. The artist has built up the foliage with layers of washy colour, which were laid when the colour underneath had dried. Warm browns and mauves are used to create that special warmth felt on a sun-kissed winter's day.

BETATAKIN
Judith S. Rein
Here the artist has actually used subtle differences in tone to build up the whole composition in sections, rather like a mosaic. Look carefully at the different tones within each area of blocked tone. Careful drawing is necessary before painting something as complex as this.

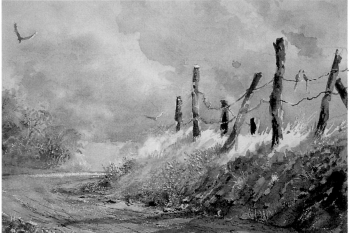

POSTS IN SUNSHINE
LaVere Hutchings
This pathway painting is slightly backlit, casting the posts dark against the sky and the top of the grassy bank is light against that same mid-tone. The highlighted grasses are scratched out of the dark paint on the bank with a sharp blade. (See GRASS, SGRAFFITO.)

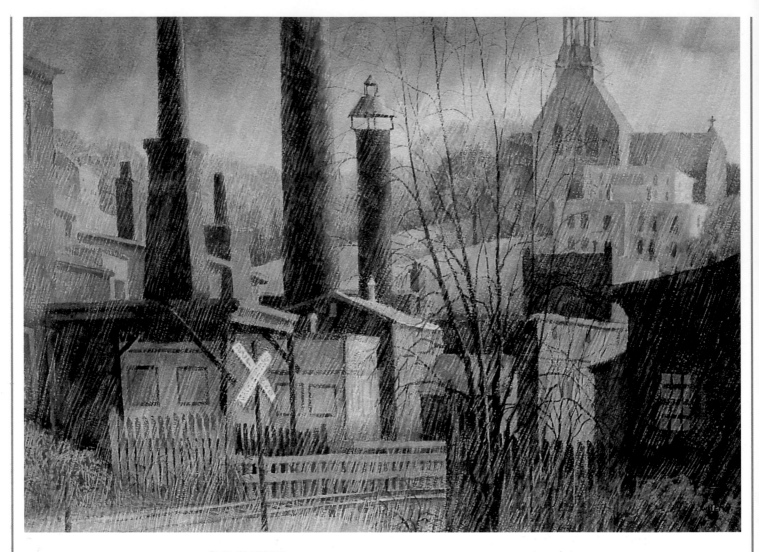

SUN SHOWER
Becky Haletky
The overall colouring, painted
with a limited palette, creates
the wet, overcast atmosphere
of a faded industrial town. The
streaks of rain laid in diagonal
strokes draw a veil over the
painting, slightly blurring the
image. It takes courage to
draw lines all over a
completed composition.

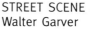

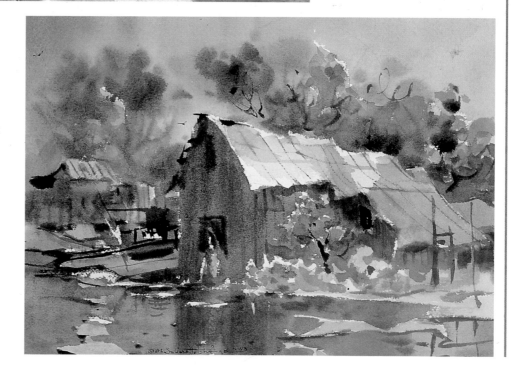

STREET SCENE
Walter Garver
This painting is full of delightful narrative content. Basically it is the painting of a puddle, but what a marvellous puddle! The figures scurrying away, the shadow cast by the sun coming out after the rain, the glare of grey-white sky mirrored in the water, all these tell a story and combine to make an exciting painting with an unusual composition. Dry brushwork and spatter are used to build up the grainy surface of the road and path. (See PATHWAYS; ROADS.)

COULTERVILLE
LaVere Hutchings
This wonderfully executed wet in wet technique for a rainy shanty-town painting shows a perfect marriage of technique and subject matter. The softness of all the merged colour is controlled by the hard-edged areas of reserved white paper, later tinted with pale glazes. The reflection of the shack is painted into the wet road wash just before it dries so that the vertical side of the building is mirrored softly without the colour spreading. (See RAIN.)

Waterscapes

The inherent movement of water brings life into a painting, whether the water is fast-moving, languid or still. The repetition of the landscape in a mirrored or blurred reflection creates a strong and appealing composition.

Several different techniques can be used to achieve similar results. In the paintings that follow, you will see highlights on the water produced by reserving white paper, masking out, lifting out, restoring with bodycolour, or revealing by scratching out. Look carefully at the way in which the artists create the wetness of water, the tonal contrast with the dry land, the movement of the reflected image and the length of the reflection.

By its very nature, watercolour is well suited to the rendering of water. The wonderful merging of colours wet in wet is ideal for the blurred image of an uncertain reflection. The irregular shapes of tiny flecks of white paper left untouched when a wash is laid are perfect for ripples of water catching the light.

The following pages explore paintings of fast-moving water, still water, mirrored reflections, rippled reflections and blurred reflections. The techniques used for painting the water are many, but paintings are not the sum of their techniques – it is the human touch and the human spirit that give a painting life.

Looking at these paintings should give you confidence to paint water in different ways. If you are disappointed with your own attempts, see how another artist has tackled water in a similar composition. Few paintings are irredeemable, and always remember that there is usually more than one way to achieve a successful image, even if your first attempt resulted in disaster!

MORNING SPIRE
Paul Kenny

A careful balance of subtle variations in tone creates this tranquil, almost romantic scene. The colours used have a mystical appeal, achieved in part by mixing some of the watercolour with a little opaque paint. The areas of foliage are painted wet in wet, greeting the sky with soft, misty edges. The light on the water under the trees has been created by lifting out colour from the wash with the strokes of a damp brush just before the wash dries.

Interesting textures on the foliage and water are the result of the pigment settling in the grain of the paper.

The balance of tone is the key to this painting, and you will notice that the artist has used masterly touches of bodycolour to even out the tone on the lower spires of the church. (See MISTS; WINTER, OPAQUE PAINT; BUILDINGS, GRANULATED WASH.)

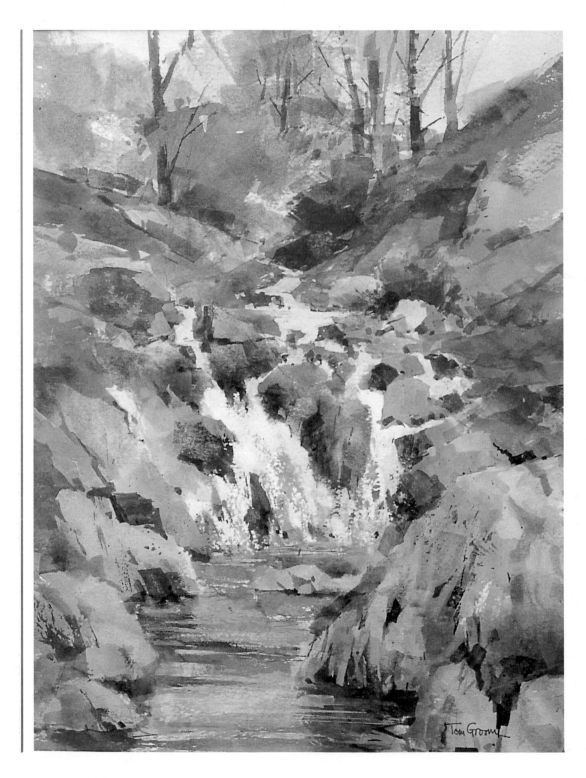

WATERFALL, CUMBRIA
Tom Groom

This fresh rendering of a mountain stream tumbling through a rocky valley is built up with transparent blocks of colour applied with a broad flat brush. The whitest whites are reserved white paper where the water finally cascades, frothing, into the stream below. Look at the other whites of the water and you will see that the artist has skilfully taken them slightly back in tone by the use of white bodycolour. This is more apparent in the distant stream, but if you look closely at the last descent, you will see that white paint is used to soften the water's edge against the rocks.

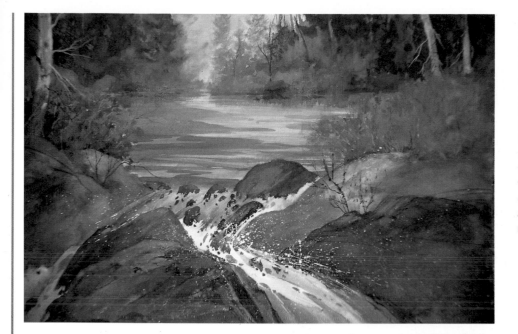

LIBERTY WATERFALL
Shirley McKay

The peaceful background of this river contrasts brilliantly with the exciting foreground. The playful splash of the froth is created by flicking white paint across the dark rocks. As in the previous painting, but with more dramatic contrast, the artist makes the white water shine out brilliantly by darkening the other water around it. (See WATERFALLS, FLICKING.)

SNOWSHED SLIDE
Betty Blevins

The detail in this painting is applied over wet in wet washes that have fully dried. The artist works carefully from top to bottom, completing each area before moving down the page. Dry brush technique is used to create the broken foamy textures of the fast moving rapids and the wild grass on the bluffs. The shadows over the foreground and the distant bluff are laid with a dark transparent glaze, which is painted over the details when the work is dry. A soft area of white paper is reserved for the steam issuing forth from the funnel of the train. (See RIVERS, MASKING.)

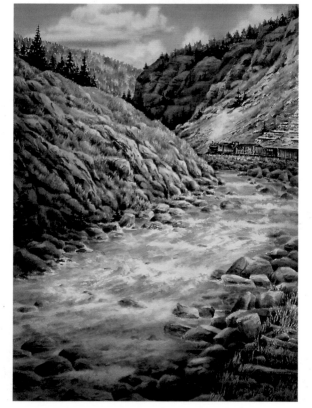

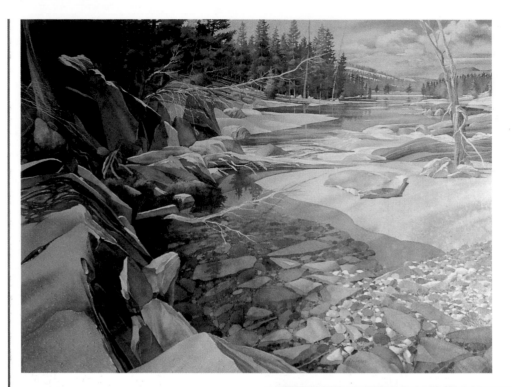

TUOLUMNE POOL
Dan Petersen

This painting has almost a fantasy feel to it. The pool of still water through which the rocky bed is revealed changes from blue to orange as it comes towards the front of the picture. The details of the rocks are drawn in first and, when dry, the colourful glaze is washed over the top. The use of perspective is quite dramatic, bringing the painting from far away directly to the viewer's feet.

FISHIN' UPSTREAM
Betty Carr

Vibrant brushwork creates a lively watercolour full of movement. The undercolour is applied wet in wet, and fast brushstrokes are laid on top to describe the trees and river edge. The movement of the figure and flight path of the fishing line scratched out from the painted surface create a focus that takes the eye back and forth across the painting. The tiny bands of light water left trailing from the fisherman's boots are essential to suggest the movement in this painting.

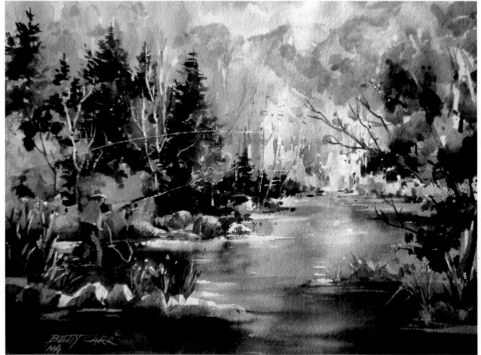

AROUND THE BEND
Sue Kemp

In this watercolour, distance is skilfully achieved by the perspective of the river and the change to a very light tone at the bend in the flow. Beyond, the glazes of colour are laid simply over dried washes, while the smooth flow of the water is described with a wet in wet wash.

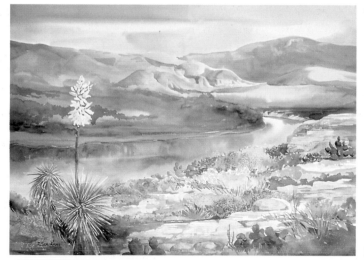

LOW TIDE, DISTANT RAIN
Robert Tilling R.I.

The artist has worked this painting very wet indeed, using large brushes absolutely loaded with paint. After laying the paint in sweeping brushmarks, he then tilts the board. Wonderful granulated patterns are created as the paint settles.

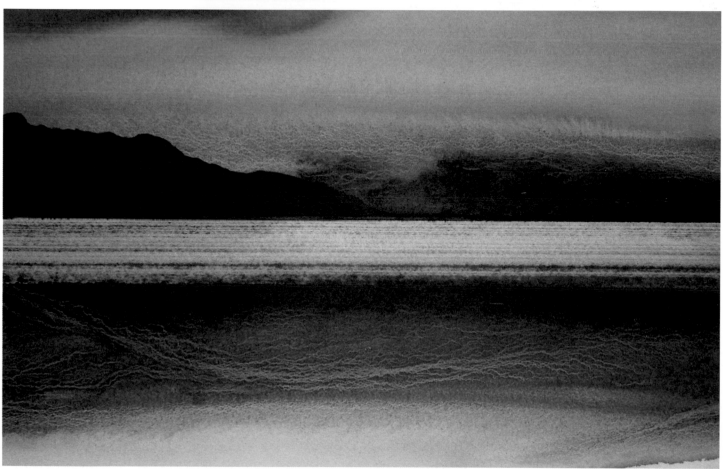

AVON RIVER NEAR CHRISTCHURCH
Donald Pass

To achieve the appearance of the sparse, dry winter foliage bordering the glassy river, the artist has used a combination of dry brush and sponging. Small highlights are then scratched out with a blade. The techniques employed are well suited to the subject matter; a cool breath of winter is created in the foreground, and a certain warmth in the middle distance and background is created from burnt sienna and umber washes. The dark tones brushed in for the reflections of the river banks add to the sense of still water created by the mirrored reflections of the trees.

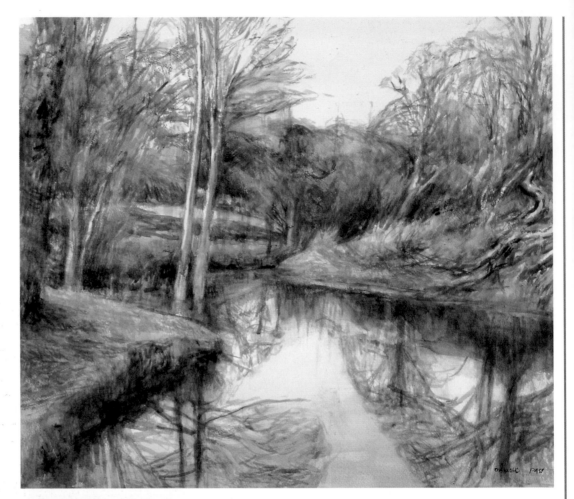

ISLANDS OFF WEST COAST OF SCOTLAND
Kay Ohsten

The beauty of watercolour as a medium is that it can quickly record a scene, as this simple silhouette of rocks and sea shows. The sparkles in the foreground are left in the white paper by brushing the wash lightly across the tooth of the paper to create a shimmering sea. (See SEAS, VARIEGATED WASH.)

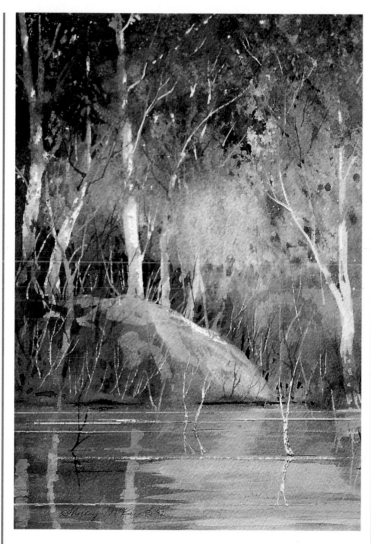

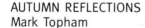

AUTUMN REFLECTIONS
Mark Topham

The puddle reflects the warm, pale grey of the winter sky above the trees. No other part of the painting is as light as this area and, reinforced by the reflection of the trees, the viewer is convinced of the puddle's wetness. Note the part of the tree and fence that is mirrored in the puddle.

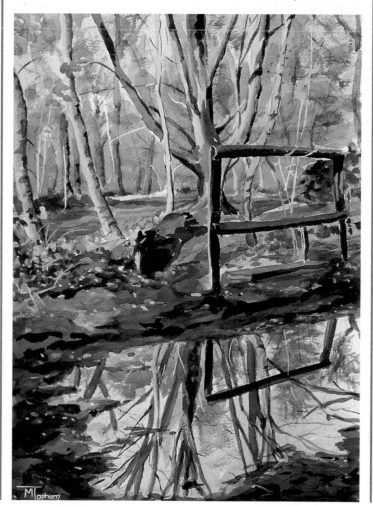

HIDDEN POND
Shirley McKay

A sense of privacy is felt as the viewer enters this painting of a secret glade. The still water is portrayed by gentle horizontal strokes and the light trunks of the trees have been masked out and then glazed over. The charming background colours merge together wet in wet.

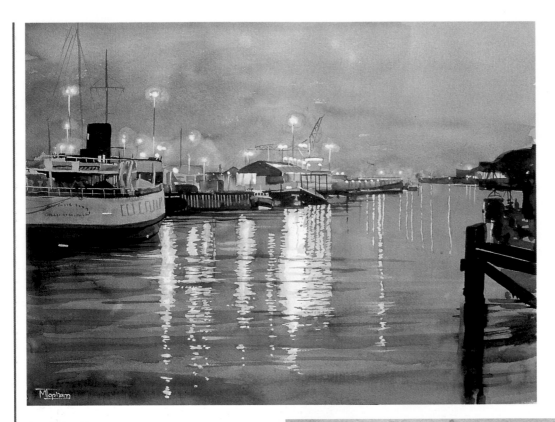

EVENING LIGHT, NEW HAVEN HARBOUR
Mark Topham

In this atmospheric night painting, the artist has used masking fluid to reserve the lights on the quay and the long rippled reflections in the dark water. The sky and water have been generously washed in above and below the quay. The halos of light are lifted out from the sky and tinted with yellow. Once the masking is removed, some small dark ripples are painted over the reflections to break the columns of light. (See NIGHT, MASKING.)

THIS IS THE PLACE
Betty Carr

Using bold brushstrokes over dried washes, this painting relies on strong contrasts of tone to build a vibrant rippled-water effect. The reflections of the rocks themselves are much lighter than the strong foreground, making a vital shift in perspective from the front of the painting to the middle distance.

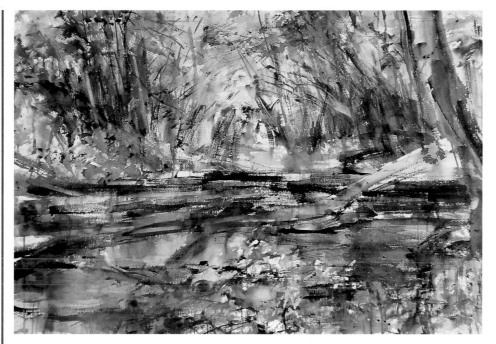

ENVIRONS OF PAMAJERA
Alex McKibbin
At close-hand the application of brushstrokes and glazes appears rather random, until you pull back from the painting and see how brilliantly the perspective falls into place. The river leads gracefully away between the banks, with its surface patterned by light and shadows cast from the umbrella of overhead trees. The long, dry brushstrokes are often used directionally to describe the verticality of tree trunks or the flatness of water.

EVENING GARDEN
Rebecca Patman
The fragmented lights on the rippled water in this charming garden painting are created by reserving white paper. The water is painted wet in wet, leaving flecks of white paper as the colour is laid and successfully mirroring the colours of the background it reflects. Further ripples are painted across the surface of the water when the wash is dry.

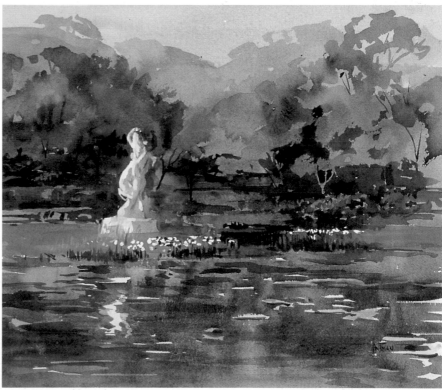

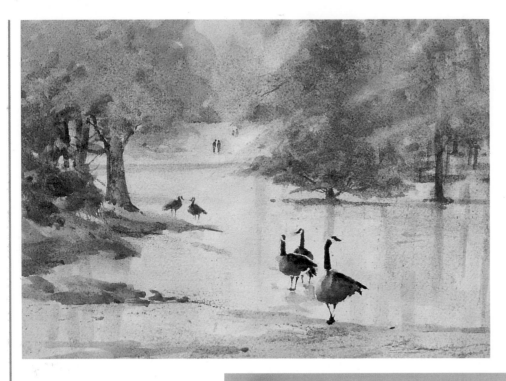

COTERIE
Jann T. Bass
Although the water in this landscape is frozen, ice still reflects something of the features above it. The tree trunks are brushed down into the ice with fairly pale, dry strokes. The geese stepping onto and across the ice tell the viewer that the surface is solid, while the subtle reflections and colour show the surface as ice.

RESERVOIR LIGHT
Robert Tilling R.I.
Working with large brushes and abundant paint, the artist uses sweeping brushstrokes to lay the washes. He then tilts the board to let the paint run into drifting reflections, allowing the effect more importance than an accurate reflection would do. The colour is then scraped back to create two bands of light across the water.

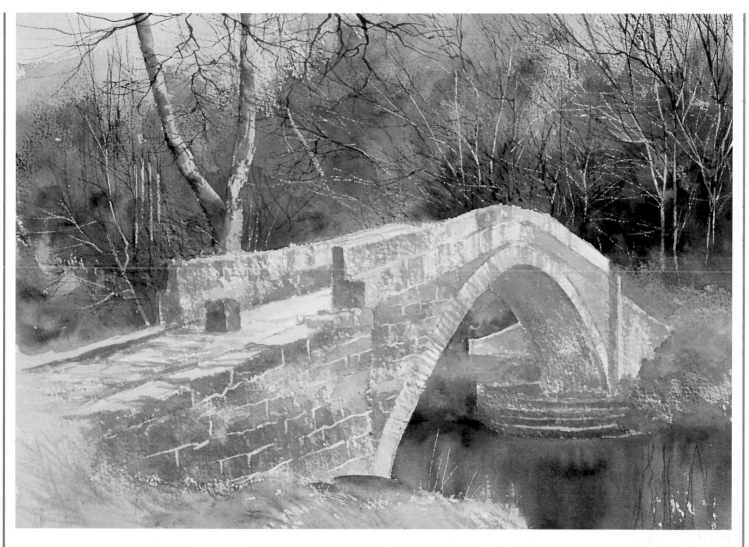

BRIDGE
R. H. Pearson

This cheery painting of a bridge in winter is painted using many different techniques. The background and water are washed wet in wet. The colour of the foreground is mostly applied with dry brushwork. The mortar of the brickwork and the narrow tree trunks have been masked out, then tinted. The skeleton branches of the winter trees are scratched out with a blade, while the dark branches are painted with a long-tipped rigger. Darks are placed against lights throughout the painting to ensure a strong tonal composition. (See BRIDGES.)

Wilderness

The wild, untrammelled regions of our planet enable the artist to find expression for grandeur, vastness and solitude. These present wonderful opportunities to play with colour and technique in a less restrained way.

Jungle, woodland, mountains, valleys, canyons, rock formations, moorland, veld and tree lines are among the subjects represented in this section. By the nature of the subject matter, some of the paintings display strong colour, vibrant contrasts, dramatic compositions and a freedom of paint. Others pick out intimate corners of the wild landscape, or bathe the subject in an all-pervasive tranquillity.

To be alone in nature that is untouched by human hand is uplifting and humbling. Sometimes it is overwhelming. The artist must choose the elements of the view that he or she most wants to paint, and leave out the rest. Once the choice of composition is established, you can be daring or subdued with your colour, wild or sensitive with your brushstroke.

Do not feel obliged to represent your subject accurately. Moving a rock to the right or left to help the composition is part of creating a painting. If you are afraid of your own ability, position yourself in a place where the composition laid out before you is pleasing to the eye, or interesting in design, and then you can simply "copy" nature! Colour can also be exaggerated to enhance the mood you are trying to express. Always remember that the painting must stand alone, away from the landscape, with no likeness to compare it to. Even if you are painting a well-known feature, you need not feel restricted; your interpretation of the landscape is special to you, and that is what others appreciate when they view the painting.

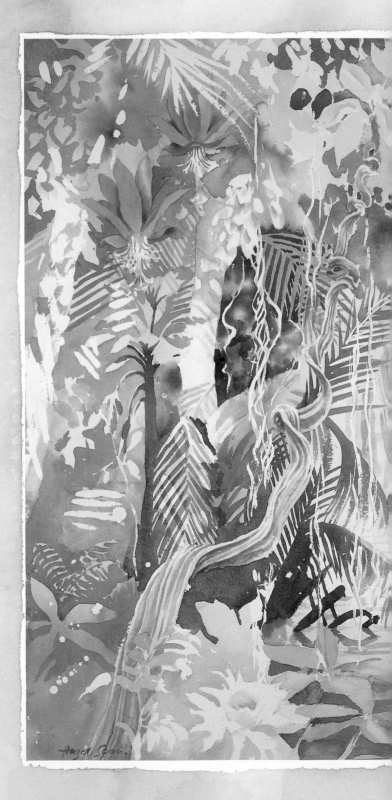

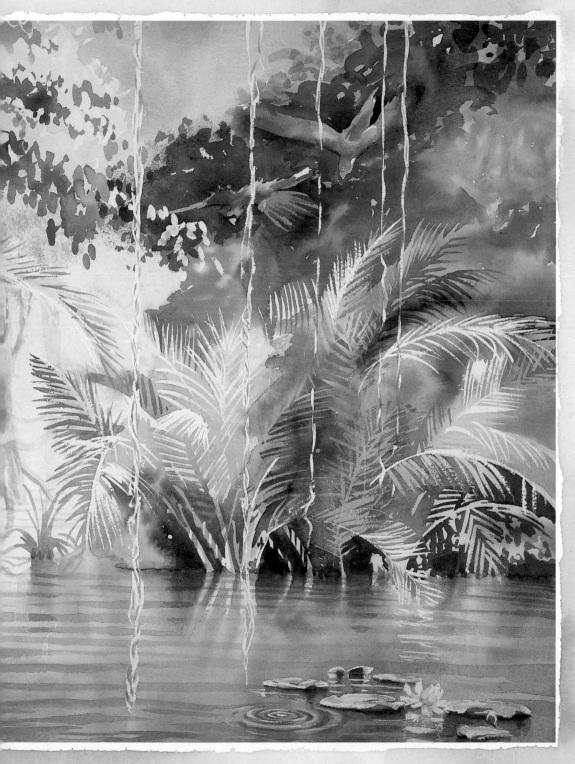

BANKS OF THE ORINOCO
Hazel Soan

The artist has sought to create some order out of the luxuriant chaos of this South American jungle. The fronds of the palms and the twists of the lianas are masked out from the equatorial profusion so that wet in wet washes can be freely applied across the foliage and then diverse colours dropped into the washes while wet.

The masking is then removed and glazed with further colour in places while some areas are kept as virgin white paper. White body colour Is used to establish the ripples on the water.

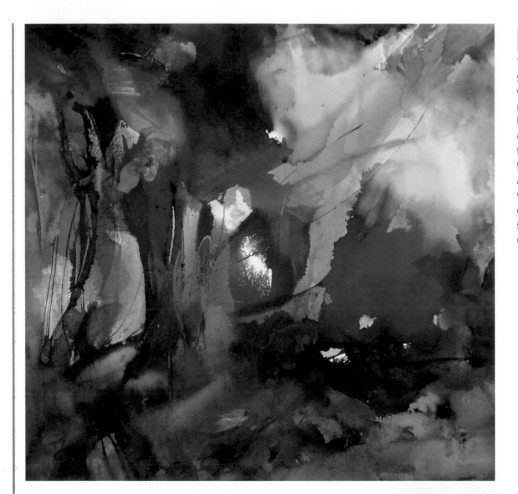

EXPRESSIONS
Bernice Alpert Winick

This exciting painting draws on strong vibrant colour applied wet in wet. The pigment is mixed in strong solutions and boldly painted with sloshes of colour. Control is exercised in the areas of light and dark tone, but the watercolour is allowed to make its own wonderful combinations of colour between areas of stillness and areas of dynamism.

ENVIRONS OF PAMAJERA
Alex McKibbin

The composition is built up with vivacious directional glazes using a flat brush and wet and dry pigment. Interesting colour combinations emerge from the overlays of colour. The irregular-shaped "bands" of white paper, reserved as lights between the strokes, narrow as they recede, strengthening the perspective of the avenue between the trees.

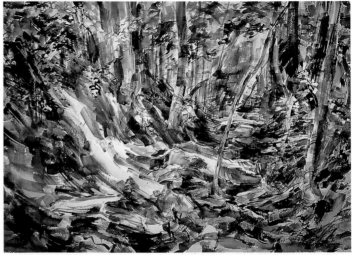

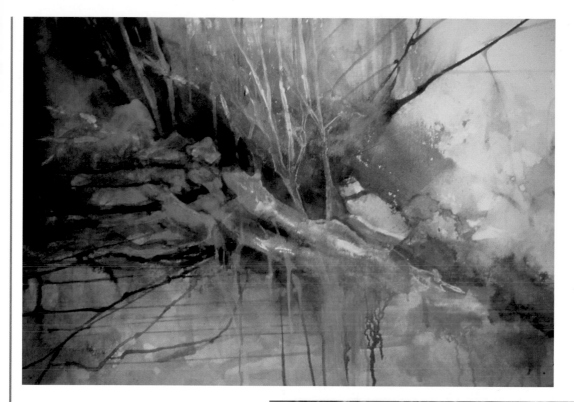

ARMONIOSO
Bernice Alpert Winick
A dynamic and intriguing painting is created by the strong diagonal composition and the energetic runs of paint. The background is painted wet in wet. The artist has tilted the paper in all directions to encourage the paint runs to become the flexible limbs of trees and the searching lines of roots. Bodycolour is mixed with the watercolour to create opaque glazes.

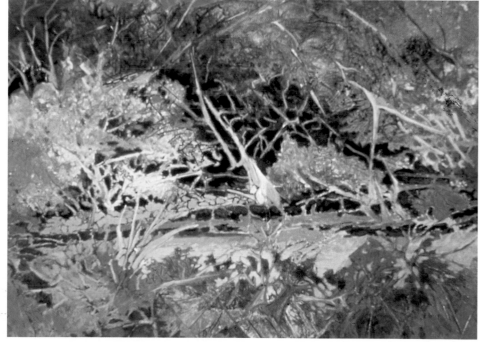

LIGHT AND SHADOW
Jerry Wray
The engaging colour of this delightful tangle of woodland scenery is built on the play of opposites. Mauve and yellow are complementary colours, as are red and green. The contrast of opposite colours creates vibrancy. The artist lays a film of clear plastic over the wet paint, and then works into the patterns produced to give form to the landscape.

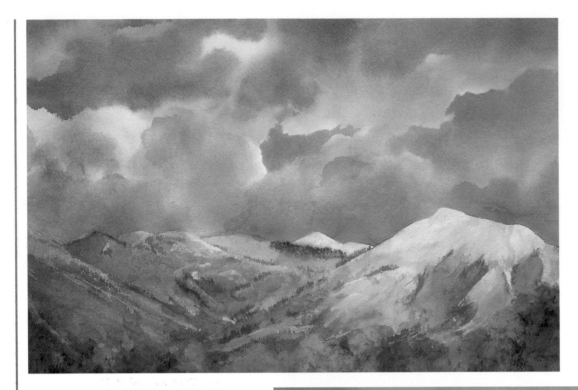

MOUNT OLYMPUS
Shirley McKay

A sky of looming rain clouds billows over the snow-clad mountains. The clouds are painted wet in wet with dark, thundery colour dropped into the damp white areas. The fluidity and shape of the clouds gives them their movement, and the dark purply colour offsets the white mountain top. White bodycolour is used neat or with pigment to make opaque glazes on the wooded ridges. (See CLOUDS; WET IN WET.)

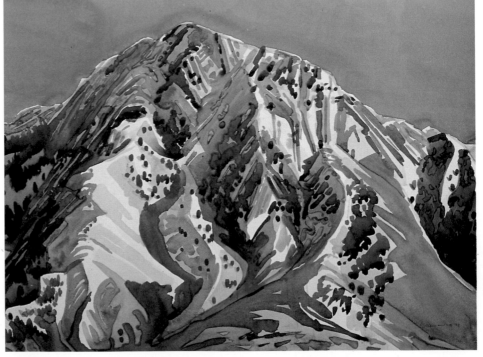

MOUNT OLYMPUS OF THE WASATCH
Willamarie Huelskamp

In this painting, the artist does not use overall washes to build up her mountain; instead, each area of tone and colour is painted separately. The colour laid is the final colour. The three-dimensional form of the ridges and valleys is accentuated by the sideways light, and achieved by using strong, dark tones in the crevices contrasted with the light on the ridges. (See MOUNTAINS; HILLS.)

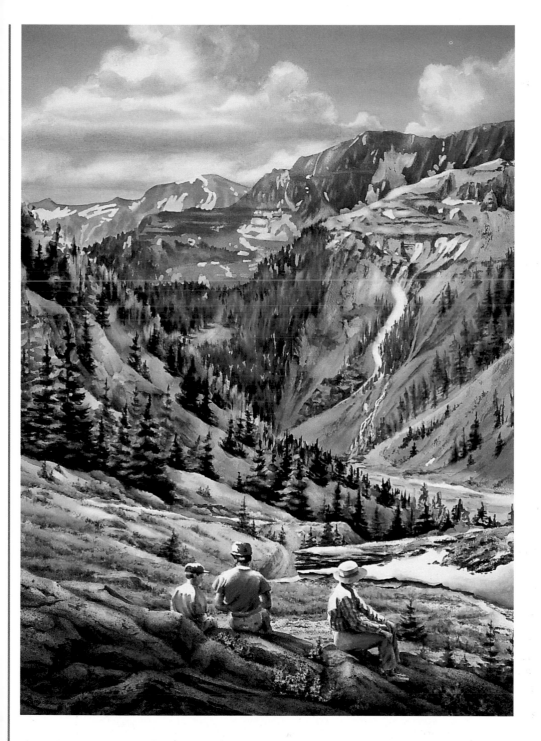

YANKEE BOY BASIN
Betty Blevins

This fairly complex subject is built up in an orderly fashion, successfully projecting the smallness of the figures in this grand panorama. The artist masks out the snow and figures first, then completes each area, working down the page, before proceeding with the next. A wet in wet underwash is laid and allowed to dry. The details are painted over the wash. When the masking is removed from the snow areas, these spaces are glazed with pale versions of their respective mountain colours to help them recede into the distance. The figures are painted last, with white paper left for the sun's highlights.

BRYCE CANYON, WINTER SHADOWS
Willamarie Huelskamp
Before painting, the artist carefully delineates the different areas of tone and colour. Areas of the same colour are then painted with strong, vibrant washes. Almost no overpainting occurs, except the delightful overlap of edge lines where two colours meet. Careful attention is paid to the different tones within an area. The result is a strong painting that comes together magnificently from a short distance away.

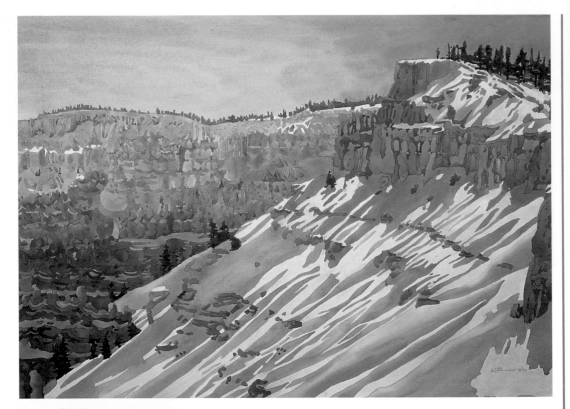

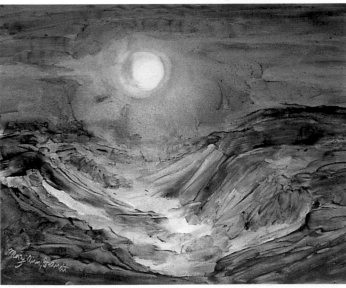

MOONSPUN
Mary Ann Brandt
This nocturnal sketch is painted with the fingers on a smooth surface so that the paint can be manipulated easily. As the paint is "smeared" into the shapes of the mountains and valleys, the residue of the pigment stains the paper slightly, creating enjoyable textures and a painting full of gaiety and light.

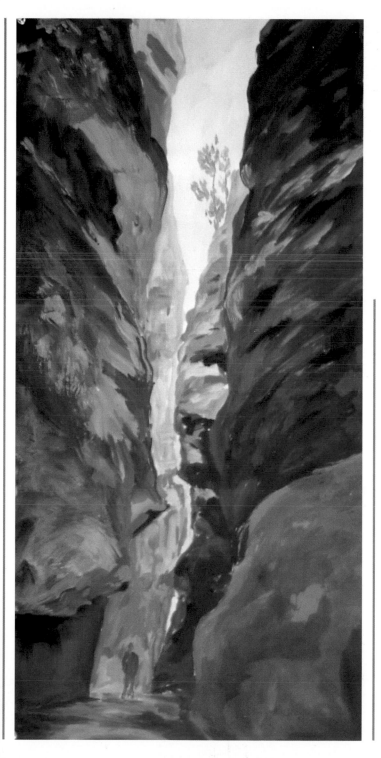

BRYCE CANYON
Angie Nagle Miller

The steep walls of the canyon make an exciting composition, with the dramatic scale indicated by the figure silhouette at the base. Using casein watercolour and bristle brushes, the artist works the paint into wet washes, blending the colour on the paper. Some dry brushwork is also used. The opaque paint gives a tremendous solidity to the rocky ravine.

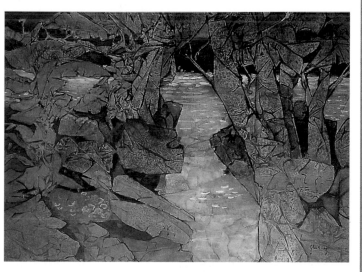

PACIFIC ISLAND
Jerry Wray

This landscape is part of a series called "Places Remembered". Rather than painting directly from the scene, the artist uses an unusual technique to recreate the island wonderland from patterns on the paper. First he pours diluted watercolour on damp paper, and then he loosely lays a covering of clear plastic film, letting it crumple into the wet paint. When dry he removes the plastic and seeks out the landscape from the textured print on the paper, creating a landscape by using his imagination.

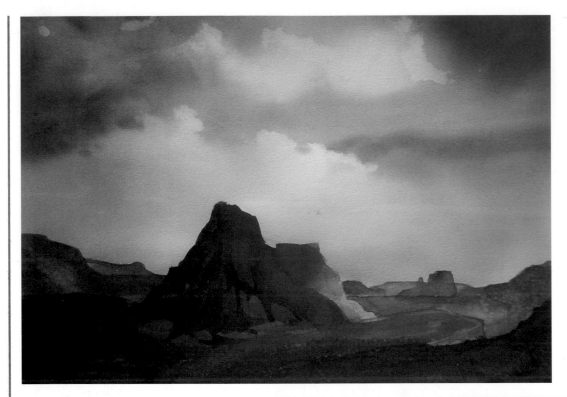

CANYON SENTINEL
Shirley McKay
Strong colour and a simple, direct approach are used to create an image of grandeur. The sunlight passing between the clouds touches the side of the flat-topped mountain in the middle of the painting, making an enjoyable change of tone. The artist has cleverly used running drips of colour to form a pattern of crevices in the peaked mountain.

GENESIS
Hazel Soan
To establish this glacial tumble of granite rocks in three-dimensional space, the artist has concentrated first on building up the forms tonally. Note that the background rocks are all slightly paler to help them recede. While the strong, dark colours are still wet, colour is dropped into the wet washes and allowed to spread. The grainy textures of the granite boulders are created by liberally sponging paint in fairly strong colours over the surfaces. (See ROCKS.)

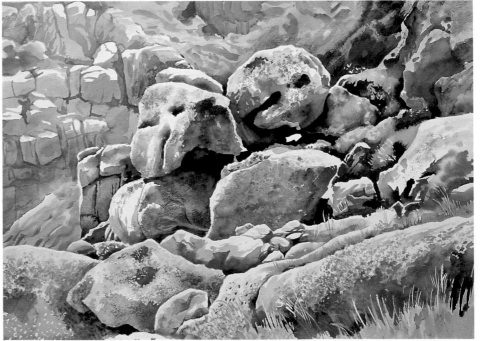

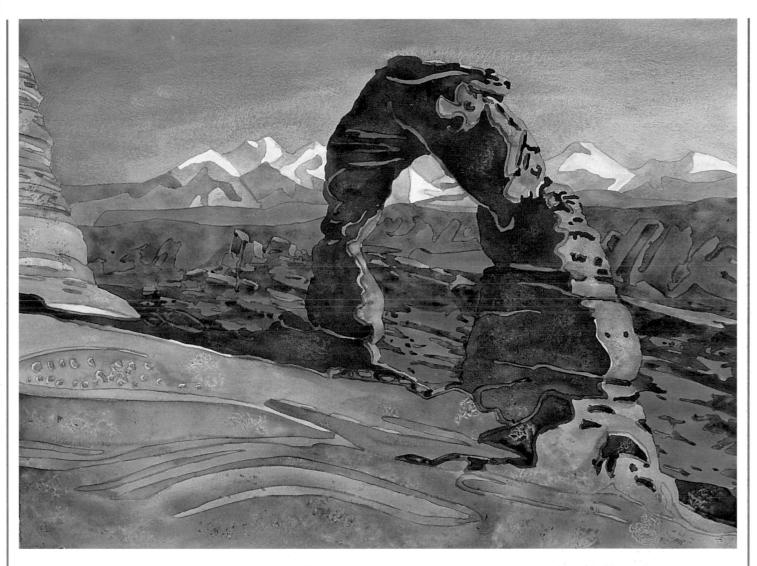

EARTH'S RAINBOW
Willamarie Huelskamp

This dynamic painting is a wonderful example of the vibrant strength of complementary colours on the picture surface, and of the nature of blue to recede and orange/red to come forward. The contrast of the blue with the orange makes each colour more intense. The artist does not overlap colours to form new colours, as in traditional watercolour techniques. Instead she draws the shapes and areas of different colour, and then literally fills them in with a few chosen colours mixed in the palette. The dark lines formed where the colours overlap cause the lighter colours to glow more brightly.

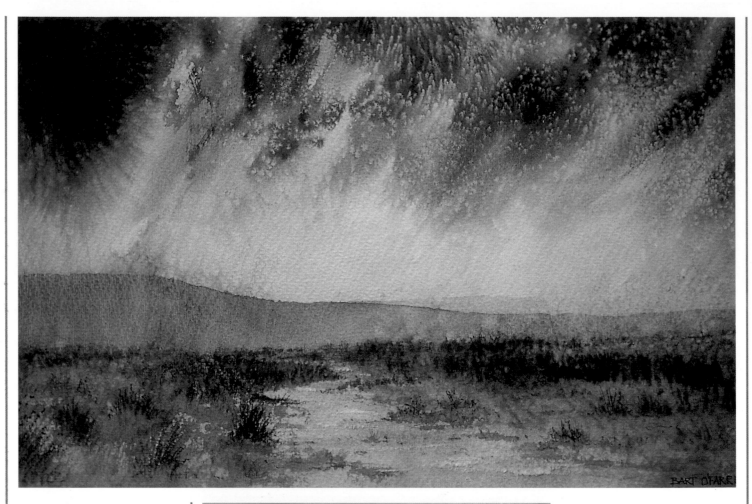

SLEET ON THE MOOR
Bart O'Farrell

With the shower of sleet extending its icy fingers across the empty moor, the bleakness of this scene is perfectly set. The flurries of sleet are created by using salt crystals to soak up the pigment from the black winter clouds and they are spread in a wonderful curving swathe. Dry brush is used for the scrubby moorland grass. (See ROCKS, SALT CRYSTALS; GRASS, DRY BRUSH.)

SPRING SEA
Robert Tilling R.I.

To achieve this broad, open landscape, the artist lays very wet paint with a large brush. The hills are painted in just before the sky wash dries to create the broken edge, which is reminiscent of the leafy tops of trees. This painting shows how much can be achieved with one colour and several tones.

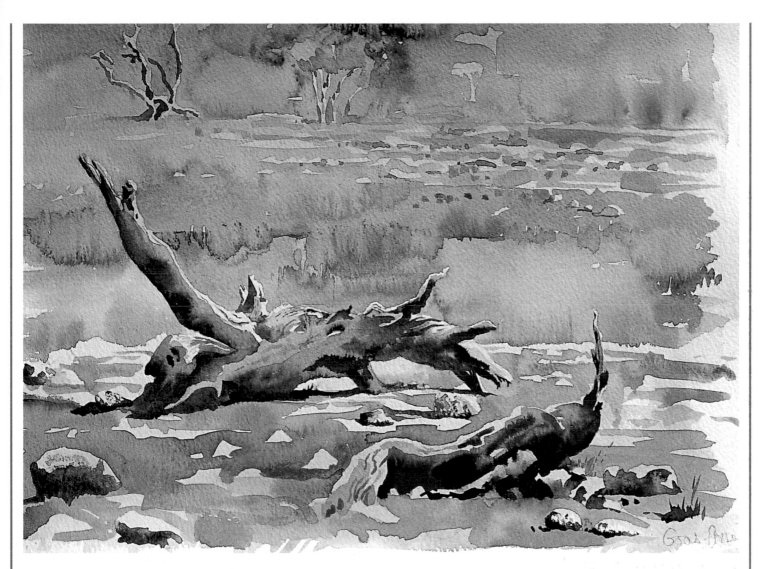

THE TURN OF THE
SEASONS
Hazel Soan
The writhing twisting tree
forms, though dead, give life
to this painting of an empty
water-hole in the African Bush.
White paper has been reserved
for delicate highlights on the
tree trunks and rocks. Small
areas of the trunks have been
painted wet in wet.

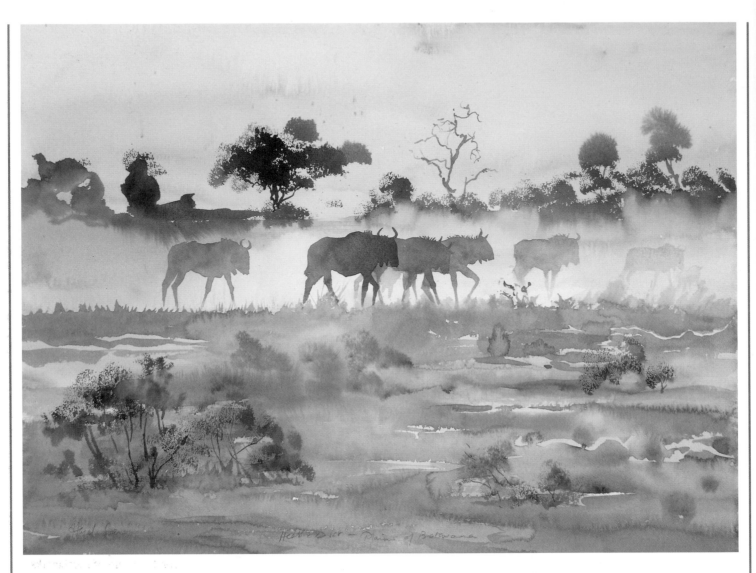

HEAT AND DUST
Hazel Soan

The overall golden colour of the African landscape is rendered with an underwash of yellow ochre laid on dampened paper, leaving a section untouched in the middle for the rising dust. The wildebeest are painted with successively darkening tones over the pale dusty area. The patina of scrubby foliage is described with dabs from a natural sponge patted on while the wash is still damp. To create the tufts of veld grass, colour is dropped into the wet foreground wash and allowed to bloom. (See DESERTS.)

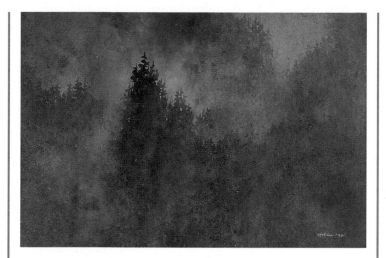

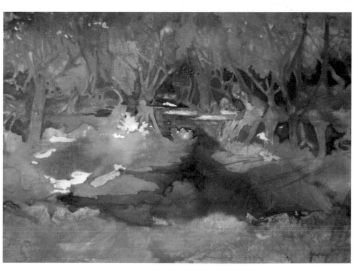

YELLOWSTONE FIRE XXXIV
Donald Holden
The drama and brightness of this forest fire is enhanced by darkening the tree forms in front of the blaze. The paint is applied wet in wet, mixing the colours on the paper. Subtle variations of tone create the layers of trees.

EARLY MORNING LIGHT
Jerry Wray
This bright vivacious painting suggests an almost magical landscape. The colour is brighter due to the use of complementary opposites, that is, blues next to oranges, and the spreading of the colours wet into wet.

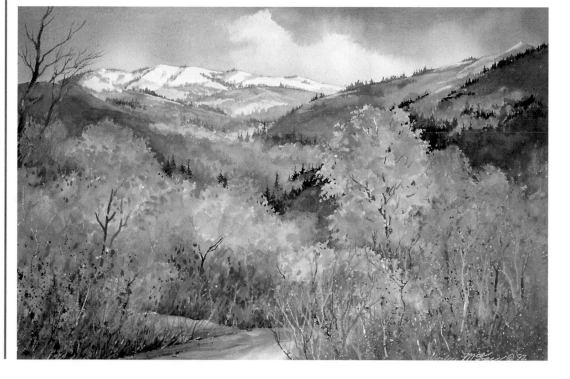

MUELLER PARK
Shirley McKay
The lively use of brushmarks and spatter adds verve to the foreground of this autumnal landscape. A wonderful sense of perspective is created by the gradually diminishing hill forms, taking the eye back to the mountains and beyond to the clouds. The complementary contrast of mauve against yellow throws the golden trees forward to the front of the picture plane.

Seascapes

The sea is always an evocative subject, offering the artist restless moods and serene vistas. The option of distant horizons, sparkling seas or broad beaches creates enjoyable perspectives and interesting compositions.

The diverse techniques available to the watercolourist can be explored by painting imaginative seascapes. Wax resist, masking or reserving the white paper are excellent techniques for retaining the whiteness of the paper for foam and broken waves. Alternatively, these whites can be restored by scratching out and adding bodycolour when the painting is complete.

The vast skies that often accompany seascapes are a wonderland for wet in wet techniques, variegated washes, backruns, or for tilting the paper to create drifts of colour. The animated surface of the sea is a marvellous area to lay on washes that allow the tooth of the paper to break up the wash and create the sparkle of light on water.

As the overall colours are harmonious, a sea and sky composition makes a good subject for practising techniques that rely on tone rather than colour to create interest. Try using just one colour in many different tones, or experiment with a very limited palette of two, or at most three, colours.

The broad expanse of beaches, warm and inviting in the foreground, are fun areas in which to practise glazes for shadows, or textural effects such as flicking and spattering. Watercolour is always well suited to a wet subject matter, and the sea is probably the most exciting subject. Do not be afraid to mix up plenty of colour and apply the paint liberally.

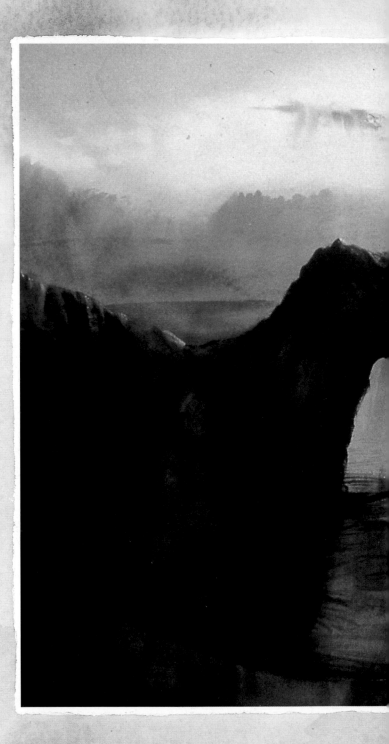

DURDLE DOOR
Leslie Worth

A wonderful hazy apparition of light and shadow is presented in this painting of a natural rock archway formed out of the cliff face. The airy quality of the painting plays games with the solid substance of the rock and the ethereal nature of shadows. The composition of backlight and forward shadows creates an exciting contrast of tone across the picture surface, the mauve shadows commanding a gentle presence across the pale sunlit water.

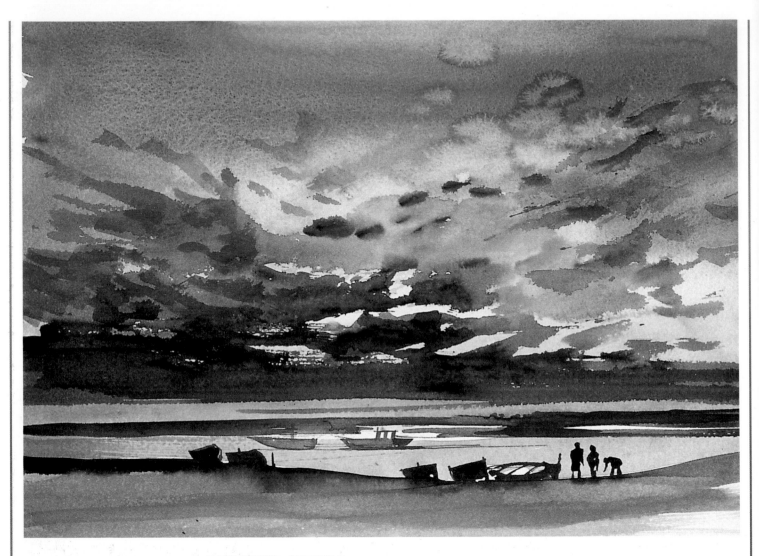

BRANCASTER, NORFOLK
Kay Ohsten
With relatively few colours and
quick, deft brushstrokes, the
artist has filled this sunset
sketch with life. The colour of
the still water is washed in at
the outset, with white paper
reserved to highlight the
mirror-effect of the glassy lake.

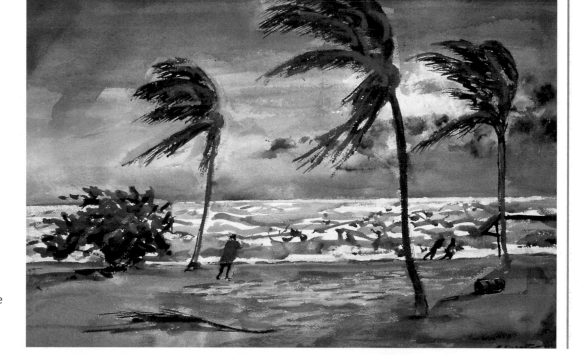

AUTUMN MIST
Robert Tilling R.I.
Here is a subject painted with very wet washes and lashings of paint. The soft edge of the base of the rocks creates the impression of rising mist, while the top of the silhouette is painted against dry colour for a hard edge. Note the warm brown colour pushed into the dark clouds.

SANIBEL STORM
Benjamin Eisenstat
The artist has worked quickly while the storm is blowing to capture the wind and rain battering the west coast of Florida. Drama is created with fast brushstrokes and dry brushed trees, with the tree fronds teased out by the strong winds. A touch of bodycolour lightens the puddle on the ground, reflecting the light from the sky above. (See TREES, DRY BRUSH.)

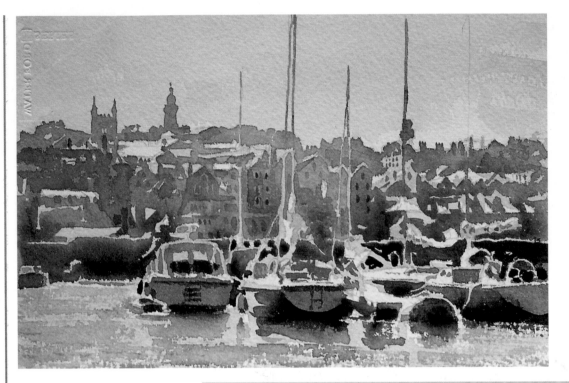

A DUSTING OF DUSK
Hazel Soan

The two paintings on this page depict the same harbour in Guernsey in the Channel Islands. Each is built up with one colour in successively darkening tones to create a different atmosphere at a different time of day. The highlights are reserved white paper, for which fairly careful drawing was necessary beforehand. An underwash of yellow ochre was laid over everything that was not to remain white. When dry this was followed with ever-darkening washes of yellow ochre mixed with a touch of alizarin crimson and ultramarine blue.

MELLOW BLUENESS
Hazel Soan

The white highlights were reserved from a pale blue wash. The sea was painted fairly dry to catch the tooth of the paper and create the sparkle of light on rippled water. The layers of blue were gradually built up using wet washes over dry. It is worth comparing the overall warmth of the ochre in *A Dusting of Dusk*, above, with the coolness of this painting to see how colour can create atmosphere and mood.

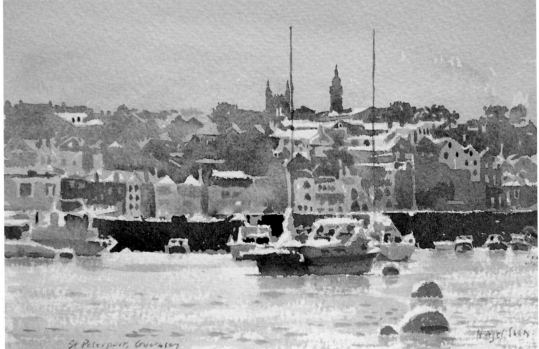

St Peterport, Guernsey

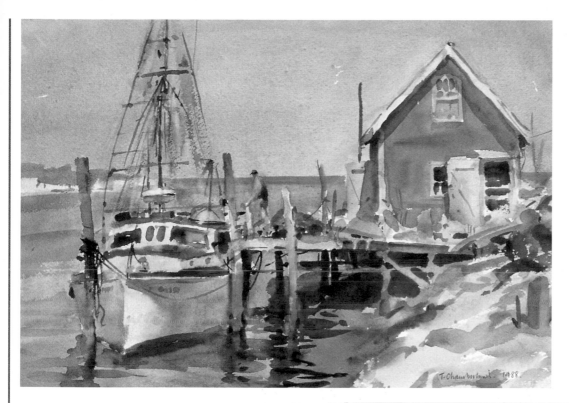

MANEMISMA HARBOUR, MARTHA'S VINEYARD
Trevor Chamberlain ROI RSMA

Swift, deft brushstrokes come together to make a lively harbour scene. Dry brushwork is used to hint at the rigging while glazes of neutral darks are laid for the shadows. The figure in transit between the house and the boat creates an interesting focal point for the narrative of the painting.

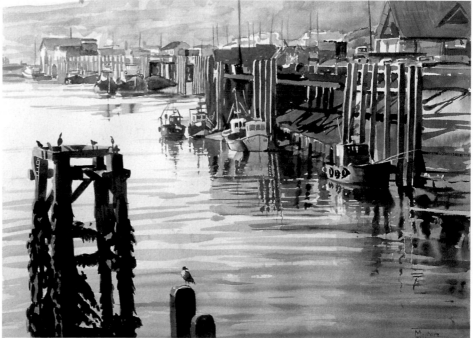

EARLY LIGHT, NEWHAVEN HARBOUR
Mark Topham

In this harbour scene, the glassy water shines white against the strong darks of the mooring posts. The reflections in the dark ripples are applied wet in wet and wet on dry, suggesting the ever-changing momentum of the water. Although there is colour in this painting, the strength of the work relies on the strong tonal play of lights and darks running through the perspective.

CRYSTAL PIER, WRIGHTSVILLE BEACH, N.C.
Neil Watson

Here the dynamic perspective is almost drawn with the paint rather than painted. The drag lines of the little boats across the sand follow the strong perspective lines of the pier. The complicated detail of the pier is balanced by the large sandy area so that the eye begins in the foreground and wanders beside the pier.

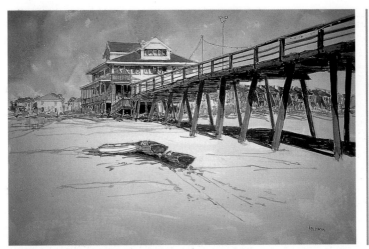

NORFOLK COAST
Alan Oliver

This deceptively simple painting explores the wet washy qualities of watercolour. Drifts of colour are formed by tilting the paper while the washes are wet. Swift ink lines demarcate the main compositional directions and pull the painting together.

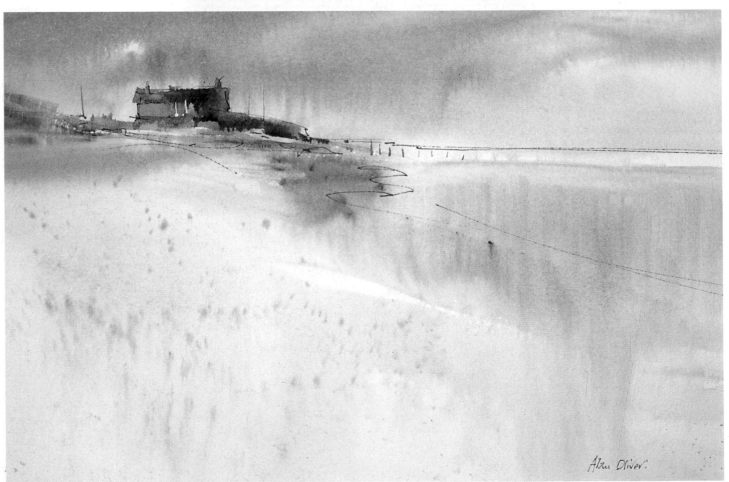

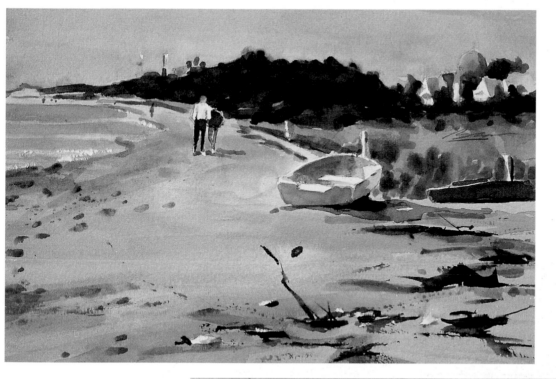

HAZY GLINT
Jann T. Bass

The bright highlights in this attractive painting are created both by reserving white paper and by scratching off. Look at the wavelets breaking on the edge of the shore to see how effectively the scratched-off highlights enhance the broken foam. A little spattering of colour enlivens the beach in the foreground.

EARLY MORNING, DELL QUAY (Detail)
Tom Groom

The little boats in this painting have a lot of character. Very few details are needed, but accurate drawing and a descriptive use of tone are of the utmost importance. The painting is built up with fairly dry washes. The mooring lines are drawn with light opaque paint, making their journeys across the picture plane an exciting element of the composition.

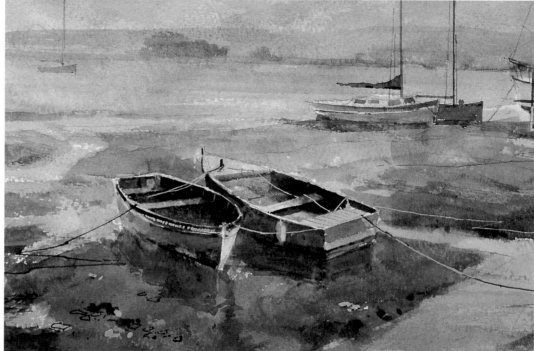

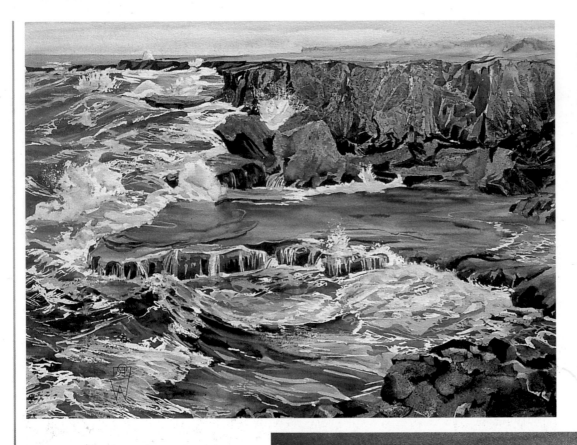

NORTH POINT, BARBADOS
D. Warren

The successful use of wax resist, masking and scratching out combine to create the turmoil of a wild sea meeting a rocky point. Both the rocks and the waves are full of lively textures, drawing the eye into an exciting pattern on the picture plane itself and in the illusion of reality. (See WATERFALLS; SEAS; RIVERS.)

WINTER LIGHT, HIGH TIDE
Robert Tilling R.I.

This evocative image of the rocky seashore is painted with an interesting, well-chosen palette. The artist lays the paint in abundant, very wet washes. When they are dry, he scrapes back the colour to create the light, watery horizon which glistens under the dark brooding rocks.

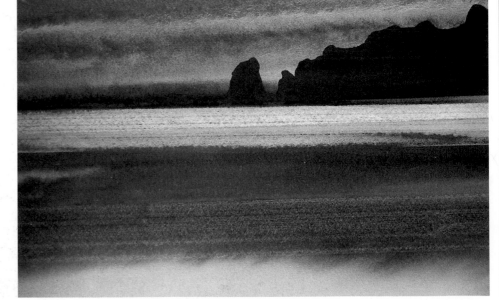

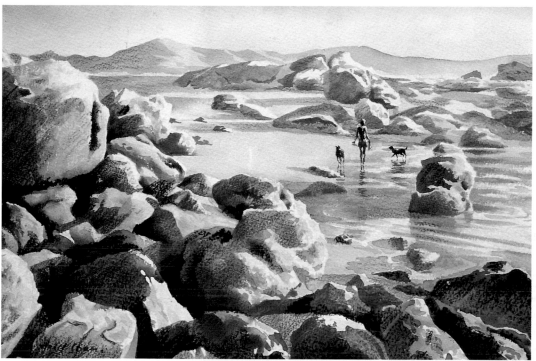

EXPLORING THE EDGE
Hazel Soan

The lights and shadows in this painting are established at the outset with washes of Prussian blue. Care is taken to suggest three-dimensionality in the boulders. Ochres and siennas are then washed into the light and dark areas to bring in warmth. The dark tones are overlaid with pencil crayon to strengthen the tones and create textures as the crayon picks out the tooth of the paper (300lb Not). The silhouette of the woman walking her dogs gives scale to the scene.

LLEYN COASTLINE
Tom Groom

Here again the tooth of the paper is used to create texture in the painting, but this time by laying dry washes over the rocks and sea so that the pigment brushes only across the top of the grain. The delightful little houses are sketched with the brush and then blocked in with a flat brush.

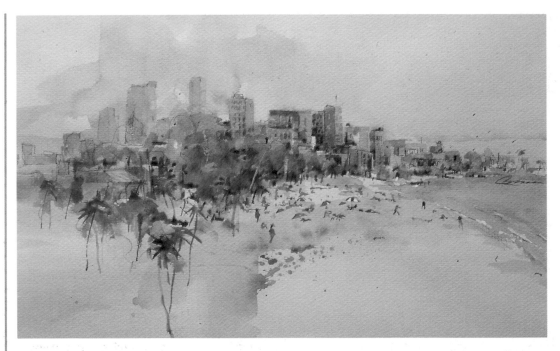

MIRAGE
Jann T. Bass

A painting need not fill the entire area of the picture plane, as this charming painting of a palm-fringed beach so ably demonstrates. The washes are laid fairly wet and quite dilute, and white bodycolour is used to create highlights. The perspective and movement of the figures as they frolic on the beach are well drawn with one-touch brushstrokes. (See FIGURES.)

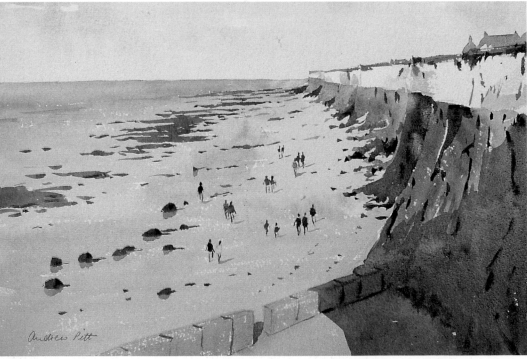

CLIFFS, HUNSTANTON
Andrew Pitt

One-touch brushstrokes are also used in this painting for the silhouettes of figures dotted along the beach. The wetness of the beach at low tide is painted with a lovely blue of almost the same tone as the sand, reflecting the colour of the sky above. This wetness is enhanced with reflections beneath the little rocks and stones.

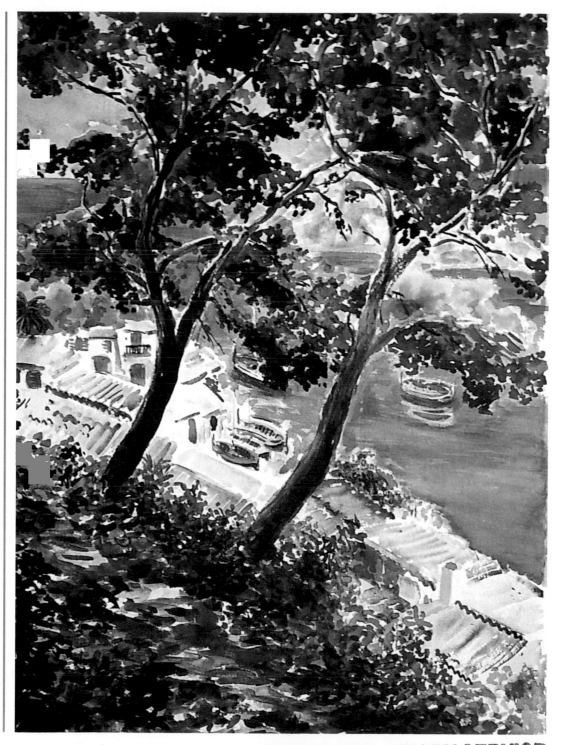

PATH TO THE SEA II
Charles Penny

Cheerful colour and almost playful brushmarks combine to create a painting full of warmth and sunshine. The dark foreground contrasts with the light houses below the trees and brings the pathway forward to the viewer. The artist successfully translates an unusual angle of view onto the picture plane, creating a painting full of interest.

Index

Page numbers in *italics* refer to illustrations

Credits

Quarto would like to thank all the artists who kindly allowed us to publish their work in this book.

We would also like to thank all the artists who did painting demonstrations:
Hazel Soan, Rima Bray, Jean Canter, Pip Carpenter, Jane Hughes, Deborah Manifold, Mark Topham, Annie Wood.